LOST CLEVELAND

Picture credits

Library of Congress: 8, 9, 10, 12, 13, 15, 20 (bottom), 21, 23, 24, 25 (top), 32, 33, 34 (bottom left and right), 35, 36, 37, 41 (right), 42, 43, 44, 45, 46 (top), 47, 48, 52, 53 (left), 55, 59 (left), 65, 66, 70, 71 (left), 86, 88, 89, 98, 99 (middle), 102, 103, 106, 107, 108, 109, 116, 117, 123 (bottom), 130, 131.

The Cleveland Press Collection, Michael Schwartz Library, Cleveland State University: 26, 27, 29 (top right), 30 (bottom right), 50 (top right), 51, 56, 57 (top), 58, 60 (left), 61, 62, 68 (middle and right), 69, 72, 73, 80 (top), 81, 84, 85, 95 (top right), 110, 111 (left), 114, 115 (bottom left), 142.

Special Collections, Michael Schwartz Library, Cleveland State University: 16, 17, 18, 19 (right), 63, 82, 115 (top right), 123 (top), 124 (right), 137 (right), 140, 141, 143.

Cleveland Public Library/Photograph Collection: 11, 22, 29 (bottom right), 31, 34 (top), 38, 39, 40, 41 (left), 46 (bottom), 49, 50 (top left and bottom left), 53 (right), 54, 60 (right), 64, 74, 76 (left), 77, 78, 79, 83, 87, 95 (bottom right), 99 (left), 101, 112 (left), 113, 115 (bottom right), 118, 120, 122, 124 (left), 125, 126, 127 (top), 129.

Plain Dealer Historical Collection: 29 (bottom left), 30 (top left and right), 57 (bottom), 68 (far left), 76 (right), 92 (left), 93, 94, 95 (top left), 96 (middle), 97, 104, 105, 111 (right), 128 (top left), 128 (top right), 132 (left), 133, 136.

Western Reserve Historical Society: 7, 19 (left), 20 (top), 59 (right), 67, 99 (right), 132 (right).

John Petkovic: 119, 134 (left), 138 (left top and bottom).

Getty Images: 14, 28.

Philadelphia Toboggan Coasters Inc.: 71 (right).

Courtesy of Michael Funtash: 75.

Photo by C.W. Ackerman, courtesy of the Albert M. Higley Co.: 80 (bottom).

Cuyahoga County Engineer's Photography Collection, Cuyahoga County Archives, Cleveland State University: 90.

U.S. National Archives and Records Administration: 91.

Miller-Ertler Studios: 96 (far left).

Roger Kobus/Mentor Sig: 96 (right).

Jim Smith, courtesy of Northern Ohio Railway Museum Collection: 100 (left).

Laura DeMarco: 100 (middle).

Friends of the Historic Variety Theatre: 100 (right).

Thom Sheridan: 121.

Wasted Time R: 128 (bottom right).

Caters News Agency: 134 (right).

Jennifer Stockdale: 137 (left and middle).

Amanda Mcilwain: 138 (top right).

Randy Fox: 139.

Acknowledgments

Lost Cleveland is dedicated to the city of Cleveland and its ghosts that live on. It would not have been possible without those who shared their wisdom and archives: George Rodrigue and my colleagues at the 175-year-strong *Cleveland Plain Dealer*; Vern Morrison and Beth Piwkowski at the Cleveland Memory Project; Milos Markovic, Brian Meggitt and Lisa Sanchez at the Cleveland Public Library; and John Grabowski of Case Western Reserve University. I would also like to thank editor David Salmo for his invaluable assistance. Love and thanks to my Cleveland family, especially John and Maria.

First published in the United Kingdom in 2017 by
PAVILION BOOKS
43 Great Ormond Street
London
WC1N 3HZ
An imprint of Pavilion Books Group Limited

© Pavilion Books, 2017

ISBN: 978-1-911595-15-1

A CIP catalogue record for this book is available from the British Library.

10 9 8 7 6 5 4 3 2 1

Endpapers show a panoramic view of Public Square (circa 1905) and a bird's eye view of Cleveland from 1877 (both courtesy of Library of Congress).

Repro by Rival Colour Ltd, UK
Printed by 1010 Printing International Ltd, China

www.pavilionbooks.com

LOST CLEVELAND

Laura DeMarco

PAVILION

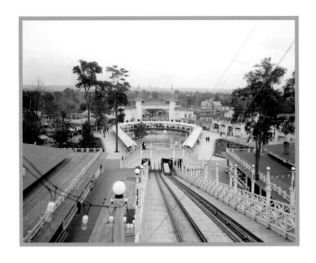

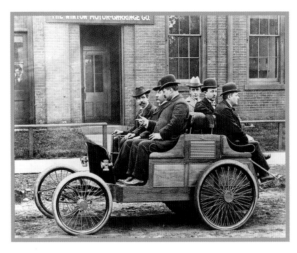

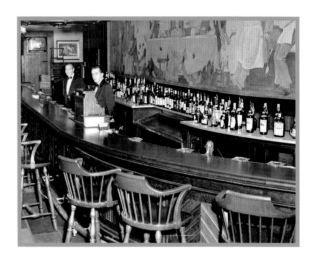

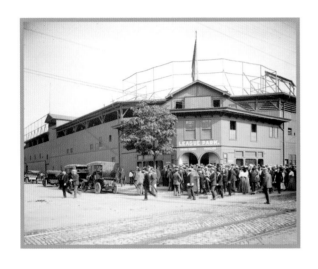

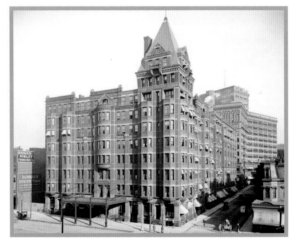

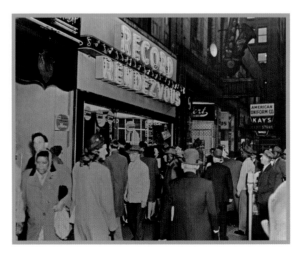

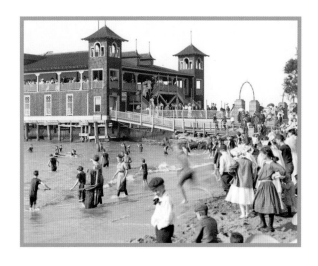

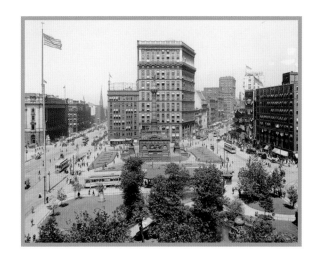

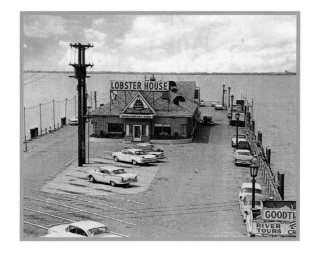

LOST IN THE...

1900s	**page 8**
1910s	**page 10**
1920s	**page 12**
1930s	**page 22**
1940s	**page 36**
1950s	**page 42**
1960s	**page 60**
1970s	**page 72**
1980s	**page 86**
1990s	**page 110**
2000s	**page 132**
2010s	**page 138**
Index	**page 144**

INTRODUCTION

The city of Cleveland has had many nicknames since 1796, when a surveyor named Moses Cleaveland landed at the mouth of the Cuyahoga, gazed upon the river and the vast greenery and founded one of America's great cities. First: "The Forest City." "The Fifth City." "The City of Champions." Then, later: "The Mistake on the Lake." "The Burning River City." "The Rock and Roll Capital of the World." And, finally: "Believeland."

These aren't just nicknames, though. They underscore the turbulent rise-and-fall-and-recovery story of a city that was once the fifth largest in America, a city where the glorious past casts a long shadow—and the inglorious moments do, too. A city that claimed one of the wealthiest streets in the world in the early 1900s, and had some of the darkest, grimiest moments in 1970s rustbelt America. A city that could boast some of the finest teams in sports history, and where the fields those teams played on, League Park and Municipal Stadium, are now just memories. A city that had some of the most stunning theaters outside of New York City, which are now parking lots. A city where a whole second downtown, Doan's Corners, filled with theaters and restaurants and shops and apartments, vanished with nary a trace—all in the cause of "progress."

Like so many of the lost buildings in this book, the story of Cleveland is one of creation, abandonment, destruction—and perseverance. For the city, that means rebuilding, like the renaissance of downtown that climaxed in 2016.

For the lost hotels and theaters and amusement parks and automobile companies and steel mills and breweries and mansions in this book, that means living on through memories, and photographs.

Cleveland's rise and fall, and rise again, would have been unthinkable when Moses Cleaveland was sent to survey the Western Reserve for the Connecticut Land Company. The area was named "Cleaveland" after its founder, who laid out a Public Square based on those in his native New England.

Cleveland was incorporated as a village in 1814, but it wasn't until the Ohio and Erie Canal was complete in 1832 that it really began to grow. Cleveland was incorporated as a city in 1836.

Following the Civil War, Cleveland's population boomed, spurred on by the Union Depot, one of the largest transportation hubs outside of New York City.

The birth of Cleveland as an industrial power took place in the post-Civil War era, thanks in part to John D. Rockefeller's founding of Standard Oil, in 1870. Cleveland's prime location on Lake Erie made it ideal for manufacturing. By 1880, steel had become big business, with companies such as Republic Steel helping provide jobs until the dream rusted in the 1970s.

In Cleveland's Gilded Age of 1865 to 1900, industry meant growth and wealth. As business and population took root, so did cultural institutions and stores and neighborhoods.

By 1870, Cleveland's population hit 93,000, more than double from before the Civil War.

Only a few of those Clevelanders had an address on Euclid Avenue, known as Millionaires' Row until the 1930s. Those that did were the names that built the city: Rockefeller and Hanna and Mather. Sadly, the grand mansions that lined this avenue were torn down in one of the greatest losses in Cleveland history.

By 1900, Cleveland boomed to 380,000—about what it is in 2017—and by 1920 there were 800,000 residents. It became known as "The Fifth City." By the 1930s, Cleveland had 900,000 residents.

Many lived in glamorous apartment buildings and residential hotels downtown, like the chic Allerton Hotel on Chester Avenue. Visitors to the city could stay at the enormous Hollenden Hotel on Superior Avenue. Both only live on in photos.

It wasn't just places to live that Clevelanders were building. The early 1900s saw several luxurious entertainment venues open.

Downtown, the magnificent Hippodrome opened in 1907, called the city's most beautiful theater. Today it's a parking lot.

Euclid Avenue blossomed as a shopping destination at this time, too, with lavish department stores such as Sterling Lindner Davis and Higbee's and Halle's. They're all gone.

There's no sign left of the Elysium ice rink, which opened in 1907 in Doan's Corners and introduced skating to Cleveland. It was at the Elysium where the Cleveland Barons played, until they moved to the Cleveland Arena in 1937. The Arena was also the first home to the Cleveland Cavaliers and the site of the world's first rock 'n' roll concert. Cultural importance couldn't save it, however. It closed in 1974.

The 1970s spawned a popular saying, "Cleveland, You've Got To Be Tough"—for good reason. The decade was very tough for Cleveland. As were the 1960s and 1980s. The city was hard hit by suburban flight, race riots, pollution and the decline of industry that plagued the rust belt. With an infrastructure built to support a much larger population, buildings were abandoned or fell into dereliction.

The 1980s were especially destructive for downtown. On Public Square, two of Cleveland's most architecturally significant buildings, the Cuyahoga and Williamson towers, were imploded in 1982. The remarkable 1910-built Engineers Building was unceremoniously demolished in 1989.

These were among the last great Cleveland losses, however. The city's fortunes have been on the rise in recent years, with the healthcare industry filling some of the employment void. Downtown, the population is growing rapidly. Buildings that would have once been demolished are being preserved. Case in point: The Engineers Buildings' twin, the 1925-built Brotherhood of Locomotive Engineers Cooperative National Bank Building, is being converted into upscale apartments.

The last decade has also seen the restoration of several other landmarks, including the 1907 Cleveland Trust Company Building by George B. Post, who designed the Williamson; and the 1971 Cleveland Trust Tower by Marcel Breuer, which narrowly missed a date with the wrecking ball. Today the Cleveland Trust Building is an upscale grocery, and the Tower a luxury hotel-apartment complex.

Like many an empire that crumbled, Clevelanders strive to recapture the glory of their city through memory. But preservation successes like these, coupled with 2016's conclusion as one of the city's most vibrant years yet, suggest glory outside of history books may again be attainable. The Cleveland Cavaliers' NBA championship, the Indians' World Series run and the renovation of Public Square into the kind of town center Moses Cleaveland conceived are raising Cleveland's national profile, and civic spirits. It may not be the "Fifth City" anymore—but it is "Believeland."

As NBA superstar LeBron James has famously said, "In Northeast Ohio, nothing is given. Everything is earned." Even the memories.

OPPOSITE *In 1927, Doan's Corners was a second downtown on Cleveland's east side, with theaters and banks and stores and apartments.*

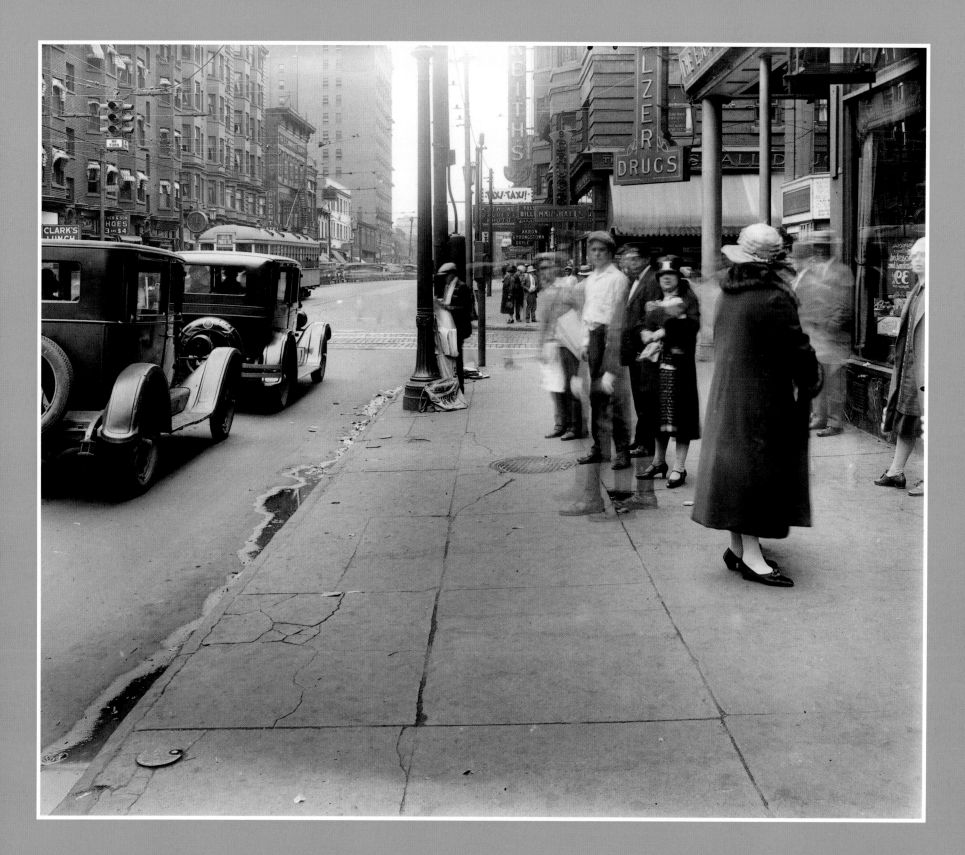

White City Amusement Park CLOSED 1908

Euclid Beach Park wasn't the only lakeside amusement park to open on the east side of Cleveland in the early 1900s. But Clevelanders can be forgiven for not remembering White City Amusement Park as fondly. Despite its unique rides, striking white buildings and prime location on the lake and a streetcar line, this early 20th-century park had a brief seven-year run. And a cursed one, at that.

Located on Lake Erie at East 140th Street, the park opened in 1900 less than a mile from Euclid Beach Park. At first, it was known as Manhattan Beach and was managed by William Ryan, the original manager of Euclid Beach, which had opened in 1894.

Manhattan Beach featured a dance hall, park and bathing areas on the lake, and was popular for family outings, though not especially profitable. But developer Edward C. Boyce, who planned and built amusement parks in New York City and Chicago, including Coney Island's famous Dreamland, thought the land had more potential. He purchased it in January of 1905 and proceeded to turn it into a White City Amusement Park, one of several in the country inspired by the White City section at the 1893 World's Columbian Exposition in Chicago. Completed in less than 11 weeks, Cleveland's White City had a shoot-the-chutes water ride, lagoon, scenic railway coaster and flying airships. A tall tower covered in lights illuminated the grounds.

Entertainment included the wild animal acts in Bostock's Animal Show, such as Bobby Mack and his lions, Salica and her leopards and Dorine and her jaguars. Boats on the shoot-the-chutes were named after areas of town, including Collinwood. There were also theaters where exotic entertainers including Omar Sami and the Flying Lady and Brandu the "Hindoo snake charmer" performed, and a boardwalk for bands and "merry-making." Fireworks over the lake were a common entertainment. Buildings were made out of white stucco, in a kind of Victorian-Moorish mash-up style, and covered with more than 50,000 incandescent lights—hence the name.

Despite its lakeside location and popular rides and performers, White City did not fare as well as Euclid Beach—though one Sunday in June 1905 the park noted a record-breaking attendance of more than 200,000 fun-seekers. It charged admission, unlike its neighbor, which hurt its draw. Stories of trainers being mauled by some of the big cats didn't help either. (Sadly, a performing elephant named Jumbo II died at the park in 1902, supposedly of "homesickness.") In 1906, more than half of the park was destroyed in a fire. A severe windstorm caused excessive damage in 1907. In 1908, the owners decided to close for good after determining it would cost too much to rebuild. The site of this dreamlike escape from reality is now a sewage treatment plant.

RIGHT *Cleveland's White City Amusement Park was one of several across the country inspired by the 1893 World's Columbian Exposition in Chicago. Buildings were made out of white stucco and covered with more than 50,000 incandescent lights.*

BELOW *White City's entrance at East 140th Street was located on one of Cleveland's streetcar lines, the same one that also stopped at Euclid Beach Park.*

BELOW LEFT *The shoot-the-chutes water ride was one of the most popular at White City. The boats that plummeted into the lagoon were named after areas of town, such as Collinwood.*

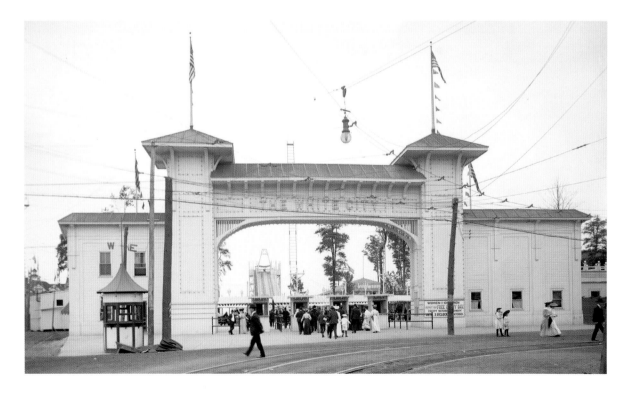

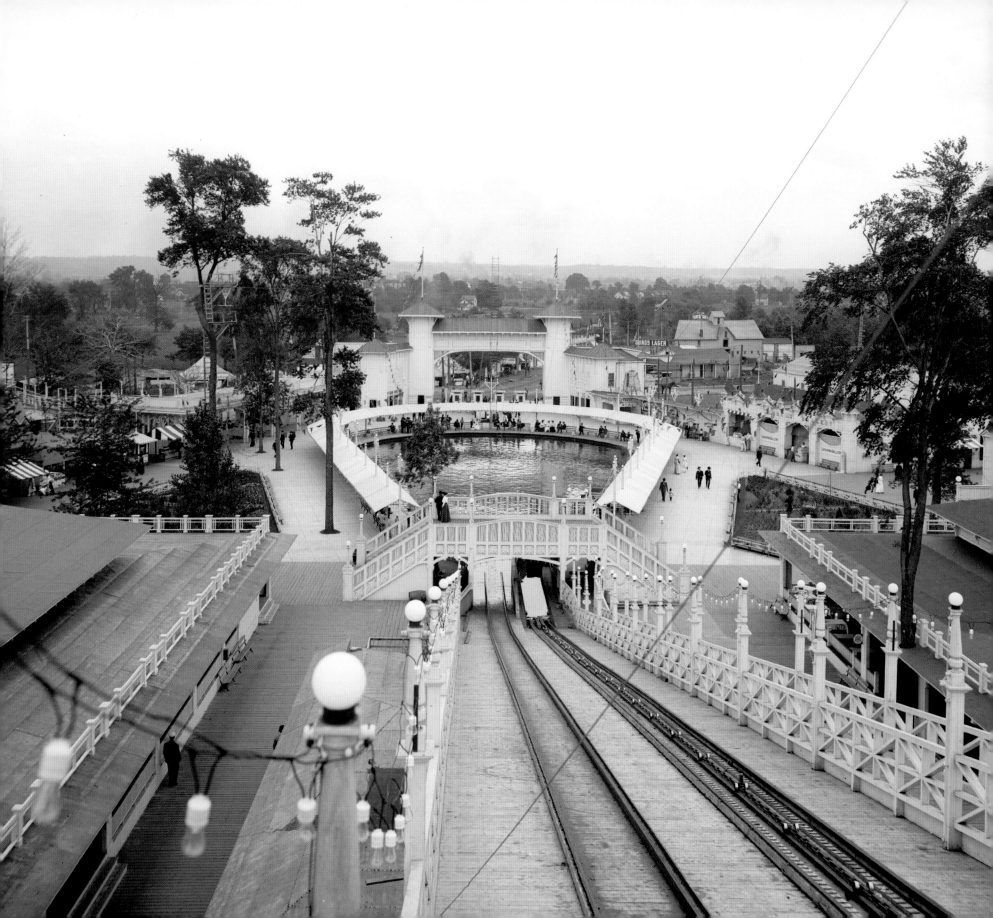

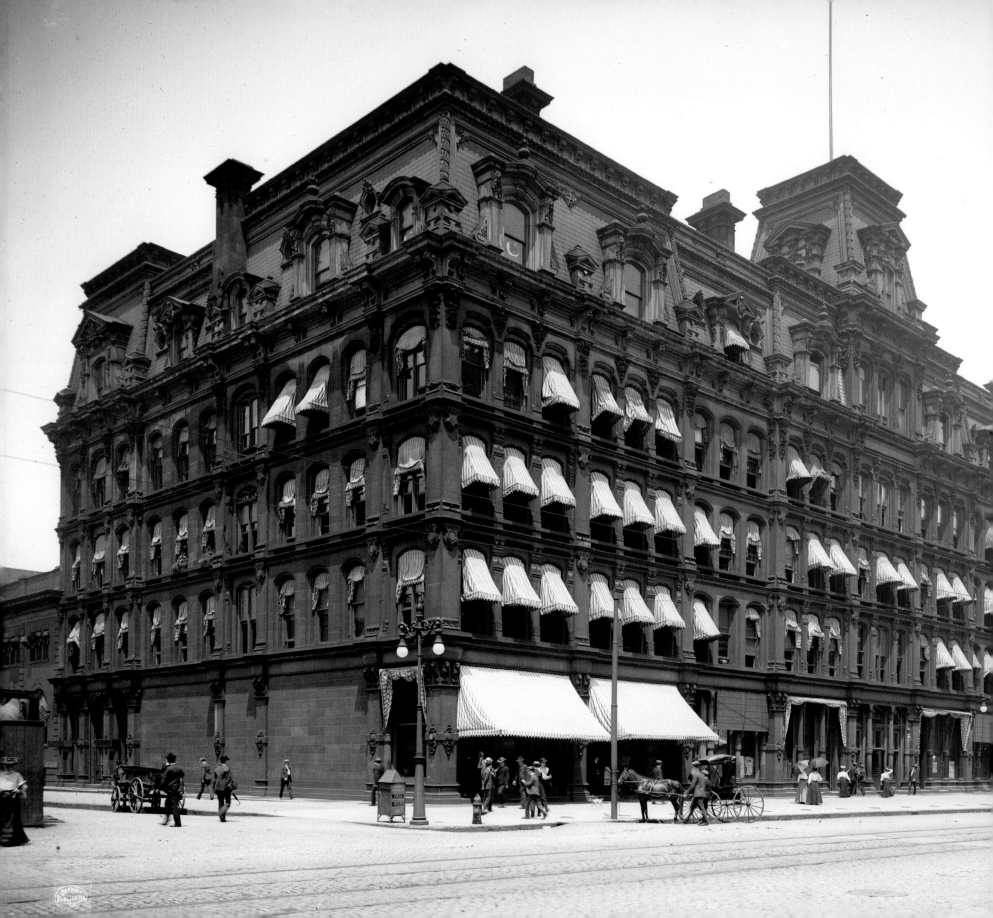

Case Block / Old City Hall DEMOLISHED 1916

Clevelanders think of their 1916-built City Hall on Lakeside Avenue as old. But it was in an even older city hall where the city's growth and power took root in the late 1800s.

The Case Block, as the building was called, opened in 1875 on Superior Avenue at East Third Street, right off of Public Square. The block-long Victorian-style building had a cupola in the center, hooded windows and modified, 20-foot mansard roof with dormer windows. It was five stories high. The commercial building was constructed to house shops and business offices—not the government offices that eventually became its most important residents. It was built on the site of the famed Ark, a clubhouse where early Cleveland intelligentsia gathered to talk philosophy, science and culture.

Named for prominent philanthropist and businessman Leonard Case—an "Arkite"—the building was designed by Charles W. Heard.

The Cleveland architect designed many other noteworthy Victorian-era buildings, including the 1875 Euclid Avenue Opera House and the 1863-built Case Hall lecture auditorium, also on Superior Avenue.

The Case Block was built for a cost of $800,000. When the city of Cleveland moved in with its offices, which had been housed in rental space in the Jones Block across Public Square, it paid $36,000 per year. The government would be run from this elegant structure until moving in 1916 to the J. Milton Dyer-designed City Hall on Lakeside Avenue that it still occupies. The city finally purchased the entire Case Block in 1906 from the Case estate. Prior to that time, city leaders had some interesting neighbors in the building. These included several animal exhibits from the Kirtland Historical Society, which found a home in the Case Block in 1876. The multipurpose building also housed the Cleveland

Library Association, later the Case Library, and several ladies' clothing stores and artists' studios at the same time it functioned as City Hall.

Considered old fashioned by 1894, it was remodeled inside by prominent Cleveland architect Levi T. Scofield, who added elevators and a skylight.

Interestingly, in 1895, City Hall planned to move out when voters approved the construction of a new city hall inside Public Square, in the north quadrants. But outcry over the loss of public space meant the project never got off the ground. Instead, Cleveland City Hall would continue in the Case Block for another two decades.

It was in this building that Cleveland's most famous mayor, the progressive Tom L. Johnson, held office from 1901 to 1909. From the Case Block, he helped build Cleveland into the great city it would soon become, commissioning roads, parks, city services, health and welfare services and much more.

It was Johnson's biggest, most lasting project that eventually led to the Case Block building's demise, however: the Group Plan designed by Daniel Burnham to create Cleveland's downtown civic center on what is now known as the Mall. Part of that plan included the construction of the new Cleveland City Hall, which eventually led the government to vacate the Case Block for its very own building for the first time in its history. The Case Block building was torn down that same year to make room for the United States Post Office, Custom House and Court House. The Case name lives on today in Cleveland in the form of Case Western Reserve University, begun with an endowment from Leonard Case.

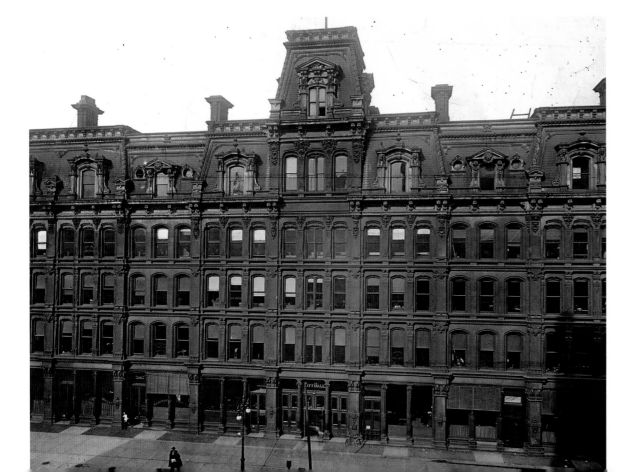

LEFT *The Case Block building was designed by Charles W. Heard, a Cleveland architect who also designed the Old Stone Church, the 1856-built Central High School and the Euclid Avenue Opera House.*

OPPOSITE *The block-long Victorian-style Case Block building at Superior Avenue and East Third Street housed the offices of Cleveland City Hall from 1875 to 1916—as well as animal exhibits, dress stores and artists' studios until the city took over the whole space in 1906.*

Superior Viaduct CLOSED 1920

Once the tallest and longest bridge in Cleveland, the Superior Viaduct is now a bridge to nowhere. Literally. The center span was demolished in 1922, making the colossal sandstone arches that remain Cleveland's most impressive architectural ruins—but totally useless.

It wasn't meant to be that way. When it was built, the Superior Viaduct was more than roadway—it was a towering, tangible sign of Cleveland's progress as a growing, industrial city. Plans for the bridge began in 1872 when Cleveland voters approved construction for the connector, which would span high over the Cuyahoga River from Detroit Avenue and West 25th Street in the Ohio City area on the west to Superior Avenue and West 10th Street downtown. When the huge bridge opened after three years of construction on December 28, 1878, at a cost of $2.17 million, it was hailed as the pathway of the future. It would get more people into the growing city faster, and allow ships faster passageway down the river below. Traffic on older low-level bridges had to stop for each boat. The Superior Viaduct was thought to be the solution to that problem.

The viaduct was constructed with 10 sandstone arches soaring over the river to a length of 1,382 feet, 72 feet above their foundation. The total bridge length was 3,211 feet. It had wrought-iron railings, sandstone sidewalks and a cobblestone roadway. There was room for two lanes of traffic and two streetcar lines. A 332-foot center iron truss span swung out and rotated to allow ships to pass.

The graceful viaduct was Cleveland's tallest bridge to date when it opened—but it still wasn't tall enough. The center span had to be drawn so many times each month to allow shipping traffic that the monumental bridge was outdated by the late 1910s. Some estimates say it was swung as many as 300 times a month, halting traffic for at least five minutes each time. In the end, the bridge meant to help speed Cleveland along was done in by its own progress—increased shipping and road traffic in the booming industrial city. Cleveland citizens again began to ask for another bridge, this time an even higher one.

When the much higher Detroit-Superior Bridge—later the Veterans Memorial Bridge—opened next to it in 1918, it led to the viaduct's closure by 1920.

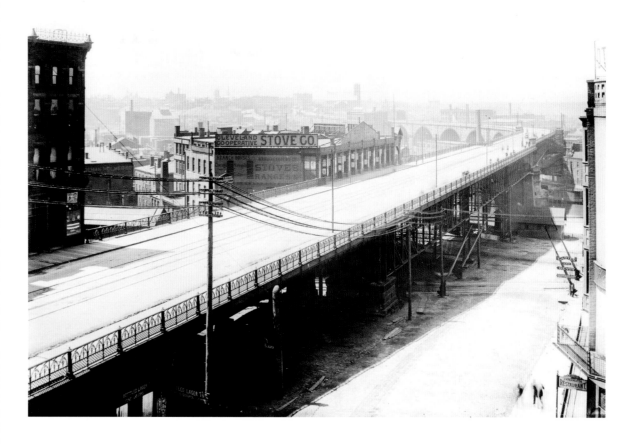

The center span was demolished two years later, and the eastern arches in 1939.

A portion of the viaduct remains on the western edge off of West 25th Street, however. The stub is home to some of Cleveland's toniest condos and the best skyline view of downtown.

ABOVE *Cleveland's first high-level bridge was 3,211 feet long. A center draw span allowed shipping traffic to pass by on the Cuyahoga River, as frequently as 300 times a month.*

RIGHT *Pedestrians, automobiles and streetcars shared the Superior Viaduct in the summer of 1912.*

OPPOSITE *When the Superior Viaduct opened in 1878, it was the longest and tallest bridge in Cleveland, transporting thousands of west siders into and out of the city daily—first on carriages and buggies, later on cars and streetcars.*

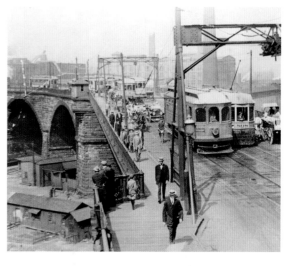

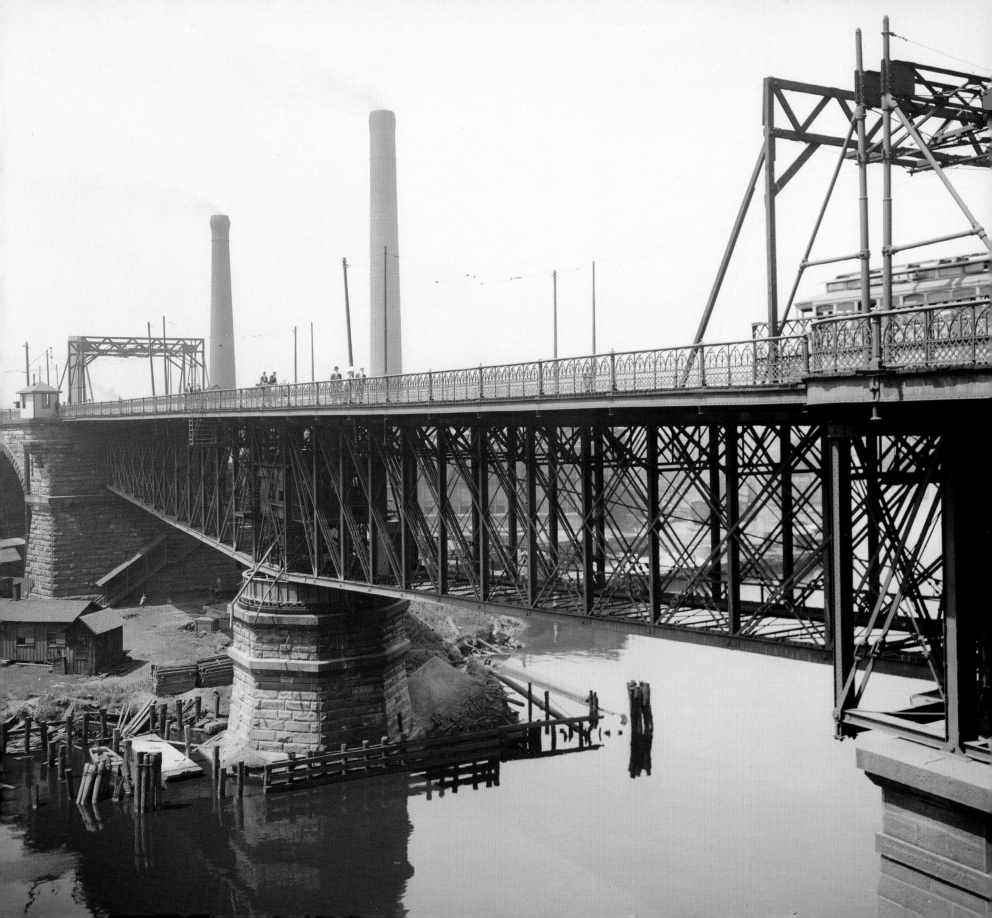

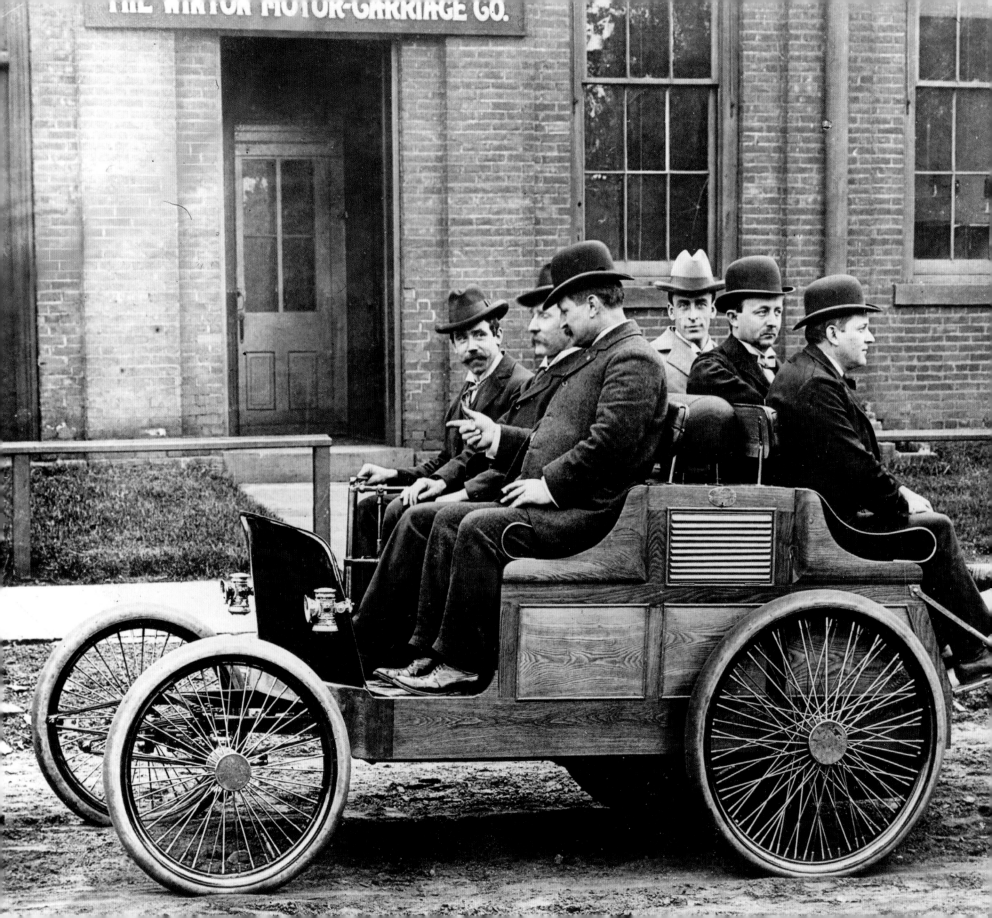

Winton Motor Carriage Company CLOSED 1924

"Dispense with a horse" read an 1898 ad for one of the first automobile companies in America, the Cleveland-based Winton Motor Carriage Company. "The Winton Motor Carriage is the best vehicle of its kind that is made."

Winton was one of several fledgling car companies in Cleveland that gave Detroit a run for its money in the early 1900s. The list included White Motor Company, Rauch & Lang, F.B. Stearns, Chandler, Templar and Peerless Motor Company.

Winton was founded in 1897 by Scottish immigrant Alexander Winton, previously a bicycle manufacturer. The company's earliest gas-powered luxury cars were built by hand at Winton's factory on Belden and Mason streets, on the near east side of downtown. Later, the factory expanded to Berea Road on the west side. In its heyday, the company employed more than 1,500 workers.

Winton spared no expense with his painstakingly constructed automobiles. They featured gas lamps, padded seats, leather roofs and tires from Akron's B.F. Goodrich. They sold for $1,000 to $2,000. The cars were fast—topping off at 33.64 mph in test runs—but sales of the pricey vehicles were slow. Winton himself decided to undertake a high-profile, high-speed PR campaign to give them a boost. In July 1897, the company founder embarked on the first of two 800-mile car treks to New York City to prove his car could make the trip. It did, in 78 hours and 43 minutes.

Not only did the remarkable road trip gain publicity for the Winton Motor Carriage Company, it also helped boost sales. James Packard, who later founded the Packard Automobile Company, even bought one of the luxurious autos. So did members of the Vanderbilt family.

By 1899, Winton had gained national notice. The company sold 100 cars that year, and opened the first auto dealership in America, in Reading, Pennsylvania. Winton had become the largest maker of gas-powered automobiles in America. The company thrived through the 1910s and early 1920s. In addition to family cars it also began to manufacture trucks, racing cars and delivery vehicles.

In 1903, a driver in a two-cylinder Winton touring car even made the first cross-country drive in the United States, from San Francisco to Manhattan. The trip took 63 days, 12 hours and 30 minutes, including time to wait for parts to arrive from Cleveland along the route.

By 1905, Winton had gone international. It established locations in New York, Honolulu, London, England and Toronto, Canada to sell models such as its sleek Winton Six two-cylinder Touring Car and self-starting Six-Teen-Six model. By 1910, the company was making 18 models. By 1915, Winton was making 2,450 vehicles in a year.

Eventually, the times caught up with the handmade car company. Unable to compete with Henry Ford's assembly lines in Detroit, sales of the expensive cars declined and the Winton Motor Carriage Company—known as the Winton Car Company since 1915—ceased production on February 11, 1924.

OPPOSITE *Alexander Winton (far left) took a group of friends, including future Cleveland mayor Tom L. Johnson (right), for a ride in an experimental two-cylinder model in 1897.*

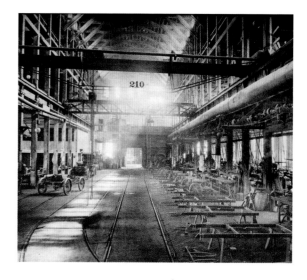

ABOVE *Inside an assembly room of the Winton Motor Carriage Company on Berea Road and Madison Avenue in the early 1920s.*

BELOW *The former Winton Motor Carriage Company machine shop and storage buildings on Berea Road and Madison Avenue in the 1970s.*

Diebolt Brewing Company CLOSED 1928

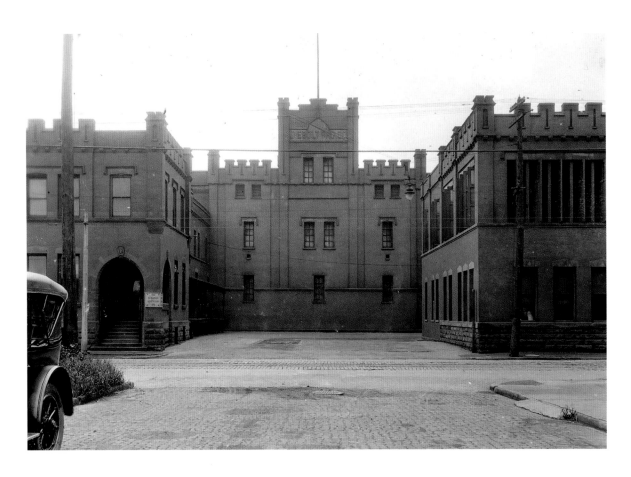

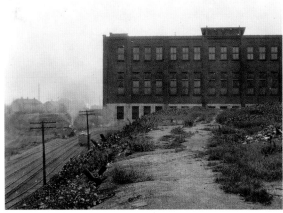

drinkers. Diebolt even built a "modern" bottling plant to clean and sterilize bottles in 1915.

Prohibition led to its decline, but Diebolt closed for good in 1928 after a contentious trial led to it being taken over by eminent domain by the Van Sweringen brothers for construction of the Union Terminal. The developers paid less than $1 million for the company despite it being valued at $2 million. Many of the buildings weren't demolished for another 50-plus years, however. The three-story fortress-like red-brick stables, with an imposing concrete horse over the door, stood until 1980. Memories of the German-style brewing company live on in black-and-white photographs and quests for one of its elusive, collectible amber bottles.

Cleveland has become known for its many small craft breweries in the 21st century. Raise a stein to a sudsy city that has come full circle. It was the same scene 100 years ago in the area founded by many German and Eastern European immigrants. They brought their recipes and fondness for beer with them to their new homeland.

Cleveland had established quite a cottage beer industry by the mid- to late-1800s. By 1910, there were 26 small, mostly family run brewing companies within the city. That's a lot of beer for a city of 500,000. The breweries included Gehring, Schlather, Star, Fishel, Bohemian, Cleveland, Columbia, City, Gund, Leisy, Pilsener, Standard and the Diebolt Brewing Company.

Diebolt opened in 1888 as Diebolt & Uehlin, run by immigrants Anthony, Joseph, Matthias and Frank Diebolt and August Uehlin. Uehlin left in 1889, replaced by Edward A. Ruble. By 1892, it was just known as the Diebolt Brewing Company. Located at Pittsburgh Avenue and East 27th Street near Broadway Avenue, the brewery had its own stables across the street for its beer wagon horses.

The mid-size brewing company reached peak-production of 80,000 barrels not long after 1888. Its White Seal Beer, called "The Triumph of Brewing," was its most popular brew. The brewery also made Diebolt's Standard Beer, a spring bock beer and a Bohemian export beer. Ads promised its Malt Tonic was "pure and wholesome—gives health and strength." Diebolt's motto was "It's the best by test." The company brewed beer for saloons, taverns and—as Prohibition approached and bars were targeted by morality-squads—for home

ABOVE LEFT *The imposing, castle-like Diebolt building on Pittsburgh Avenue in 1923, five years before it closed for good.*

ABOVE *Train tracks next to the Diebolt building illustrate how close it was to the railway approach for the planned Cleveland Union Terminal in the early 1920s.*

RIGHT *The Diebolt Brewing Company was at 2702 Pittsburgh Avenue, near the eastern approach to Cleveland's Union Terminal, known as the Terminal Tower today. It was closed for the construction of the terminal in 1928.*

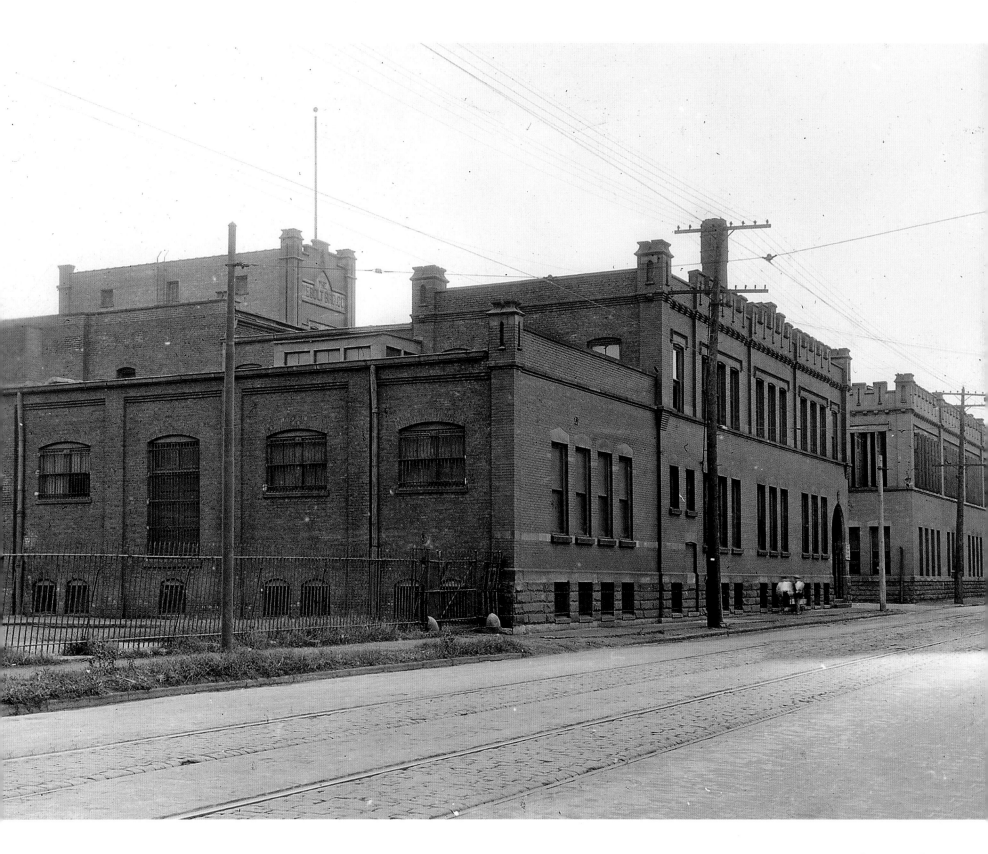

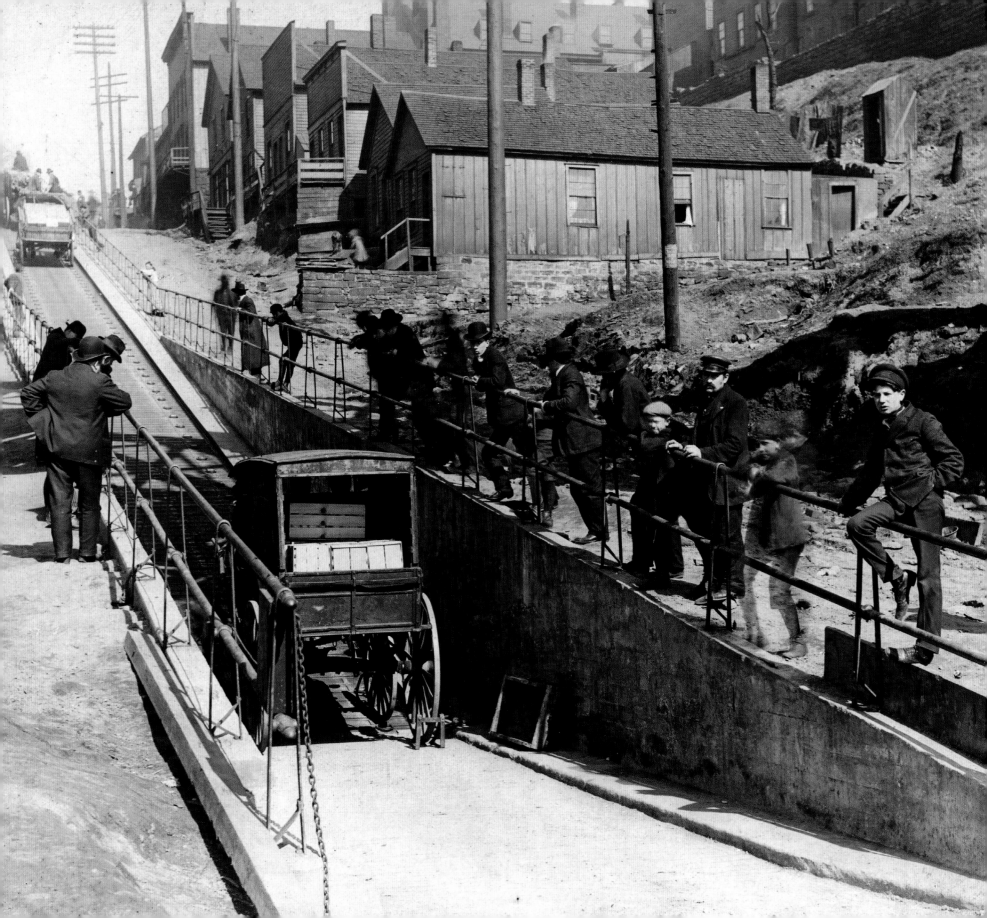

Rolling Road DEMOLISHED 1928

Much attention has been paid to the role of chugging factories and a brisk shipping industry in Cleveland's ascendancy to being an economic powerhouse. Less is known about the small but important role played by an almost forgotten driver of industrial growth, the Smead Rolling Road. Truck by truck and cart by cart, this moving road on Eagle Avenue helped Cleveland companies ascend, literally, to new levels.

Opened in 1905 and similar to an outdoor escalator, the Smead Rolling Road transported horses and wagons up the steep incline between the industrial Flats near the Cuyahoga River to Ontario Street near Central Market.

The moving road was the creation of inventor Colonel Isaac D. Smead, who worked in the heating industry in Ohio. The 420-foot road featured an electric-powered device built into the roadbed to pull wagons up the very steep hill, and operated like a moving belt. It rose 65 feet and was 12 feet wide. Horses were unharnessed and walked up the hill, while the heavy wagons were pulled up at speeds of three to six miles an hour. This modern technology accomplished in two minutes what had previously taken 20 minutes to an hour.

Smead's patented road was considered an engineering marvel at the time. "A moving roadway ascending a steep hill at the rate of four miles an hour and bearing with it heavily laden teams and vehicles of all kinds is a sight which now greets the astonished visitor to Cleveland, Ohio," said the May 1905 issue of *Popular Mechanics* magazine. "Moving sidewalks have been much talked of and experimented with, but it has remained for engineers of that city to successfully apply the principles of their construction to a roadway and put it into everyday use."

It was an immediate boon to industry in the area. "It has been impossible, hitherto, to use this street, or hill, for heavy trucking because of its steep, treacherous ascent of 70 some feet," read an article in *Municipal Journal and Engineer* the year it opened. "Teams have been obliged to make a long detour instead of using this natural shortcut from the lowlands to the city's level, thereby losing a vast amount of time to say nothing of the wear and tear on horses, harness and wagons."

The toll was 10 cents to transport a horse, buggy and driver; 15 cents for a horse, barouche and two persons; and 20 cents for a horse, carriage and driver. Foot passengers were charged two cents to walk up the road. Horses and an "extraordinarily loaded wagon" and driver cost 50 cents.

For more than two decades, the Rolling Road helped Cleveland grow, one cart load at a time. But by the late 1920s, it was becoming less useful with the development of powerful trucks that could easily carry large loads. Horse-drawn wagons were becoming obsolete, and with them the Rolling Road.

Colonel Smead's brilliant invention was eventually demolished in 1928 to make way for the Cleveland Union Terminal station.

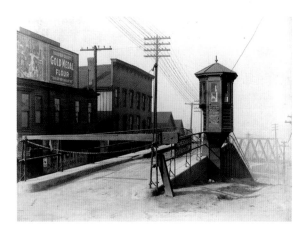

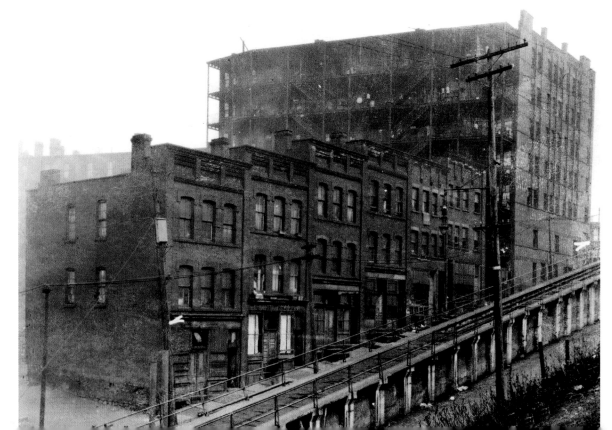

ABOVE *The view of the Rolling Road from the top of Eagle Avenue.*

LEFT *The Rolling Road took passengers by Cleveland's largest tenement building, at the top of the hill. All of these buildings were demolished for the Terminal Tower complex and Cleveland Union Terminal station in 1928.*

OPPOSITE *Spectators take in the view from the bottom of Colonel Smead's Rolling Road, on Eagle Avenue in Cleveland's industrial Flats area, in the early 1920s. It cost 10 cents to transport a horse, driver and buggy like this.*

Luna Park CLOSED 1929

"**Cleveland's fairyland of** pleasure" couldn't survive the reality of the Great Depression. Luna Park had a magical run for more than two decades, however.

Located at the end of a trolley line near Woodland Avenue, Woodhill Road and East 110th Street in what was then the Woodland Hills area, Luna Park was a twinkling, exotic playland for the young and young at heart for 24 years.

Opened in 1905 by famed amusement park architect Frederick Ingersoll—who went on to build more than 40 parks—Cleveland's Luna Park was the builder's second complete venue, after a

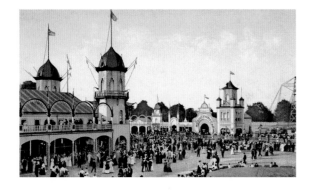

location in his home base of Pittsburgh. It took less than a year to complete.

The 35-acre park was done up in a hodge-podge of styles: Moorish, Italian Renaissance, Gothic and Egyptian, with buildings that looked like everything from Japanese pagodas to Arabic palaces to German beer halls. The buildings were mostly white, especially on the midway, and covered in twinkling lights to show off the park's electricity. In the middle, there was a large pool surrounded by a promenade on all sides. It was into this pool that the shoot-the-chutes water ride landed, splashing those in and out of the ride boats, usually dressed in their fine frocks and suits. Other rides included a slide that looked like Mother Goose's giant shoe, a Ferris wheel, bumper cars, the spinning Rainbow Dip ride and Jack Rabbit and Pippin-themed roller coasters. A scenic river ride was popular with courting couples, who would take any chance they could to get close in the restrictive early 1900s.

Future superstar Bob Hope even got his start at Luna Park, in a Charlie Chaplin costume contest in 1915. Young Bob—then known as Leslie—would busk on streetcars running to the park to try to make change.

Other amenities included a large swimming pool, a fun house and dancing pavilion. Unlike

competing Euclid Beach Park, Luna Park served alcohol, making Fitzgerald's German Village and the beer hall quite a draw, too. Also unlike Euclid Beach Park, which charged per ride, Luna Park charged admission—one factor that would eventually lead to its closure.

The sprawling funland also included a roller rink and the 20,000-seat Luna Bowl. In the 1920s, the large stadium was home to Cleveland's first professional football teams: the Cleveland Bulldogs and the Cleveland Panthers.

Alas, the fun had to end at some time. Prohibition and the country's financial collapse led to waning park attendance as America's attention turned to survival, not escape. With its popular beer hall, Luna Park was hit especially hard by alcohol restrictions.

Declining attendance eventually led owner Michael Bramley, who had bought the park from Ingersoll in 1908, to close Luna Park in 1929. Most rides were demolished in 1931, with arson claiming the remnants over the next decade. The Luna Bowl stayed open for a few more years, hosting football games as well as several Cleveland Negro League teams, including the Cleveland Stars and Cleveland Red Sox.

By 1938, only the roller rink remained, and it was burned down that year. It was a sad end for the majestic, celestially named park. Ingersoll's end was more tragic, however. Plagued by financial problems, the man who dreamed up so much fun for millions of Americans killed himself in an Omaha amusement park in 1927.

In 1940, the low-income Woodland Hills housing development was constructed on the Luna Park site—a concrete sign of reality where the dreamlike park once stood.

ABOVE LEFT *Even on hot summer days, suits, hats and long gowns were de rigueur at Luna Park.*

LEFT *Crowds surround stunt performers in the Circus Ring area at Luna Park in 1905.*

RIGHT *Designed by famed amusement park planner Frederick Ingersoll, Luna Park was a dreamlike collection of architectural styles, from Moorish to Italian Renaissance, Japanese, Victorian and German. The shoot-the-chutes water ride was in the center.*

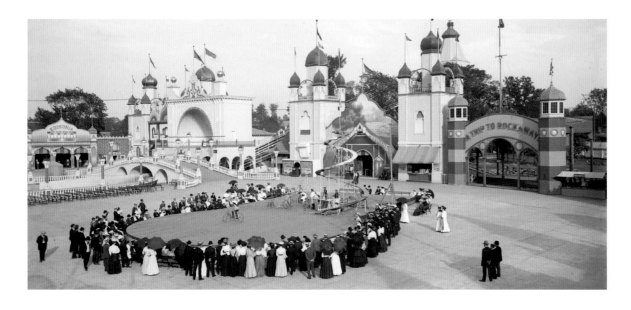

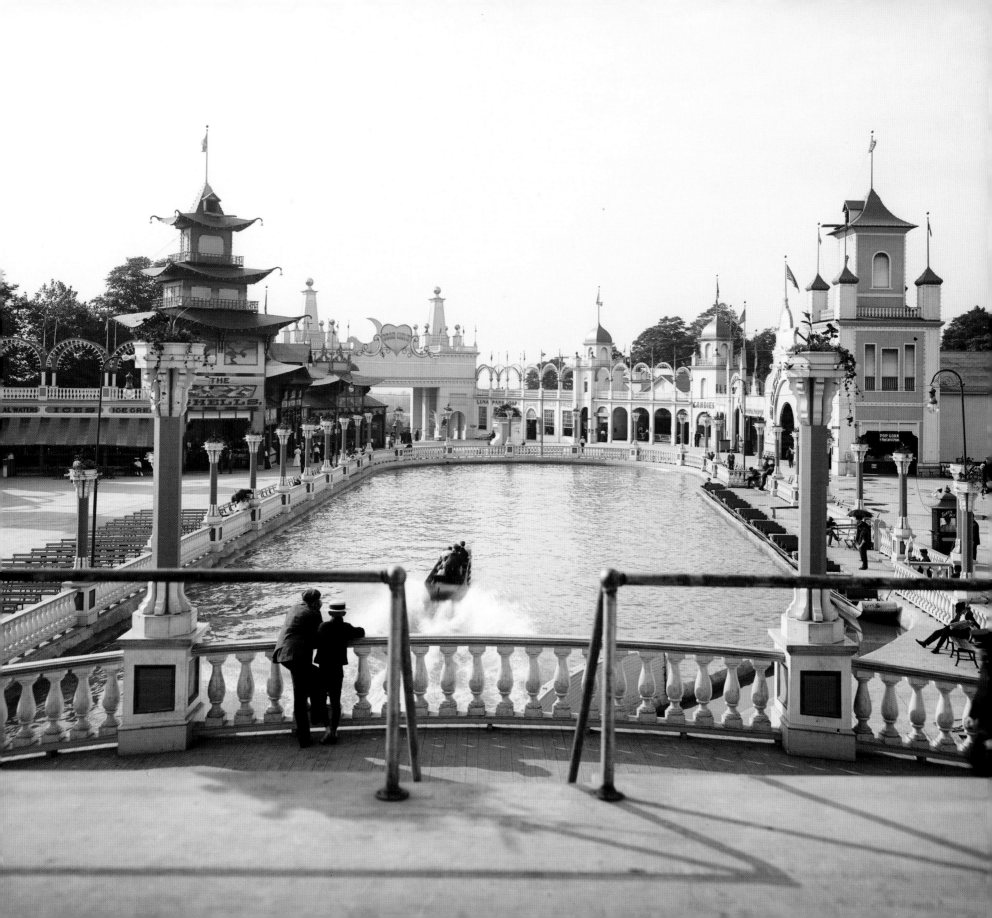

Sheriff Street Market BURNED 1930

Shopping on Christmas Eve 1891 was more exciting than usual in downtown Cleveland. That was the day the second and largest of Cleveland's historic markets opened: the Sheriff Street Market, located on what is now East Fourth Street, between Huron and Bolivar roads. At the time, the area was a densely packed urban jungle, teeming with thousands of Clevelanders, many of them recent immigrants from Germany and Eastern Europe. Sheriff Street itself was home to apartment buildings and the popular Euclid Avenue Opera House, opened in 1875.

Opened at a time when there was no home refrigeration, the stands selling freshly butchered meat, cheeses, milk and produce became a popular daily destination with residents. The 71,200-square-foot market designed by Israel Lehman and Theodore Schmitt opened with a remarkable 312 stands on the ground floor. Two five-story towers on either end had cold storage units. Offices occupied the floors above the markets. It was open daily until noon, and till 11 p.m. on Saturdays.

Outside, the market had an attractive Victorian veneer, but inside it was all business, with closely packed stalls jammed with produce and meat hawked by men in white coats. A large dome and two skylights in the center provided natural lighting, and canvas awnings were meant to keep out the hot summer sun and heat. Pipes of cold brine ran under the floors to each stall to provide refrigeration in the modern marketplace.

"Over its entrance floated flags of the nation, and inside the building the galleries and stalls were gaily decorated with evergreen ropes and brightly colored pom-poms," said the *Plain Dealer* newspaper on Christmas Day. An orchestra played on the gallery connecting two sides of the second floor.

At the time of its opening, the Sheriff Street Market was considered a catalyst for urban development. "With the advent of this new market building, a marked change in the surrounding neighborhood was very rapidly developed," said the *Plain Dealer* in 1896. "Building after building was erected" in the area and old buildings were renovated. The paper also credited the market's popularity for the installation of better street lighting and street cleaning. "In short, the bright, busy, modern and up-to-date district of today stands as an evidence of Cleveland's progress, of 'Greater Cleveland' realized," said the paper.

The market continued to grow in popularity over the next several decades, despite competition with the nearby Central Market, then at the intersection of Woodland, Ontario and Broadway avenues. In 1919, Sheriff Street Market even added a 12-story "first-class steel fire-proof cold storage unit." The era of shopping on Sheriff Street came to an abrupt end on May 9, 1930, however. A massive fire started during renovations to add a bus terminal and garage. Most of the building was torn down, except for a portion of the south wing that remained open with a much smaller version of the market until it, too, closed in 1936.

Ironically, after being used for storage from 1936 to 1950, market shopping came back to the building in 1950 when the Sheriff Street's former competitor, the Central Market, relocated to the address on Bolivar and what had become East Fourth Street. Opened with 171 stalls, far fewer than the Sheriff Street Market, Central Market closed in 1986. Today the site where the markets once stood is home to The Q Arena and the Cleveland Cavaliers.

RIGHT *Horse-drawn carts delivered fresh produce, meat and dairy daily to the 300-plus stalls of the Sheriff Street Market in the early 1900s.*

BELOW *Vendors and shoppers pose inside the Sheriff Street Market in 1930, before a massive fire destroyed much of the building.*

BELOW LEFT *Shoppers walk to the Sherriff Street Market, often called the "New Market" at the time, circa 1901.*

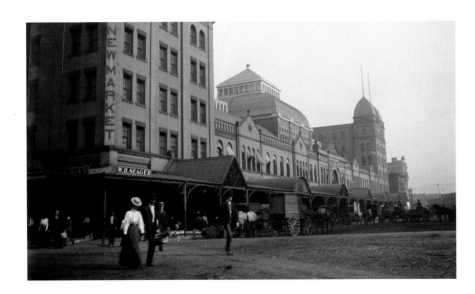

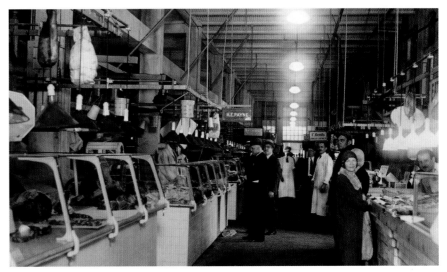

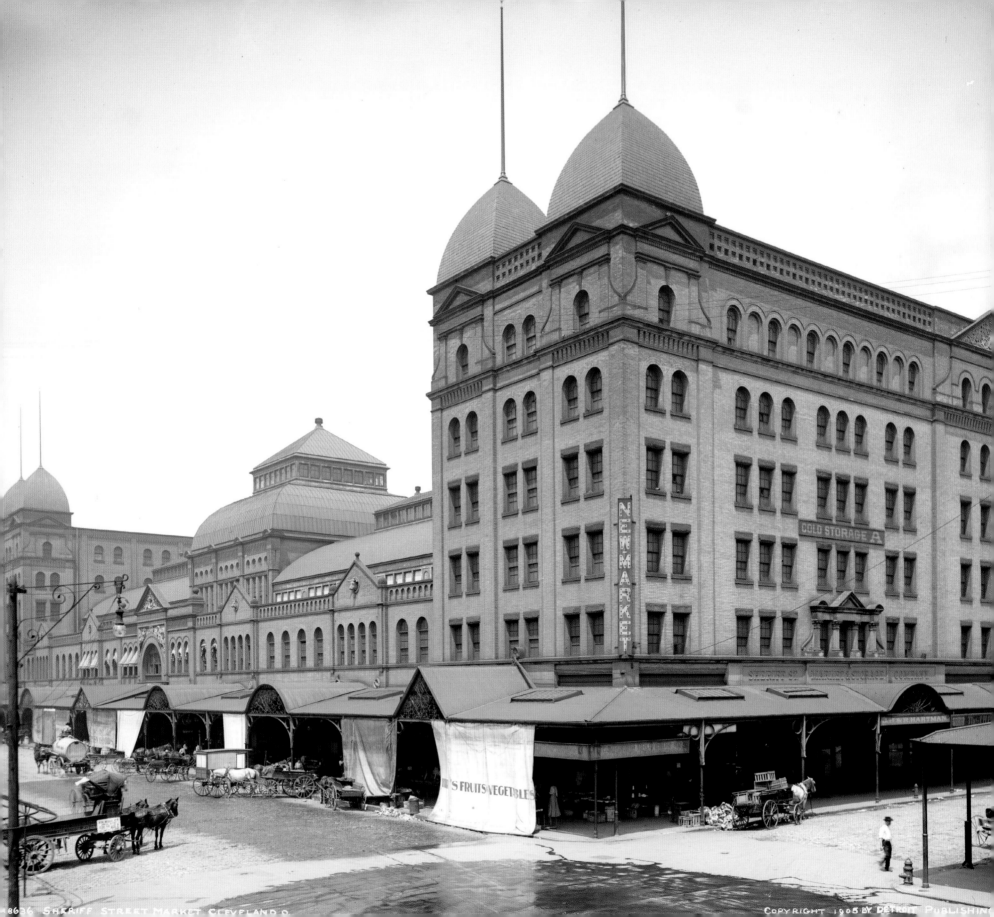

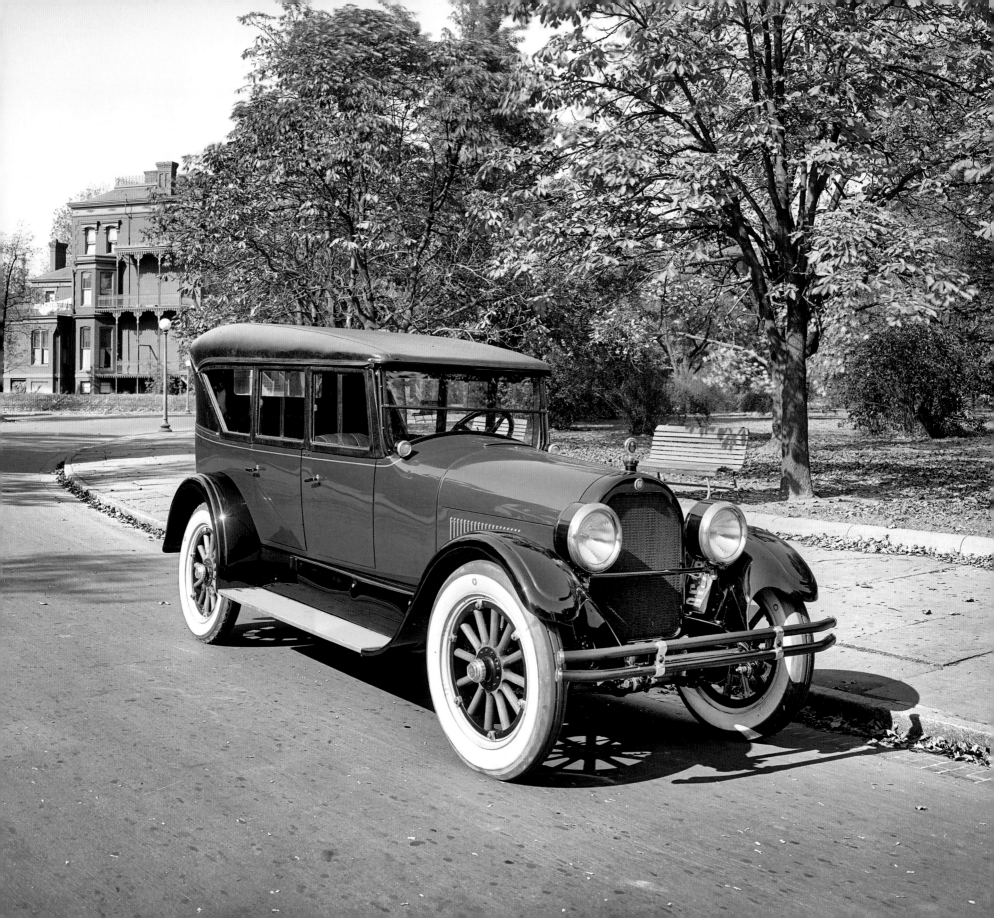

Peerless Motor Car Company CLOSED 1931

Cleveland was a hub of auto building in the early 1900s that challenged Detroit in the race for industry dominance. White Motor Company, the Winton Motor Carriage Company, the Rauch & Lang Carriage Company, F.B. Stearns Company, the Chandler Motor Car Company, Templar Motors and Peerless Motor Car Company all revved up in Cleveland. But no company had as varied and storied a run as Peerless.

Founded in 1900, Peerless was best known for its luxury cars. It began in Cleveland in 1889 as the Peerless Wringer & Manufacturing Company, near the railroad depots at Cleveland and Pittsburgh streets. Its first business was washing machine wringers. By the late 1890s, the forward-thinking company had changed its business to bikes and dropped the "Wringer" from the name. By 1901, Peerless started to manufacture cars and car parts. Two years later it changed its name yet again, to the Peerless Motor Car Company. Peerless had its own factory on Quincy Avenue by 1906, a set of sleek, massive buildings designed by prominent Cleveland architect J. Milton Dyer. Dyer, who had studied at the École des Beaux-Arts in Paris, went on to design Cleveland City Hall and the U.S. Coast Guard Station on Whiskey Island.

Known as one of the "Three Ps" (along with Detroit's Packard and Buffalo's Pierce-Arrow), the Cleveland company was the first to build drum brakes and cars with enclosed bodies. Both soon became standard industry-wide. Under the direction of engineer Louis P. Mooers, the company went on to invent the front-mounted engine, which also became industry standard. Other innovations included being one of the first brands to incorporate electric lighting, in 1911, and electric starters in 1913. By 1915, Peerless had built its first V8 engine.

Peerless's high-quality, high-priced autos were large touring cars, designed to fit multiple passengers and luggage—not speed. In 1905, prices ranged from $3,200 to a hefty $6,000. Mooers did, however, design a 35-horsepower racecar known as the Green Dragon that Barney Oldfield drove in the World's First Endurance Race in Columbus, Ohio in 1905. Oldfield led the race before crashing into a fence, leading to a third-place finish.

Clients of the company's upscale touring

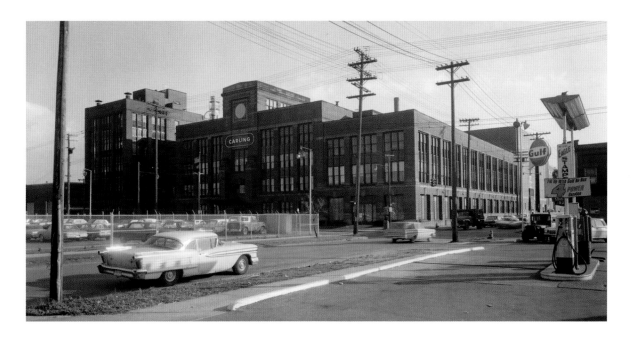

cars included John D. Rockefeller and Cornelius Vanderbilt. But high-priced luxury cars had a limited market, and by 1915 the company was forced to merge with General Vehicle Company of New York. The 1920s were tough for the company, which could not compete with the smaller, lower-cost cars rolling off assembly lines in Detroit. The Great Depression led Peerless to shutter in 1931. Its last car was the one-and-only Peerless V16, produced in June of that year.

There was a silver lining, though. After Prohibition ended, Peerless president Jason A. Bohannon opened the American Carling Brewing Company in the former Peerless plant. From 1934 to 1971, Red Cap ale and Black Label beer rolled off the assembly lines.

ABOVE *The former Peerless Motor Car Company plant in 1965, when it was occupied by Carling Brewing Company.*

RIGHT *An early ad promises "all that the name implies."*

OPPOSITE *A Peerless luxury car in 1924. Clients of the company's upscale touring cars included John D. Rockefeller and Cornelius Vanderbilt.*

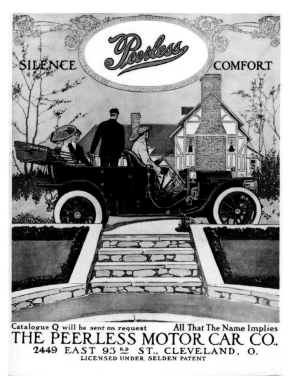

Hotel Winton CLOSED 1931

Cleveland's glamorous Hotel Winton had two claims to fame in the first half of the 20th century. They could not have been more different. During its lifetime, the theater district hotel at Prospect Avenue and East 10th Street was beloved for its world-famous Rainbow Room where Cleveland's 1920s glitterati gathered to sip swanky cocktails and dance the night away to Artie Shaw and other big band leaders. The parties were so extravagant that sometimes the dance floor was even covered with ice and skaters were hired to entertain.

The hotel's other claim to fame was its equally world-famous chef, Hector Boiardi—later "Boy-ar-dee." Now known as the man behind the most famous brand of canned spaghetti in the United States, at the time Boiardi's reputation was far more upscale. The immigrant chef helped introduce Italian cuisine to the city with antipasto dishes, stuffed artichokes, olive plates, cold meats, tomato sauce and pasta—along with a decadent continental menu of caviar, lobster, squab and capon. Not only did the lauded chef help make the Winton the hottest reservation in town, his popularity led diners to begin to ask how they could take his food home, too. Enter the Hotel Winton carry-out bag: marinara in a milk bottle sent home with pasta and cheese.

When the Winton opened in 1917 though, it was its modern design and sheer luxury that garnered attention, not its sauce. With 600 rooms done in the new en suite style—bathrooms in each one—the 12-story Chicago-style building was designed by the Windy City's Nelson Max Dunning. Rooms cost between $1.50 and $5 per night. The first two stories were stone, with the remainder in white terracotta and brick. Inside, the lobby was done in white marble and included a coffee shop, barbershop and boutiques. There was even air-conditioning, or as they called it, "washed air year round." The hotel was named after Cleveland automobile maker Alexander Winton.

The sunken Rainbow Room was located down four marble steps from the lobby. Guests entered on a terrace that surrounded the main dining area and stage. The room could comfortably seat 900 diners, and was bordered by walls of blue and ivory and lit by silk lanterns. Not only was the Rainbow Room a big draw for its food and world-class

entertainment; it was also home to some of the first live radio national broadcasts: "Life from the Rainbow Room."

Sadly, this grand room was destroyed decades later. It's now an underground parking garage. The Winton was sold in 1931 and carried on as the Carter Hotel, then the Carter-Pick Hotel, until a tragic fire in 1971 claimed seven lives and damaged the building. At first, the Carter functioned much like the Winton with high-profile shows in the Rainbow Room and catering to upscale guests. But the city's falling economy and suburban flight led to its gradual decline. After the fire, the once magnificent hotel was reopened as low-income senior housing, a dim shadow of its former self. Chef Boyardee pasta in a can is still found in grocery stores across America.

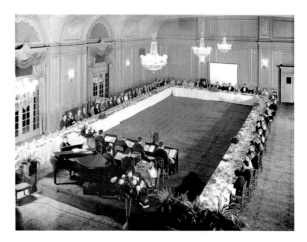

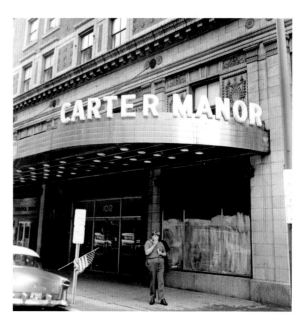

ABOVE LEFT *The Hotel Winton had 600 rooms, all with their own bathrooms—a luxury when it opened in 1917.*

TOP *A banquet in the elegant hotel dining room in 1931.*

ABOVE *By 1973, the Hotel Winton had devolved into the low-income Carter Manor apartment building.*

RIGHT *Bartenders await thirsty patrons in search of martinis and other elixirs in the posh bar that changed little from the Hotel Winton to the early years of the Hotel Carter.*

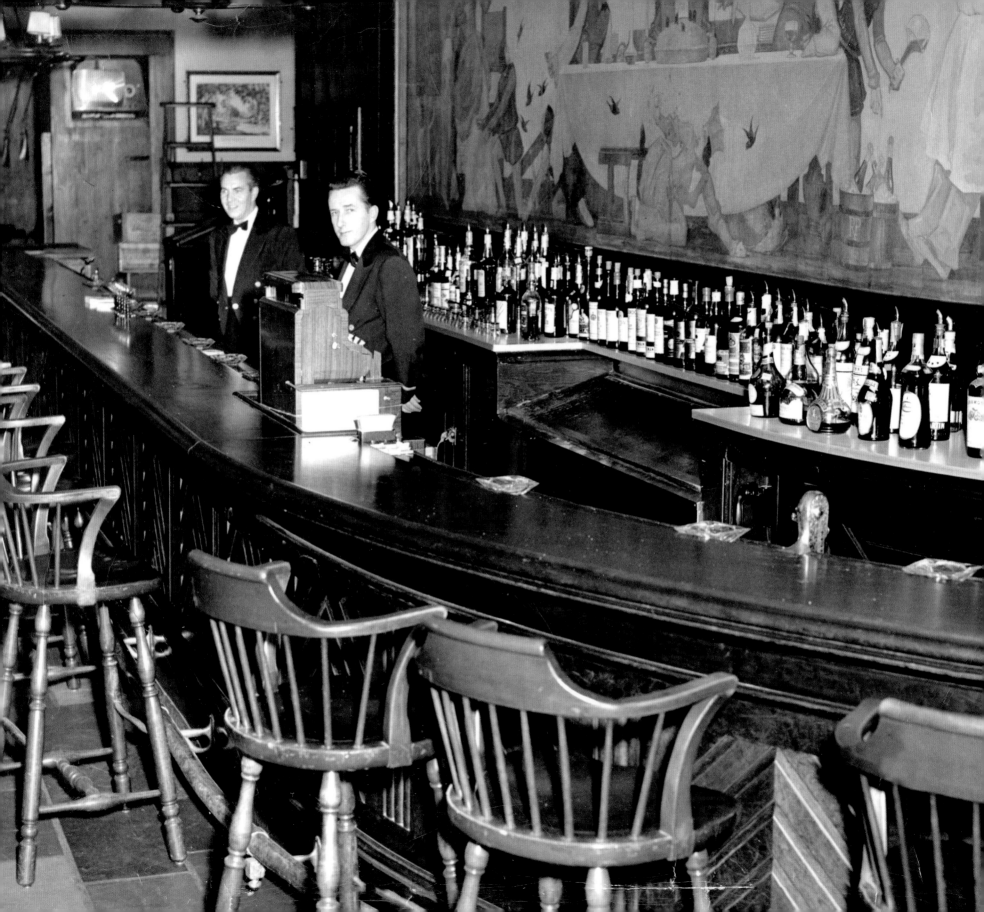

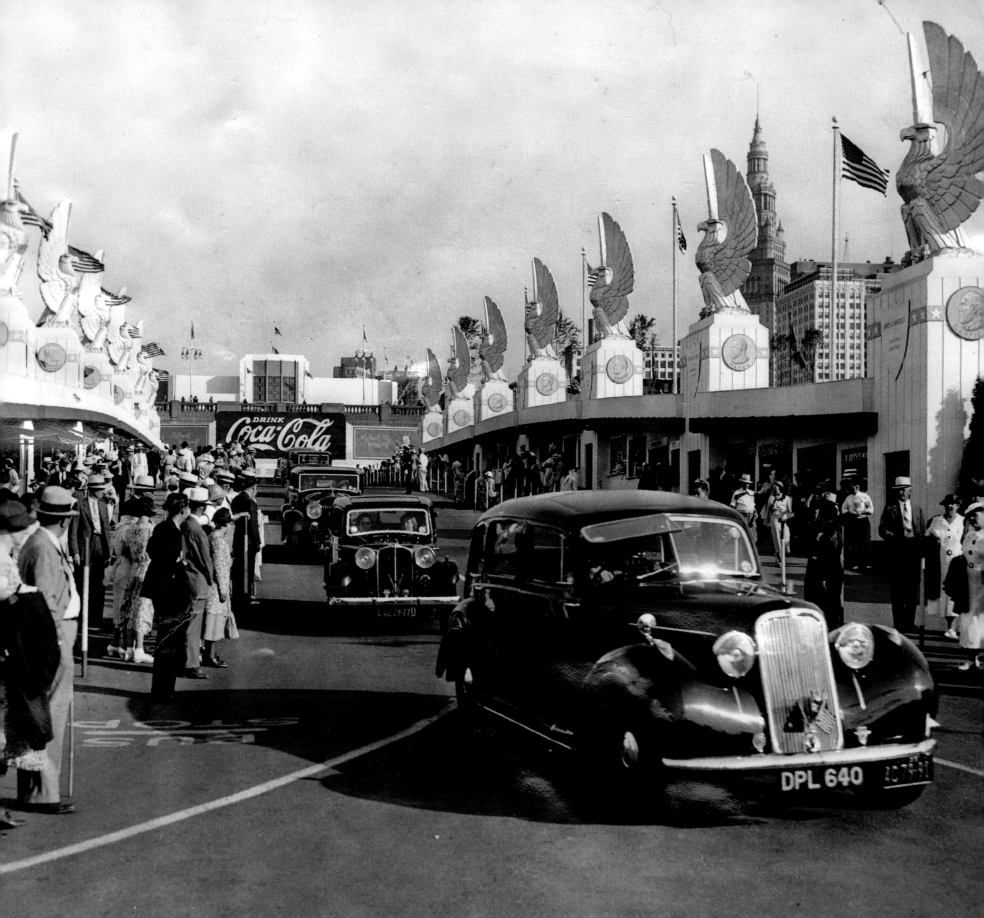

Great Lakes Exposition of 1936 and 1937

DEMOLISHED 1937

It was the greatest party Cleveland ever threw—but the Great Lakes Exposition of 1936 and 1937 left nary a trace it ever occurred.

Planned to coincide with the centennial of the city's incorporation and help draw the city of 900,000 out of the Great Depression, the Expo attracted four million visitors in the 1936 season. It was the same year Cleveland hosted its second Republican National Convention at Public Hall in June and the infamous Torso Murderer haunted the streets. Based on its popularity, the Expo was extended for a second summer. By September 1937, the fest had drawn seven million attendees to downtown Cleveland.

The goal of the Exposition, as stated in the brochure, was to highlight "the material, social and cultural progress which has been achieved in the Great Lakes Region in the past 100 years" and to "indicate the paths of progress for the future."

Similar to the 1893 World's Columbian Exposition in Chicago, exhibits were designed to expose visitors to different world cultures and celebrate American industry. They were also meant to help promote local businesses such as John D. Rockefeller's Standard Oil Company, which had a dedicated exhibition area, and Higbee's department store. They even had a shop on the grounds. The General Electric area showed off a new thing called "fluorescent lights." The White Motor Company, Firestone Tire & Rubber Company and Sherwin Williams all had exhibits. For $3, guests could take a spin in the Goodyear blimp.

The elaborate midway, adorned with huge majestic eagles, was dedicated to "Streets of the World" and featured carnival acts. Some were in quite bad taste to modern sensibilities, to say the least. These included a troupe of 260-pound ballerinas and a midget circus. Nude can-can

OPPOSITE *Pedestrians and cars promenade in the Court of the Presidents, lined with huge, majestic eagle statues.*

BELOW LEFT *Crowds line up to enter the Exposition. An estimated seven million people visited in 1936–37.*

BELOW *The Industry Building at the Great Lakes Exposition included a demonstration of television in which visitors could see themselves three times larger than life.*

BOTTOM *The elaborate shows at Billy Rose's Aquacade were performed in a 5,000-seat theater-restaurant where patrons could watch the water shows as they dined.*

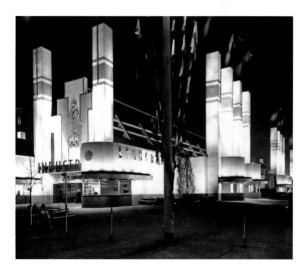

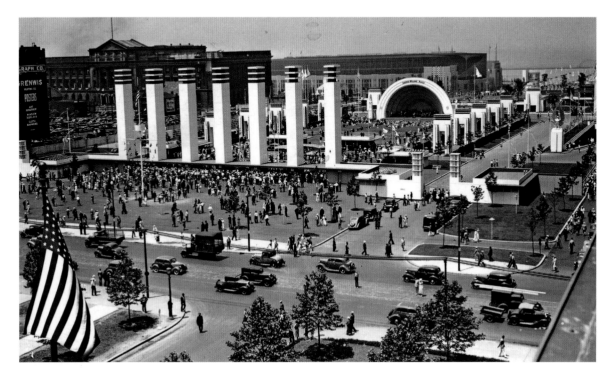

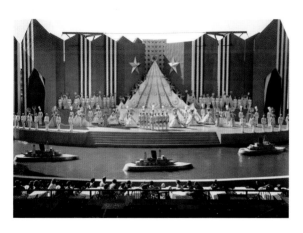

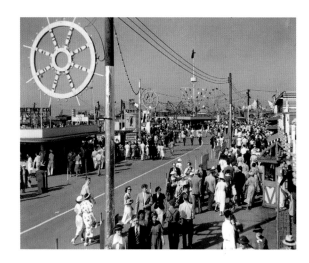

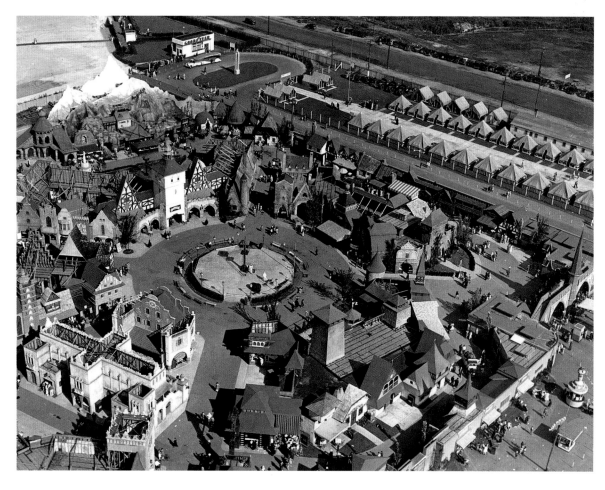

dancers in the French Casino also created a stir, and were eventually banned.

A subway was even constructed to connect two sections of the massive grounds.

In 1937, the Expo added one of its most popular acts, Billy Rose's Aquacade. Visitors at the 5,000-seat theater-restaurant could dine as they watched diving and synchronized swimming, plus performances by Olympic champion Eleanor Holm and Johnny Weissmuller. Rose also featured special guests such as then little-known Esther Williams. The water show made such a splash, Rose also created a popular Winterland skating show.

Other celebrities who came to visit over the two summers included crooner Rudy Vallée and his band; hometown hero Olympian Jesse Owens; and the world's most famous munchkin, Meinhardt Raabe—who was still a few years away from his *Wizard of Oz* fame. Famous Cleveland restaurateur Herman Pirchner set up an outpost of his Alpine Village that featured scandalous fan dancers, and brought in Cab Calloway and Jimmy Durante to play.

The Expo was said to partly be the idea of showman Pirchner, along with Public Hall commissioner Lincoln G. Dickey. Thanks to free Works Progress Administration labor, the fair took only 80 days to construct. Work began in April of 1936, and the Expo was ready to open on June 27. There were more than 200 Art Deco buildings constructed, all built in white. One writer at the time called it "a city of ivory, a new Baghdad risen in the desert." It was a "city" of over 135 acres.

Never meant to be permanent, the Expo was dismantled almost as quickly as it was built. Most everything was razed not long after its closing on September 26, 1937. Only the Donald Gray Gardens lingered on behind the old Cleveland Municipal Stadium, until FirstEnergy Stadium was begun in 1997. Today nothing remains of those acres of buildings and exhibits—except a few photos and colorful memories in the minds of Cleveland's oldest residents.

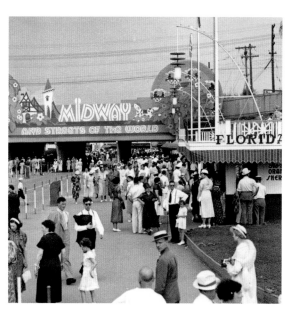

ABOVE LEFT *Clevelanders take in the sights at the Exposition in 1937, including "Alive Penguins."*

ABOVE *An aerial view of the Streets of the World with the International Circle stage in the center.*

RIGHT *Orange sherbet was introduced to Clevelanders at the Florida exhibit in the Streets of the World area.*

OPPOSITE *"Hello?" Visitors excitedly check out the Ohio Bell Telephone Company's wares in its pavilion. Part of the goal of the Expo was to help promote local businesses.*

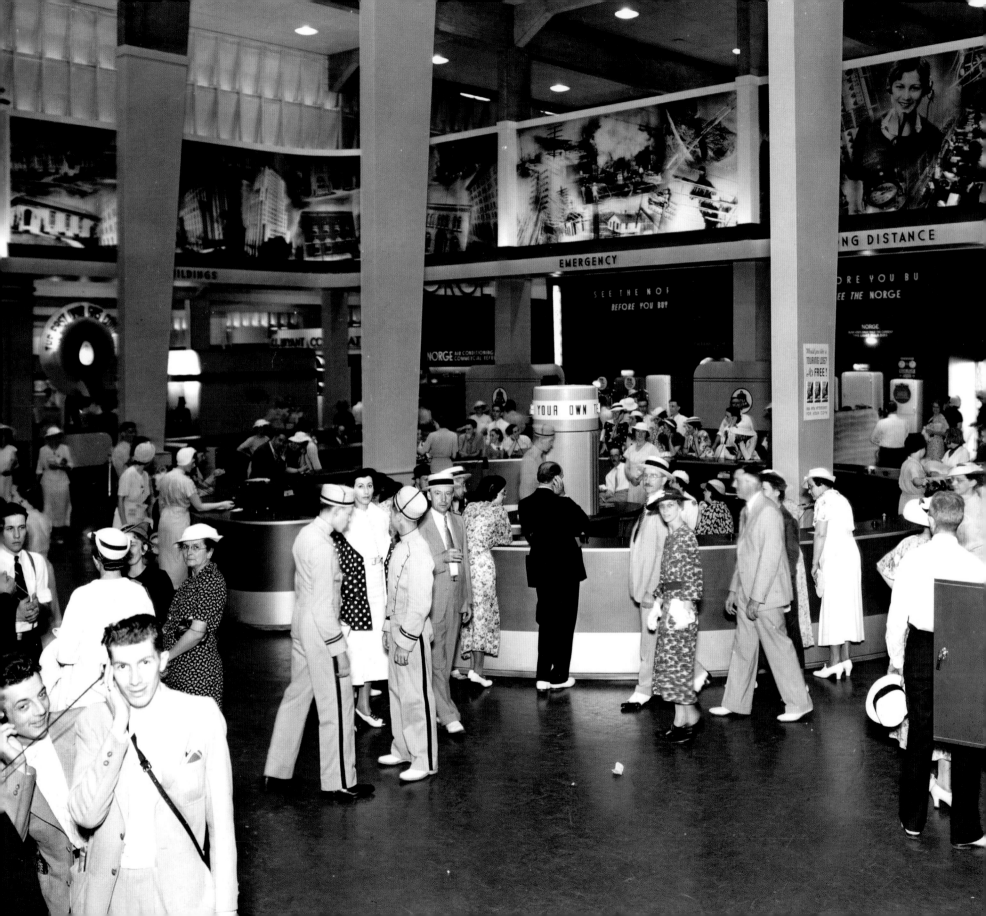

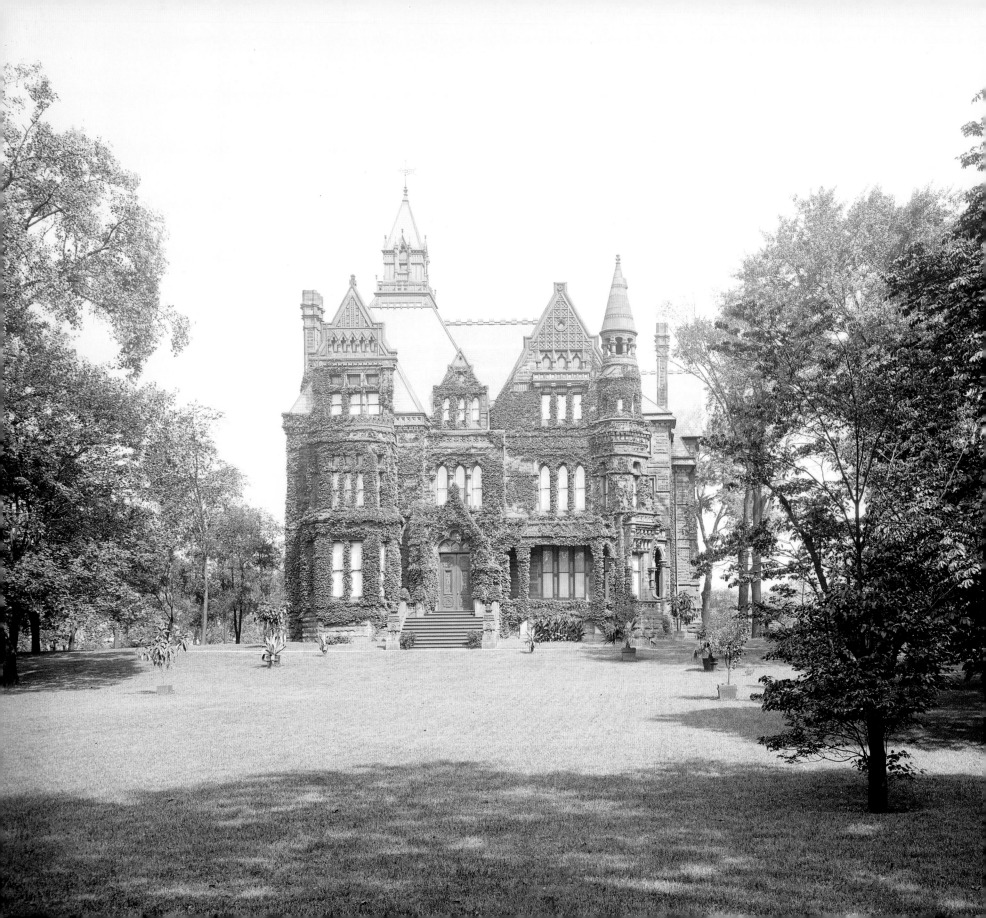

Millionaires' Row MOSTLY DEMOLISHED 1937

There may be no bigger loss in Cleveland history than the destruction of Millionaires' Row. It was said no avenue in the world featured such a "continuous succession of charming residences and such uniformly beautiful grounds" as Euclid Avenue did between East Ninth Street and East 55th Street.

From the late 1800s to the 1930s, the portion of Euclid Avenue known as Millionaires' Row housed the *crème de la crème* of Cleveland society: industrialists, inventors and philanthropists such as John D. Rockefeller, Marcus Hanna, Leonard Hanna, Jeptha Wade, Charles F. Brush, Amasa Stone and John Hay. The residents even included a con artist, Cassie Chadwick, who tried to ingratiate herself to the high-society residents of the street by claiming to be the illegitimate daughter of Andrew Carnegie.

With its 40 grand mansions—and many other very large houses—Millionaires' Row was often compared to the Champs-Élysées in Paris, Fifth Avenue in New York and the Unter den Linden in Berlin for its beauty and collection of wealth. In his 1876 book *Cleveland Illustrated: A Pictorial History of the Forest City*, author William Payne said

visiting Cleveland without seeing Millionaires' Row was like going to Rome without seeing St. Peter's or London without visiting the Tower. Baedeker's Travel Guide called the elm-lined stretch of Euclid Avenue the "Showplace of America" in the late 1800s, urging all visitors to America to pay a visit. For Clevelanders, it was the most fashionable, exclusive address in town.

The enormous mansions were set several acres back from the avenue, which was paved with Medina sandstone. Between the houses and the street, landscaped grounds and elaborate gardens added to the allure. Many driveways had imposing gates signaling the importance of the residents of the house. Architectural styles varied, but the overall theme was grandeur and size—such as Leonard Hanna's Neoclassical mansion near East 30th Street.

The biggest, most impressive house was no doubt "Andrew's Folly," as the Victorian Gothic erected by Standard Oil co-founder Samuel Andrews from 1882 to 1885 was dubbed. Envisioned by architect George H. Smith, who also designed the Hickox Building and Euclid Arcade,

the mansion was located on the northwest corner of East 30th Street. It had 100 rooms, including a huge central hall. It was said Andrews hoped to entertain Queen Victoria at his home. However, its cumbersome size made it impossible to maintain and it was shuttered by 1898.

Fifteen of the mansions were by architect Charles Frederick Schweinfurth, who also designed Cleveland's Old Stone Church and Trinity Cathedral. Schweinfurth's first Euclid Avenue home was a sprawling Romanesque mansion for banker Sylvester T. Everett, while the Samuel Mather mansion was a 45-room Tudor masterpiece. Built in 1910, Mather's home was the most expensive on Millionaires' Row. Made of handcrafted stone, it included a third-floor ballroom with a 16-foot ceiling that could fit 300 guests.

Mather's extravagant effort was also the last mansion built on Millionaires' Row. By the 1920s, many of the wealthy had begun to flee to the eastern suburbs as the Euclid Avenue commercial district began to creep closer. Euclid Avenue was also becoming busier as a main east–west thoroughfare through the city, making it a less exclusive address.

By the 1930s, many of the mansions had been chopped up into rooming houses. By 1937, most of the houses had been torn down—primarily for commercial buildings or parking lots. None were occupied as single family homes. The 1950s meant the demise of the majority of the remaining houses for the Innerbelt Freeway. A few remnants of the once glorious Row remain, however. The Mather Mansion escaped the wrecking ball and is now part of Cleveland State University, while the 1863-built Second Empire-style Stager-Beckwith mansion was acquired by the Cleveland Children's Museum in 2014.

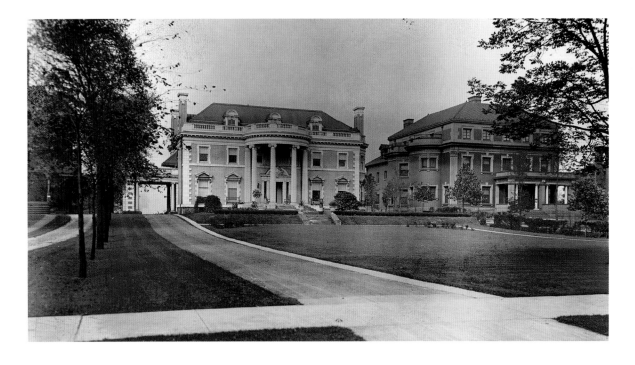

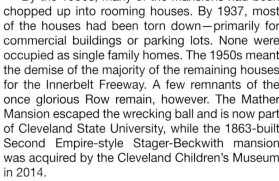

LEFT *In the early 1900s, Euclid Avenue was home to more than 40 grand mansions. It was compared to the Champs-Élysées in Paris and Fifth Avenue in New York.*

OPPOSITE *"Andrew's Folly" was the name given to the Euclid Avenue residence of Standard Oil co-founder Samuel Andrews. The home had 100 rooms. The massive mansion proved too big to maintain, and Andrews moved out by 1898. It stood vacant until it was demolished in 1923.*

Forest Hill Estate HOUSE BURNED 1917, LAND DONATED 1939

The shadow of John D. Rockefeller on Cleveland is a long one. Called the richest man in American history, Rockefeller began his empire in Cleveland when he founded Standard Oil in 1870. But Rockefeller did more than build his business in the city—he helped establish Cleveland as an industrial power and created thousands of jobs. The oil baron also helped build up the city through numerous philanthropic interests. And, in a roundabout way, Rockefeller can also be credited for creating one of the city's most interesting planned housing estates: the Forest Hill development that sits on the site of his former summer home on the city's far east side.

Rockefeller, who lived in a Millionaires' Row townhouse with his wife and five children, originally purchased the Forest Hill land on eastern Euclid Avenue in 1873 to build a "water cure resort," a popular fad at the time. He constructed a towering Victorian Second Empire-style mansion on the highest point of his estate, so it could overlook both downtown Cleveland and Lake Erie. The white wooden house had a mansard roof and was surrounded by a veranda on all sides. Located acres from the entranceway, it was hidden by trees for privacy as the hill sloped down. Rockefeller added bridle trails, footpaths with stone bridges,

a nine-hole golf course and a race track for horses to the naturally stunning property. There was also a small lake for swimming and boating.

The resort never took off, though, and by 1878 Rockefeller had converted the house into his private family summer home. The Rockefellers called it "The Homestead." In 1884 the family moved to a mansion in New York, but they ventured back to Cleveland each summer for rest and relaxation in the secluded, woodsy estate until the death of John D. Rockefeller's wife Laura in 1915. The magnate never returned to Cleveland again—at least while he was alive.

In 1917, the house that had been mostly uninhabited for two years mysteriously burned down—but that wasn't the end for the Forest Hill Estate. In 1923, Rockefeller sold the estate that had expanded to 700 acres through acquisitions to his son for $2.8 million. John D. Rockefeller Jr. planned to build an upscale housing development on the site, and by 1925, 81 French Norman-style houses were constructed on the land, as well as the imposing Heights Rockefeller bank and retail building. The Great Depression eventually put an end to John D. Rockefeller Jr.'s suburban housing dreams.

In 1939, he donated much of the remaining land to the neighboring cities of Cleveland Heights and East Cleveland to remain as parkland. Nearby, Forest Hill's Norman-style houses remain some of the most desirable in the area, while the Heights Rockefeller building is home to boutiques and a party center. The site of "The Homestead" is a popular sledding hill for kids to this day, less than a mile away from John D. Rockefeller's final resting place in Lake View Cemetery.

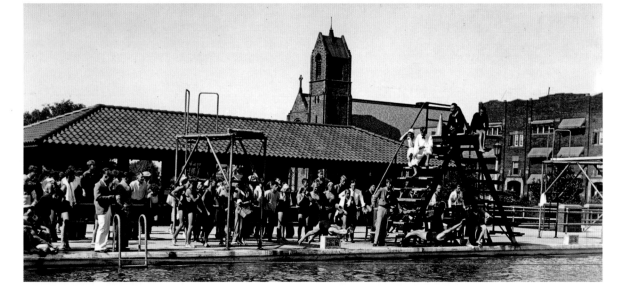

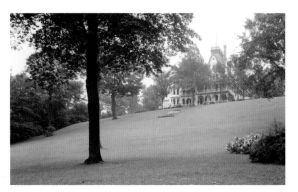

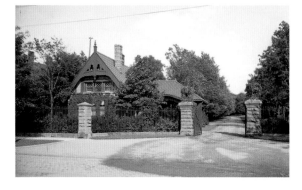

ABOVE LEFT *Men prepare for the start of a pentathlon at the Forest Hill swimming pool in 1931.*

FAR LEFT *John D. Rockefeller's Victorian mansion was built on a hilltop that provided views of both downtown Cleveland and Lake Erie.*

LEFT *The gatehouse to Rockefeller's Forest Hill Estate.*

RIGHT *Rockefeller's Forest Hill Estate was originally planned to be a "water-cure and place of public resort." By 1878 it had been converted into the family's summer home.*

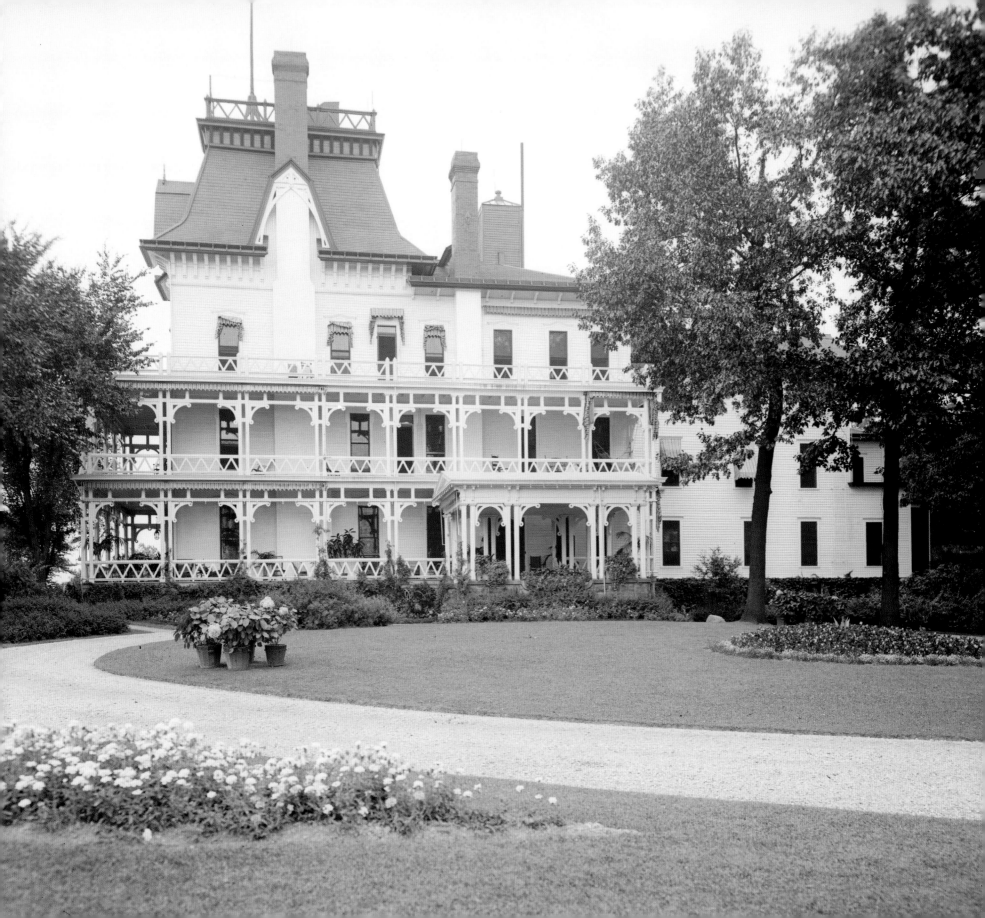

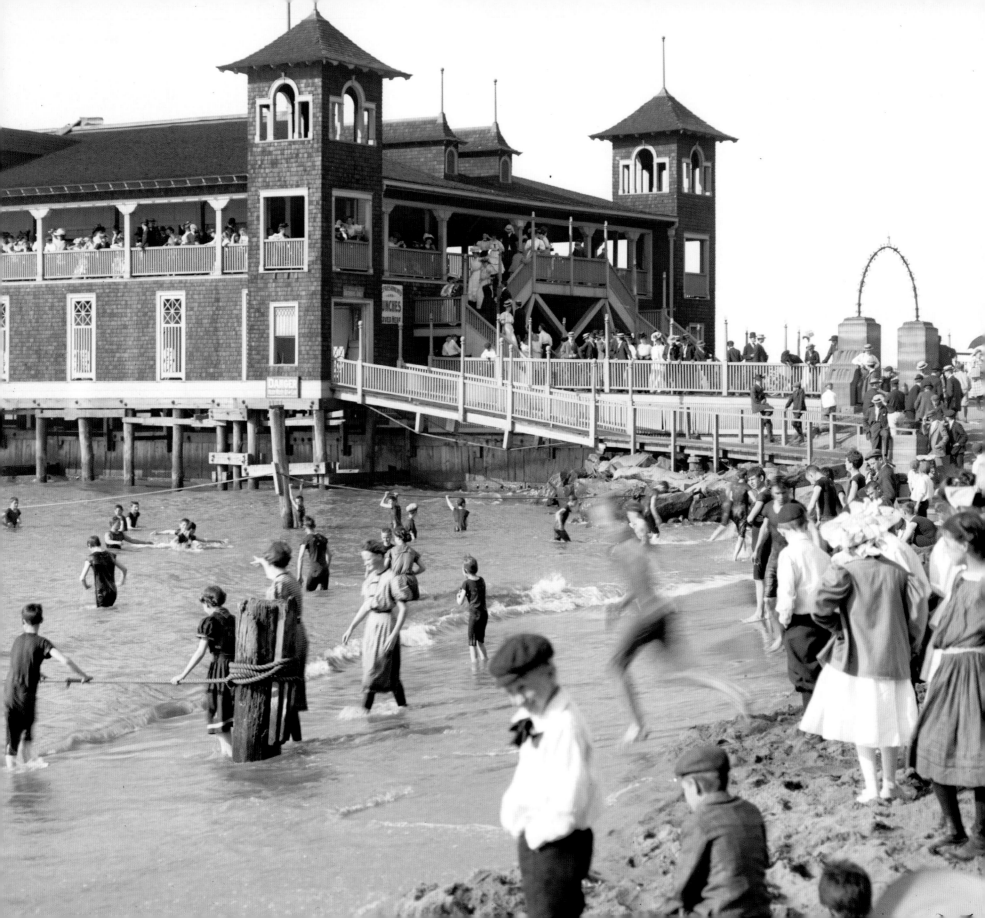

Gordon Park Bathhouse CLOSED 1943

Summers in Cleveland meant hours spent at Gordon Park in the decades before World War II. Swimming, strolling, fishing and picnicking were all popular pastimes at the lakeside park. But it was the cooling waters of Lake Erie and the elegant bathhouse that were the biggest draws for Clevelanders seeking an escape within the city limits.

The 122-acre lakeside park east of downtown at 72nd Street was one of the biggest gifts ever made to the city of Cleveland. Once the estate of successful iron ore dealer William Gordon, it was deeded to the city at the time of his 1892 death with only one condition: it had to be maintained forever and open to all of the public under the name Gordon Park. It was one of many philanthropic efforts of Gordon, who also was known for building and selling houses on both sides of town at affordable rates to encourage home ownership in the city.

No expense was spared at Gordon's estate on the lake. It was landscaped with walking trails, stone bridges, wooded groves for relaxing or picnics, formal gardens and ponds. When the city took over and opened the park in 1893, it added a large, lovely bathhouse where Clevelanders who had arrived on a streetcar or walked could stop and change before taking the plunge into the waters of Lake Erie. Built on stilts over the lake, the pavilion had ramps that took bathers right into the water, with a second-floor viewing area where mothers could watch their youngsters frolic near the shore. It was an attractive open-air Victorian structure with towers on each corner that was popular day and night.

Said a 1920s postcard: "A splendid bathing pavilion spans the entrance to Doan Brook and its motor boat anchorage off Gordon Park, where over two hundred private crafts are anchored during the summer months. Over 50,000 people enjoy the use of the Bath House and beach during the hot summer season."

Despite its popularity, by the 1930s such *fin de siècle* wooden bathhouses had gone out of style. A new brick bathhouse was built in 1937 by the Works Progress Administration. Roads to accommodate cars, which more and more Clevelanders were now driving to Gordon Park, were added at that time.

Thought to be safer than the old wooden

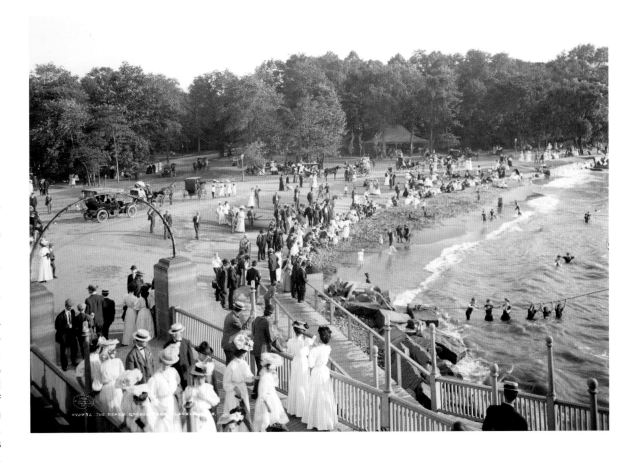

structure, the new bathhouse was built inland from the lake so it could also be used by players on the baseball diamonds. Not only did the utilitarian brick building have none of the original facility's grandeur; it was also built so far away from the water that bathers had to take a stairway over a road. Soon enough, it had fallen out of favor with swimmers.

In 1943, the structure was converted into a Trailside Museum by the city and the Cleveland Museum of Natural History. The nature museum, which focused on the history of Lake Erie and the Doan Brook Valley, remained in the structure until 1954, when the building took on yet another water-related role. It became the Cleveland Aquarium. The aquarium remained in this space until 1985, with its signature octagonal shape added in 1967.

By the 1960s, it was not just bathing at Gordon Park that was in decline. The construction of the Memorial Shoreway in the early 1960s effectively cut William Gordon's magnificent estate in half, cutting off the lake and leading the park to fall into neglect and crime. The 1937 bathhouse and its 1967 aquarium addition still exist today—a vacant, garbage- and graffiti-filled reminder of Gordon's once grand gift.

ABOVE *More than 50,000 Clevelanders and 200 private crafts a year were said to enjoy the charms of Gordon Park beach and bathhouse in the early 1900s.*

OPPOSITE *The bathhouse offered areas for weary Clevelanders who had walked or arrived on a streetcar to change into bathing gear before plunging into Lake Erie.*

East Ohio Gas Explosion, East 61st and 62nd Streets DESTROYED 1944

Clevelanders thought the Nazis were bombing America when they heard and felt the awful explosions on October 20, 1944.

In reality, it was a homemade disaster that struck the working-class Slovenian neighborhood east of downtown, one of the worst domestic catastrophes in American history. The East Ohio Gas Explosion wiped out one square mile of Cleveland, including almost every house on East 61st and 62nd streets north of St. Clair Avenue. A total of 79 homes and two factories were destroyed.

The death toll hit 130 people, and it would have been higher if school had not been in session at the time, preventing most children from being in the danger zone. When those children—whose teachers took them to the school basement for safety—finally did come home, their world had changed. Where there were once bustling streets of wood-frame houses built in the late 1800s and early 1900s for industrious Eastern European immigrants, there was nothing but rubble and ash. Only a few brick buildings on the blocks survived the massive explosion. Not only did survivors lose their homes. In the years following the Great Depression, many had taken to keeping their savings in the house, and those were wiped out, too. As were 217 cars.

The blast hit precisely at 2:40 p.m. The massive explosion was the result of liquefied gas stored in four tanks in a lot at the north end of East 61st Street drifting into sewer lines. It mixed with sewer gas and ignited into a huge fireball that blew up the manhole covers. More than 100 million gallons of liquefied natural gas exploded in the dense residential area, destroying homes and streets, causing trees and telephone poles to burn like torches, and sending manhole covers hundreds of feet into the air. Charred birds were said to fall from the sky. Burned shells of cars stood on the buckled street.

The first explosion was followed by a second at 3 p.m. as another tank blew up, killing many who had rushed to the scene of the first accident, thinking the impact over. Several smaller explosions took place throughout the course of the day.

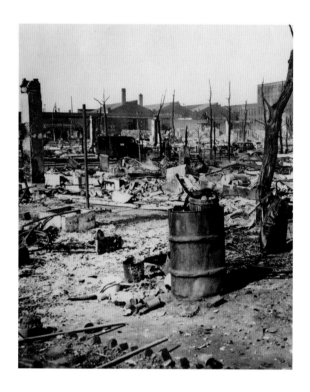

More than 30 local fire companies rushed to the area, with more than 3,000 firemen, policemen, doctors and nurses assisting. Casualties were taken to a junior high school on East 55th Street, where the Red Cross cared for them—and helped house the 700 people left homeless by the blasts.

The fire was put out by the next afternoon, but rebuilding the street took much longer. Gradually, residents did return to the area, constructing homes in more modern styles. Visitors to East 61st and 62nd streets today often remark on how these two streets look like nowhere else in the inner city, lined with post-war bungalows and ranches unlike the older homes that surround them.

East Ohio Gas soon drained the remaining tanks and took to storing their gas outside the city, a much safer practice. A small marker on the site of the explosion, which is now Grdina Park, honors the victims.

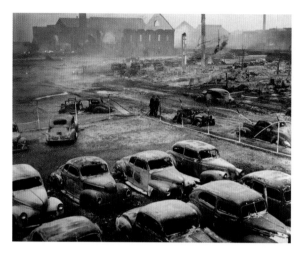

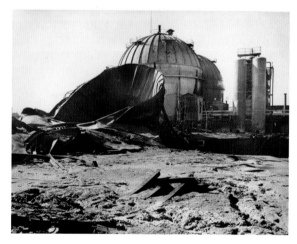

ABOVE LEFT *The East Ohio Gas Explosion obliterated one square mile of the east side of Cleveland. Seventy-nine homes and two factories were destroyed.*

TOP *A total of 217 cars were destroyed in the East Ohio Gas Explosion, many said to have hurtled through the air.*

ABOVE *Debris surrounds the remaining gas storage tanks in the days after the October 20, 1944 explosion.*

RIGHT *Streets and sidewalks around the East Ohio Gas company caved in as the sewer lines underneath exploded.*

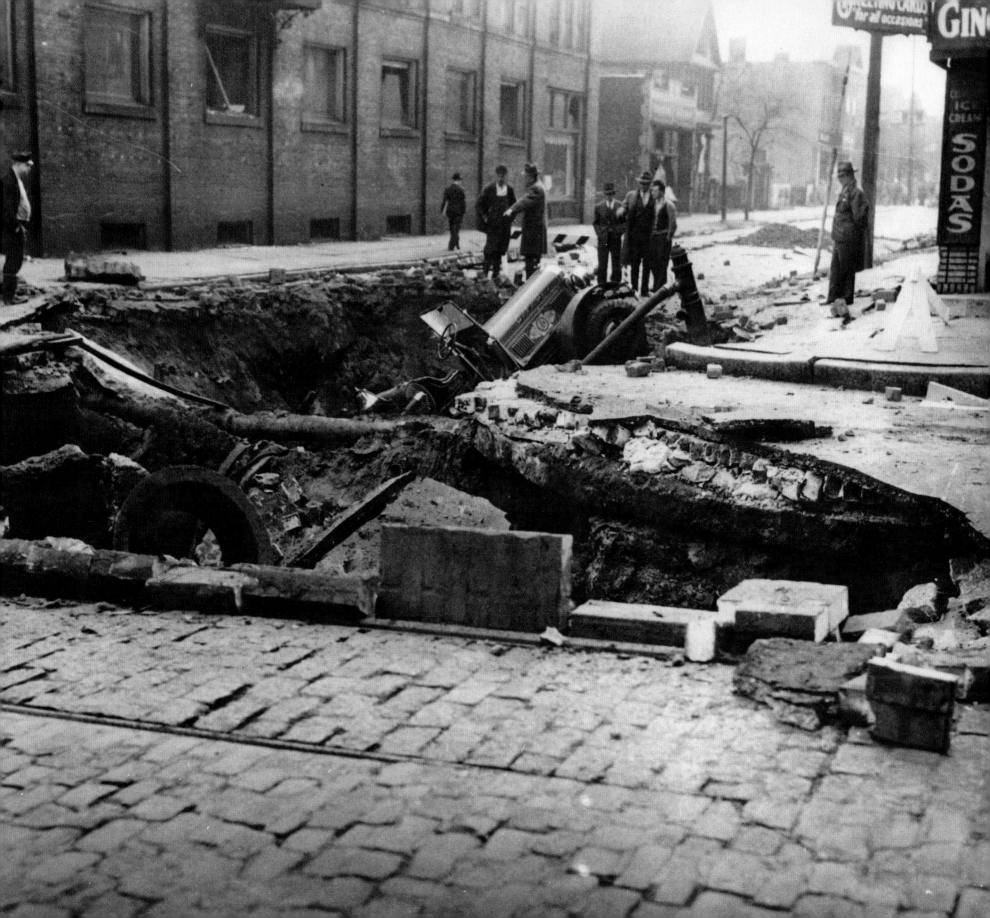

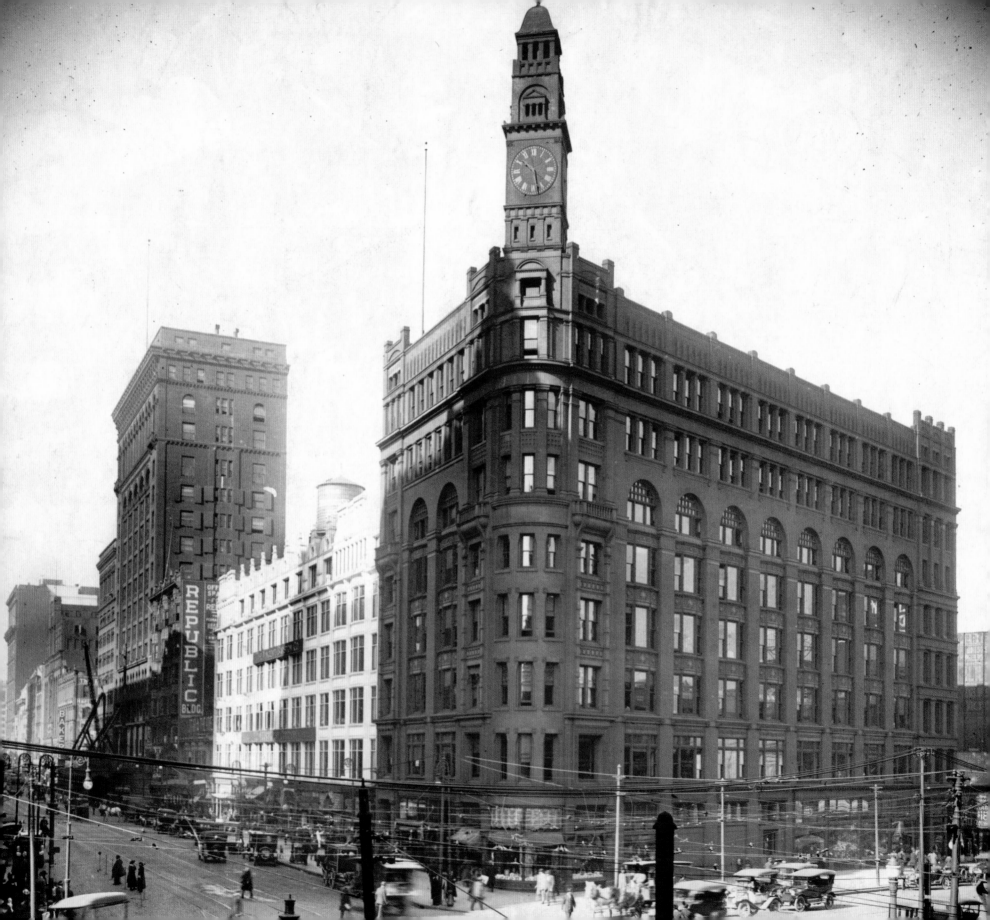

Hickox Building DEMOLISHED 1946

The northwest corner of Euclid Avenue and East Ninth Street—one of the busiest in all of the city—has had a storied history. The first major site on the corner was the Plymouth Congregational Church, which opened in 1853. It was said to be the finest looking church in the young city. The First Baptist Church, where many of the most prominent members of Cleveland society worshipped, took over the building in 1855. They moved down to Prospect Avenue in 1887.

That cleared the way for one of the wealthiest and most powerful men in Cleveland, Charles G. Hickox, to begin to construct a building to bear his name at the corner. Hickox, who made his wealth as a director of the Cleveland, Painesville & Ashtabula Railroad Company, hired architect George H. Smith to design his namesake. Smith was also working on his most famous building, the magnificent

Cleveland Arcade, just a few blocks down Euclid Avenue, at the same time. Both buildings opened in 1890. Sadly, Hickox died just a few months before the structure he had commissioned opened. Newspapers said he consulted on "the magnificent new building" until the day he died at his home on Millionaires' Row.

Smith's design integrated the steeple from the First Baptist Church, transformed into a clock tower at the southeast corner of the building. The huge clock, centered 132 feet above the ground, had a dial that was nine feet in diameter and a minute hand that was four-and-a-half feet. It was Charles himself who requested the steeple be saved.

Smith's nine-story, red brick Romanesque Revival building featured thick masonry walls and heavy rounded arches. The architect solved the problem of the intersection's acute angle by making

the clock tower rounded, which fit the Romanesque style. The street level featured awning-covered storefronts. Offices occupied the spaces above.

The Hickox almost didn't make it past its first decade. In March of 1899, an elevator boy found a mysterious package lying in front of the building on the sidewalk while shoveling snow. He showed it to the janitor who unwrapped it to find a galvanized tube stamped "Insert this end" inside, filled with what turned out to be nitroglycerin. He called the police, who determined it was in fact a real bomb with a fuse and enough nitroglycerin to destroy the whole building. They threw it into the river.

The Hickox Building outlived a bomb scare, but despite being considered a masterpiece of design it had a far shorter life than Smith's Arcade. The Bond Clothing Company had occupied many stories in the building since the 1920s, and by the early 1940s the company decided they needed an updated building that would suit their clothing for the modern man and woman. In 1945, Bond began to demolish the Hickox. In 1947 the company opened the glamorous Art Moderne masterpiece that would occupy the corner until it was demolished in 1978 to make way for a National City Bank building.

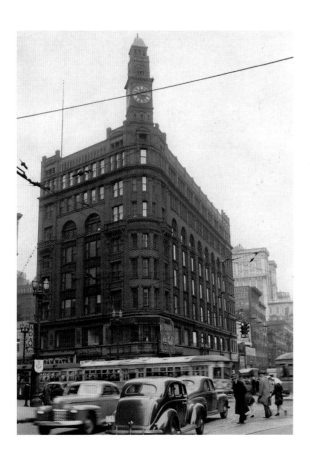

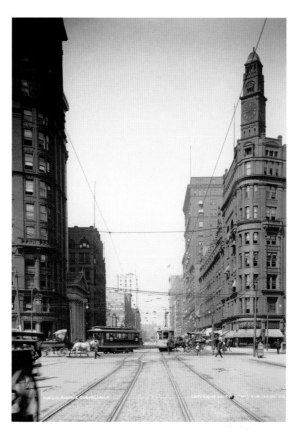

LEFT *The view of Euclid Avenue looking toward Public Square from the east in 1905 included the Hickox Building on the right. The 1902-built Schofield Building on the left is still standing.*

FAR LEFT *The Hickox Building was built at one of Cleveland's busiest intersections, as this 1946 photo of cars, streetcars and pedestrians suggests. This was taken the year of the building's demolition.*

OPPOSITE *The Hickox Building soared over East Ninth Street and Euclid Avenue. The clock tower, constructed from the steeple of the First Baptist Church, featured an enormous clock centered 132 feet above the ground.*

City of Cleveland Steamship **LAST VOYAGE 1950**

Travel in the Great Lakes area was much more glamorous a century ago. Unlike today, when it takes monotonous hours on dreary interstate highways to get between Cleveland and Detroit, in the early 1900s it was possible to book a refined steamship journey between the cities. It was an overnight trip with fine refreshments and even finer accommodations.

No steamer on the Great Lakes was said to be more beautiful than the *City of Cleveland*, operated by the Detroit and Cleveland Steamboat Line that began in Detroit in 1850. The best-known passenger line on the Great Lakes for more than a century, Detroit and Cleveland built ships that were known as "Floating Palaces" or "Honeymoon" ships.

The *City of Cleveland* took her maiden voyage in 1908, one year later than originally planned. She was meant to set sail in 1907, but a fire erupted when the boat was being fitted in dry dock that May. It cost more than $500,000 to repair the $750,000 ship and took a year to rebuild.

By summer of 1908, the grande dame was finally ready. Her first voyage was on June 9, between the "City of the Straits" and the "Forest City," as Detroit and Cleveland were called at the time. Cleveland Mayor Tom L. Johnson greeted her as the biggest and costliest ship on the Great Lakes drew into the Cleveland harbor for the first time. It was engineered with a 6,500 indicated horsepower, three-cylinder inclined compound steam engine and eight coal-fired Scotch boilers.

The *City of Cleveland* could carry 4,500 passengers, with sleeping accommodations for 1,500. It usually left one city at 11 p.m. and arrived in the other at 6 a.m. Other vessels did daytime routes, but the *City of Cleveland* remained the overnight cruiser.

No luxury was left out in building the steamer, even though most passengers would not even be awake the majority of the time when they sailed. The boat featured a stunning convention hall, with gilded columns, wooden panels, plush leather seats and Baroque paintings of angels and putti on the walls and ceilings. Regal lion statues topped the stairs.

The Grand Salon was even more majestic, with four open levels in the center and ornate metal railings framing the balconies and walls made of

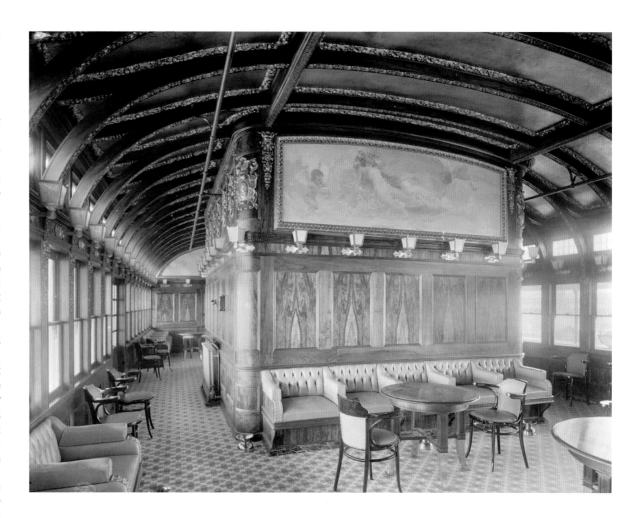

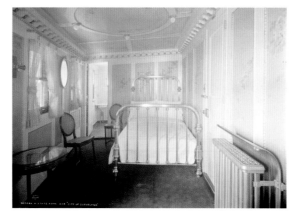

ABOVE *The ornate convention hall on the* City of Cleveland *featured gilded columns and ceiling, plush leather seats and Baroque-style art.*

LEFT *Though guests didn't have much time to sleep on the short trips between Cleveland and Detroit, staterooms were luxurious with brass beds and white linens.*

RIGHT *The* City of Cleveland's *palatial Grand Salon was open in the center, with ornate railings and balconies, classical artwork and even a fireplace.*

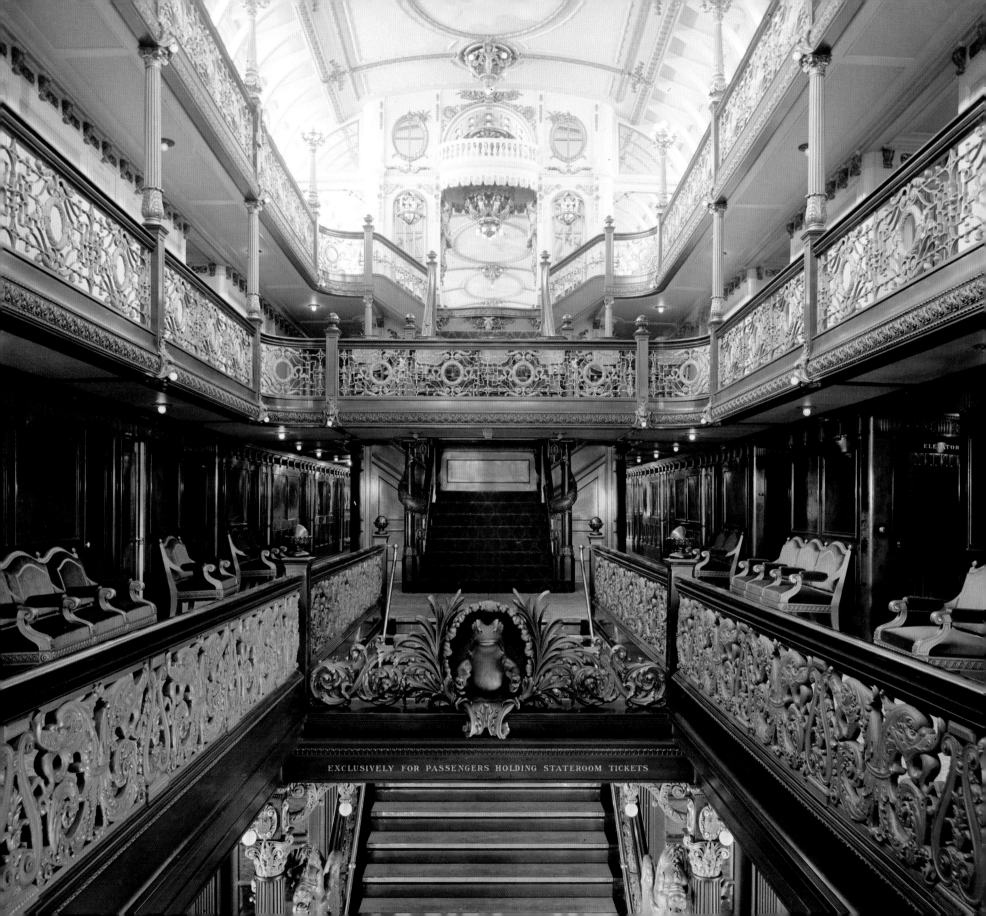

EXCLUSIVELY FOR PASSENGERS HOLDING STATEROOM TICKETS

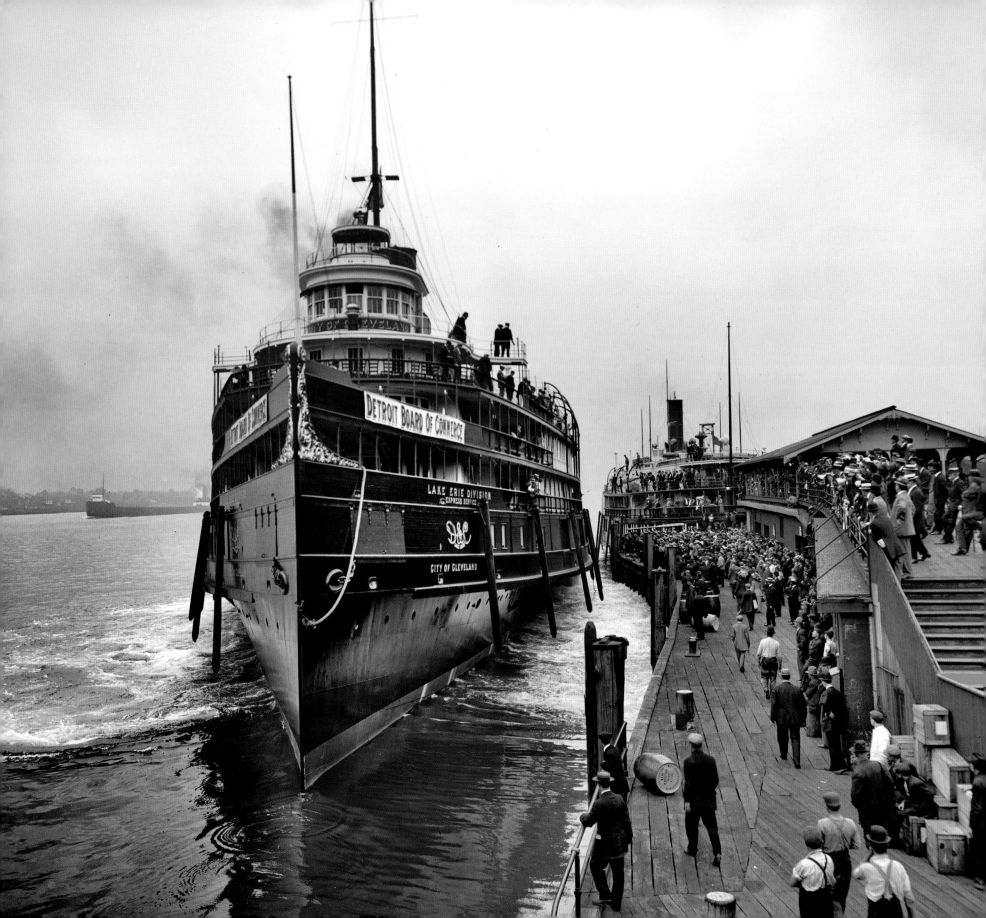

wooded panels and mirrors. There were crystal chandeliers, and fireplaces to warm your hands. This luxurious room was also decorated with classical art works.

Staterooms featured brass beds with white linens, reading areas, couches, windows, private bathrooms with showers, and outdoor balconies. In the 1920s, a top-of-the-line stateroom was $15 per night.

In addition to honeymooners and business travelers, the steamship line was used by baseball teams and big bands playing Cleveland and Detroit.

There were three levels of decks for passengers to enjoy fresh air and the views as they approached the city.

Renamed the *City of Cleveland III* in 1912, this steamboat had a long voyage on the Great Lakes. She cruised on until June 26, 1950, when the boat collided with the Norwegian freighter *Ravnefjell* in the fog off of Michigan. Four passengers were killed in the collision, but the ship was able to carry on to Detroit to let the rest disembark. The *City of Cleveland III* never sailed again, and was scrapped in Buffalo, N.Y. in 1956. The Detroit and Cleveland

Navigation Company called its last ship in to port in 1950, a victim of changing travel habits in which speed, not ambiance, was the primary concern.

OPPOSITE *Passengers wait to board the* City of Cleveland *in Detroit in 1910. In addition to voyages to Cleveland across Lake Erie, the steamer also traveled the upper Great Lakes.*

BELOW *The* City of Cleveland *steamship took her maiden voyage in 1908.*

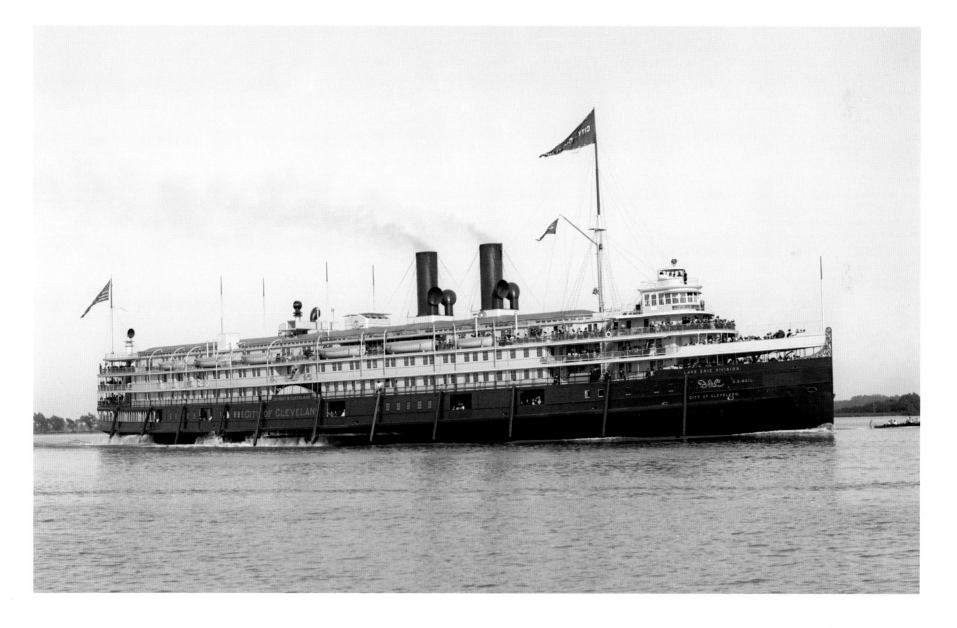

League Park DEMOLISHED 1951

League Park was home to one of the finest moments in Cleveland sports history: the Cleveland Indians 1920 World Series win over the Brooklyn Dodgers in game seven on October 12. It was a dramatic series, featuring the only World Series triple play, the first World Series grand slam and the first World Series home run by a pitcher.

It was also the first of only two World Series victories for the American League team that goes all the way back to 1901.

This was just one of many victorious moments at the stadium built at the corner of East 66th Street and Lexington Avenue in the Hough area. Crowds at League Park saw Babe Ruth hit his 500th home run on August 11, 1929, and the Cleveland Buckeyes win the Negro League World Series in 1945. Ruth hit the ball so hard it flew out of the park onto Lexington Avenue, where a neighborhood "urchin" found it and later returned it to the slugger for $20. The park opened in 1891 with an appearance on the mound by none other than the great Cy Young on May 2, 1891. He led the Cleveland Spiders to a 12–3 win over the Cincinnati Reds.

Famed Indians pitcher Bob Feller pitched his first game in the park in 1936. Minor league female pitcher Alta Weiss also threw at League Park, in 1907.

League Park hosted games until it was demolished in 1951. Originally a small field that sat 9,000, it was built by Cleveland City Cable Railway Company owner Frank De Haas Robison to host his Cleveland Spiders National League team. Not coincidentally, one of his streetcars took fans right to the entrance.

The Spiders played in the park from 1891 until 1899. The Indians played there through 1946, mostly weekday games after Municipal Stadium opened in 1932. In the 1940s the Negro League Cleveland Buckeyes also played at League Park.

Though remembered solely as League Park, the venue was actually called Dunn Field for 11 years during its run. Owner "Sunny Jim" Dunn renamed it after himself in 1916. It stayed Dunn Field till his widow sold it in 1927, when the name reverted to League Park.

The park was originally constructed of wood, with bleacher seating. There was a grandstand behind home plate and a covered pavilion along the first base line. More rectangular than modern parks, it had a 40-foot home-run fence—which didn't stop the Babe. Soon considered too small for the baseball-loving city, League Park was expanded to add more seats and rebuilt with concrete and steel prior to the 1910 season. The addition raised the capacity to 27,000 seats by adding a second level.

The final baseball game in League Park, which never added lighting for night games, was September 21, 1946. The Indians lost 5–3 to the Detroit Tigers in front of just 2,772 fans.

Baseball wasn't the only draw at League Park. The Cleveland Rams football team played there in the 1940s, and the Cleveland Browns practiced in the field in the same decade.

Most of League Park was demolished by the city in 1951, except for the 1909 ticket office, now the small Baseball Heritage Museum, and parts of the East 66th Street grandstand wall. The site of the landmark was listed on the National Register of Historic Places in 1979. Today there are playing fields for neighborhood kids on the site where so many of baseball's greats once stood.

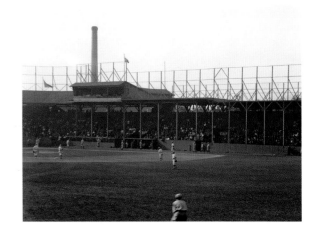

ABOVE *When it was built in 1891, League Park only had seating for 9,000.*

RIGHT *Well-dressed men, and a few women, line up for an afternoon game at League Park in the early 1900s.*

BELOW *A college football game between the Western Reserve and Baldwin-Wallace football teams in 1935.*

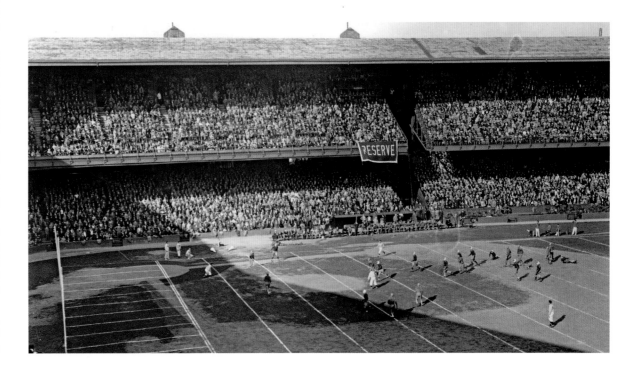

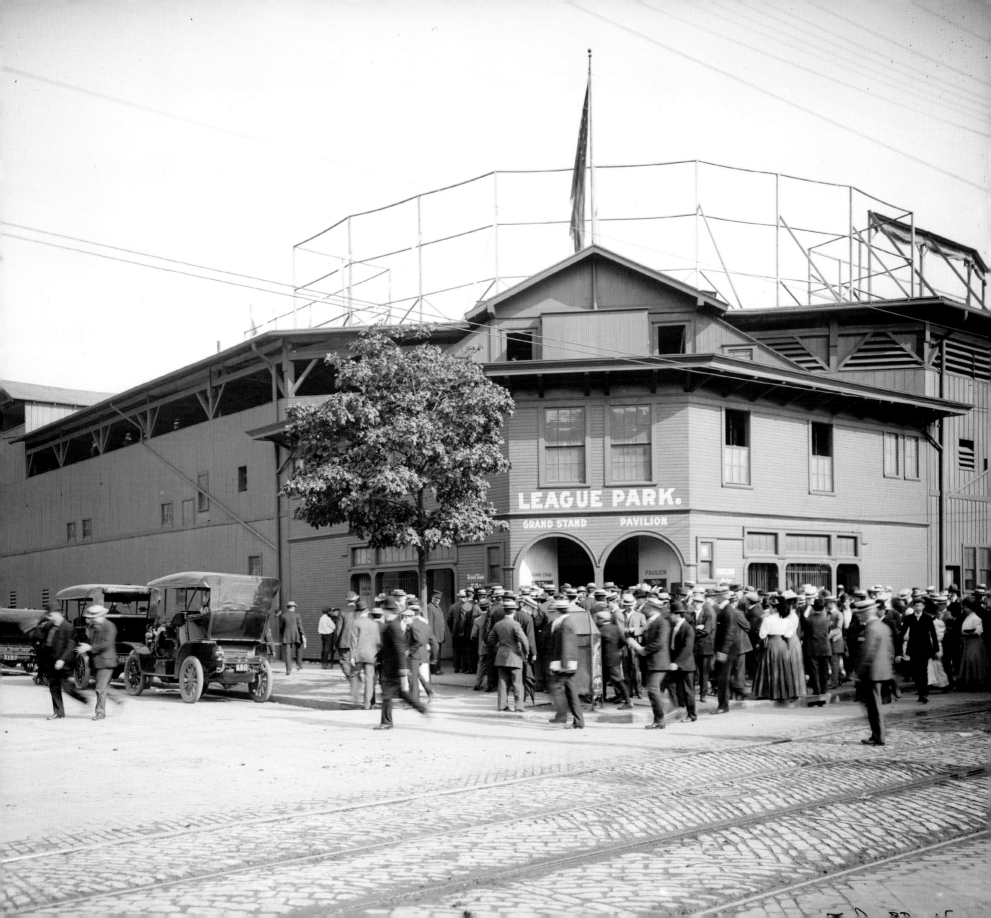

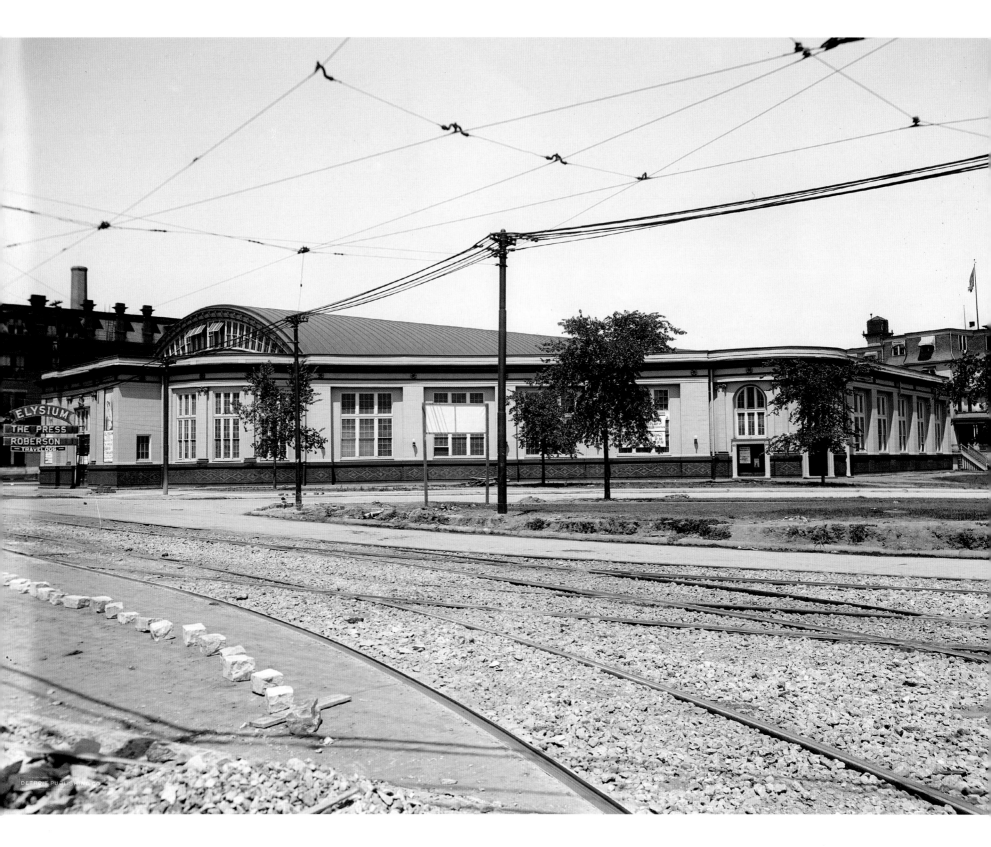

The Elysium Arena DEMOLISHED 1951

Without the Humphrey family, Cleveland would have been a lot less fun in the first half of the 20th century. Known for their popular popcorn stands throughout the city at the turn of the century, the Humphreys went on to run Euclid Beach Park for nearly 70 years. But that wasn't all. Dudley Humphrey was also the visionary behind the Elysium, once the largest indoor ice rink in the world. The rink is now largely forgotten to Clevelanders, unless they see the small marker located near the Cleveland Museum of Art and Chester Avenue in the University Circle area. But at one time this grand rink was one of the most popular entertainment destinations in town—at least when Euclid Beach Park was closed for the season, which was Dudley Humphrey's goal in building the rink at East 107th Street and Euclid Avenue in 1907.

Located in the bustling entertainment district of Doan's Corners, the massive Elysium cost $150,000 to build. Outside, the one-story building had a simplified Beaux-Arts style. Inside, the viewing area could seat 2,000 under the soaring arched ceiling. The ice was poured directly on the ground, not onto a floor or ice pan.

"The latest novelty in the form of healthy amusement for Cleveland has proved itself a success from the start," read the November 27, 1907 issue of the *Plain Dealer* newspaper. "The idea of using artificial ice for skating surfaces is new to Cleveland, but has been enjoyed by New Yorkers for several years. Now Cleveland can boast of the largest artificial ice rink in America ..."

The Elysium was open from October to May, when Euclid Beach was closed. It was popular with leisure skaters of all ages, hosting weekly lessons for beginners. Open skate sessions featured live bands playing waltzes and popular tunes of the time.

In the evenings, professional skating competitions and figure-skating shows offered a different kind of nightlife experience than the theaters, jazz clubs and cabarets in the area.

The Elysium was also home to early professional hockey team the Cleveland Falcons, later the Barons. Ironically, the Barons' popularity helped lead to the Elysium's downfall. There wasn't enough seating for its growing fanbase, so the team had to

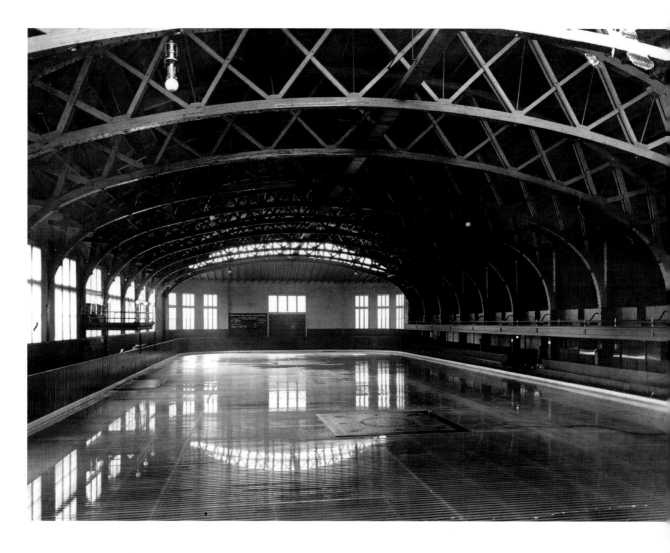

move to the new Cleveland Arena built by owner Albert C. Sutphin downtown in 1937.

The Elysium also played a role in World War I, used as barracks for the Student Army Training Corps for the nearby Case Institute university. World War II meant the end of the Elysium, however. With the building set to be taken over by the military once again, and dealing with declining attendance due to the war effort and Americans' newfound frugality, the Humphreys decided to close the rink for good in 1941. The Case School of Applied Science took over the site, which it

rented out as a bowling alley, and later a used-car showroom. After falling into disrepair, the city of Cleveland took over the site in 1951 and demolished the former ice palace to make more room for the Chester Avenue expansion.

ABOVE *When it was built in 1907, the Elysium Arena was called the "largest artificial ice rink in America."*

OPPOSITE *Many skaters took streetcars to the Elysium Arena in the early 1900s. The rink was part of the long-gone Doan's Corners entertainment district.*

Central High School

MERGED WITH EAST TECHNICAL HIGH SCHOOL 1952

Cleveland's Central High School was first in its class in many ways. It was Cleveland's very first high school, but Central's significance went beyond city borders. Opened in July of 1846 in a Universalist Church on Prospect Avenue, Central was the first free public high school opened west of the Allegheny Mountains in the United States. At a time when most of the public believed education after elementary school should not be publicly funded, it was a symbol of the progressive thinking of Cleveland leaders at the time. Central was also known for graduating large numbers of female students in its early years, and some of the most important names in African-American history.

Central was attended by many of the most significant names in early Cleveland history. Graduates include several of the biggest names in industry, even John D. Rockefeller himself, who attended from 1853 to 1855. Other notable students include philanthropists John L. Severance and Samuel Mather, and politician Marcus A. Hanna. Female students in those early days joined groups such as the Literacy Club for Girls.

The first curriculum included English, Greek, mathematics, natural science, bookkeeping, rhetoric and philosophy. By 1928, students were taking English and foreign language classes, mathematics, social science, physical science, commercial education, technical education, art, home economics and music.

Writer Langston Hughes, a star of the Harlem Renaissance and one of the most influential voices in American literature, was inspired while a student at Central High School in 1916 and 1917. Russell and Rowena Jelliffe, founders of the influential Karamu House African-American theater and settlement house, helped him hone his creative voice while at Central.

In the era Hughes attended Central it had a diverse student body, with immigrants from all around Europe mingling in the halls. Hughes once recalled his high school as "nearly entirely a foreign-born school" and that "we got on very well."

Following World War I, however, European immigration slowed and Central's African-American population boomed, growing by almost 400 percent. The school's make-up reflected these demographic changes, and Hughes was only one of many famous African-American graduates of Central High School. Others included U.S. Rep. Louis Stokes in 1943; Mary B. Martin, the first black elected school board member; and bandleader Noble Sissle, of "I'm Just Wild About Harry" fame.

The location these students attended was Central High's most famous building, a soaring Gothic-style castellated structure on East 55th Street, built in 1878. It was designed by famed Cleveland architect Levi T. Scofield. This, the most well-known Central High, was the third location, following 22 years in a building on Euclid Avenue near East Ninth Street from 1856 to 1878.

By the 1930s, the 1878-built school in the booming Central neighborhood was too small, and was considered outdated. Students were crammed into tiny classrooms in the front tower portion of the building. A new building on East 40th Street was built, and the students were moved just short of Central's centennial in 1940. In 1952, Central High School was closed altogether and the students were combined with East Technical High School. The famous East 55th Street building was demolished that same year.

TOP LEFT *When the new, and final, Central High School opened in 1940 on East 40th Street, it was considered a showpiece of modern school design.*

ABOVE *Central High lobby in 1939. By that time, the school in the growing Central area was already overcrowded.*

LEFT *Central High School female students joined groups such as the Literacy Club for Girls in the late 1800s.*

RIGHT *Built in 1878 on East 55th Street, the castle-like Central High School location was attended by writer Langston Hughes, U.S. Rep. Louis Stokes and many other prominent Clevelanders.*

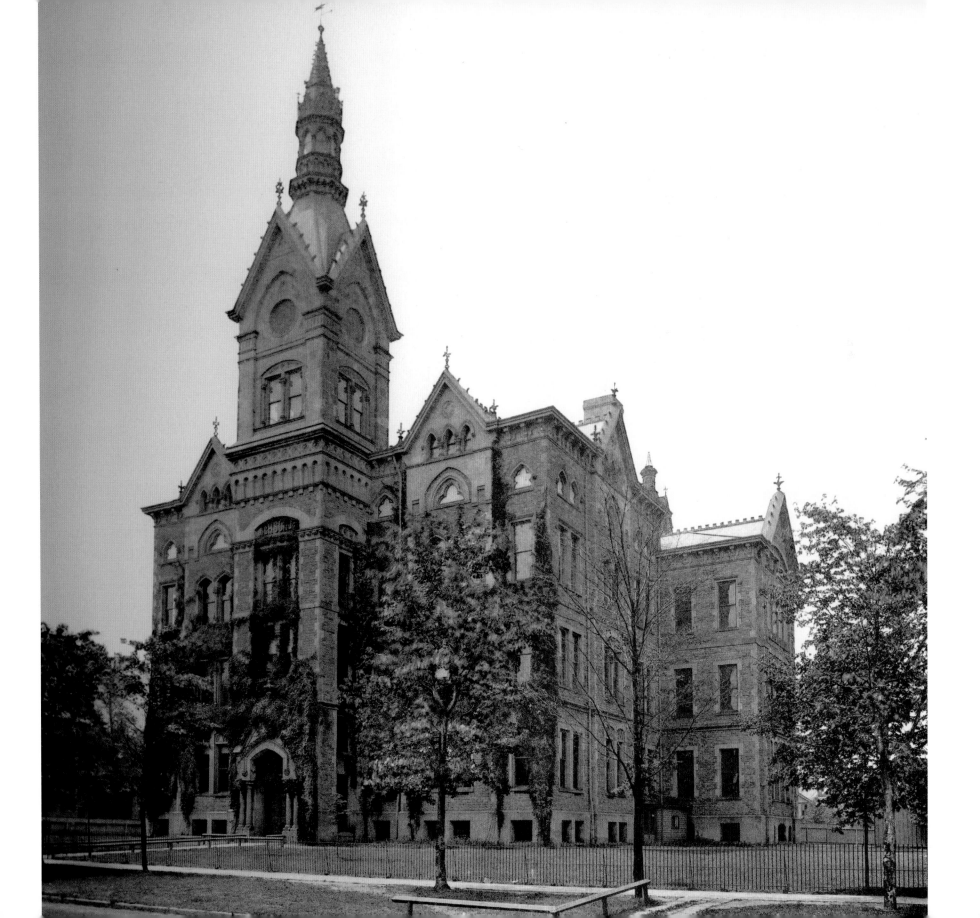

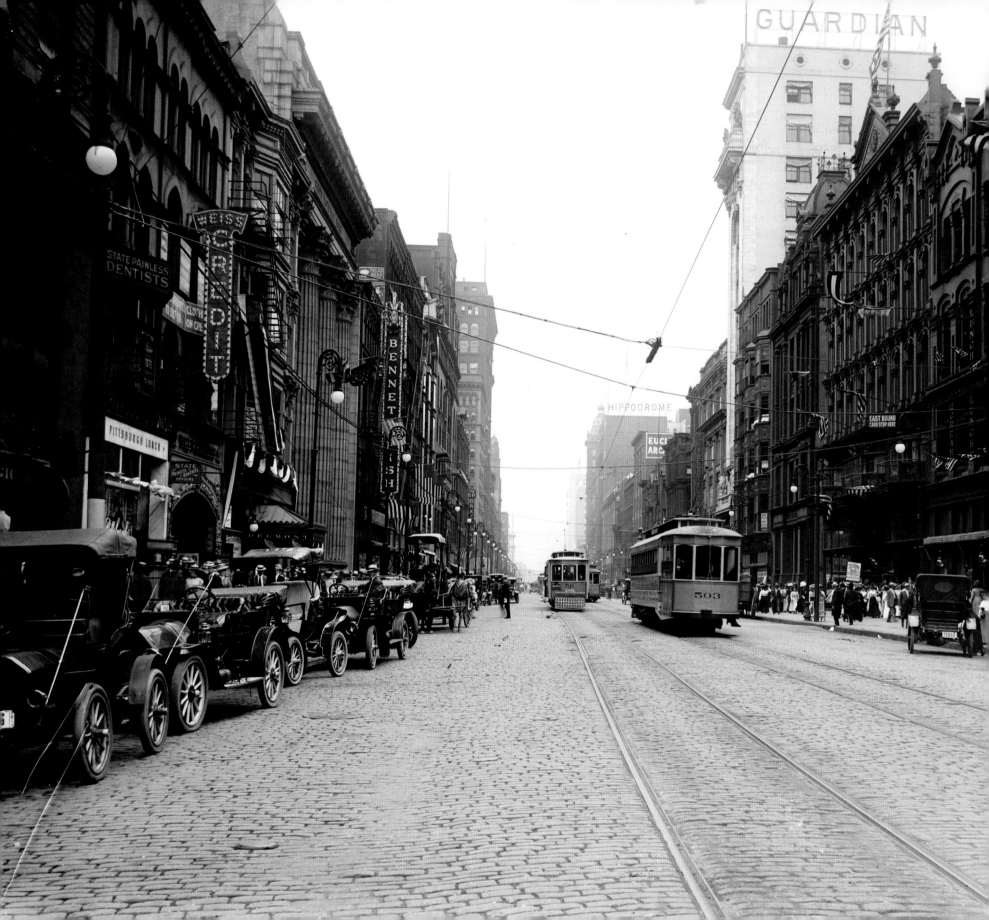

Streetcars DISCONTINUED 1954

Hopping on a streetcar to get around town was once an everyday occurrence in Cleveland. From 1888 to 1954, electric trolleys transported Clevelanders throughout the city and inner-ring suburbs.

The very first public transportation goes back even earlier, to urban railways that began in the 1830s. Horse-drawn omnibuses also transported large numbers of people in the mid-1800s, as did suburban steam lines. These forms were all problematic, however, as the 1872 horse flu epidemic, which brought public transportation to a standstill, proved.

It wasn't until the late 1870s that electric lines began to be installed in the city. This was no concerted effort by one central company, however; various competing companies from different areas of town were working independently to get the new technology running. The first successful streetcar run was in 1888, by the East Cleveland Street Railway Company. On December 18, they tested out their new line. By the next day, they had four cars running. By July of 1889, their Euclid line had reached Public Square. They weren't the first, though. That honor went to South Side Railroad's West 14th Street line.

Streetcar travel boomed in the next decade. By 1893, there were 22 lines operated by eight companies. By 1901, all of Cleveland's trolleys were electrified. Having so many companies owning streetcar lines, all with different fees and schedules, wasn't the most efficient way for a city's transportation system to run, however. Companies began to merge in the 1890s, but this was not without problems. In 1899, the violent Streetcar Strike on the Big Consolidated Line led to citywide rioting as mobs tried to attack nonunion replacement drivers. Bloody battles continued for more than three weeks until the strikers went back to work. The "streetcar wars" of competing companies carried on for nearly another decade.

Finally, in 1910, thanks to the efforts of progressive Mayor Tom L. Johnson, who sought to standardize fares, and a ruling by federal judge Robert Walker Tayler, the companies were consolidated and prices regulated by a City Council motion approved by a public vote. The Cleveland Railway Company joined together the lines, and a new more efficient era of streetcar transportation with a standard 3 cent fare began.

Streetcars traveled almost everywhere Clevelanders needed to go in town: Public Square, Wade Park, Central Avenue, Scovill Avenue, West 25th Street, Union and Broadway avenues, Woodland Avenue, St. Clair Avenue, Buckeye Avenue, East 55th Street and beyond. It was thanks to these lines that so many famous Cleveland institutions grew. Euclid Beach Park, Gordon Park, League Park and Luna Park all had streetcar stations at their entrances, and big crowds who used them.

The Cleveland Railway Company oversaw public transportation in Cleveland for the next three decades. Under the unified company, ridership sped away. By 1920, business had doubled to more than 450 million rides per year, from 228 million in 1910. That was the peak.

As Americans' love affair with the automobile took off in the 1920s, and the Great Depression hit in the '30s, ridership began to decline. The Van Sweringen brothers' development of the Shaker Heights Rapid Line also took a toll on streetcar traffic. As did buses. With less income, the streetcar system began to age. Lines began to close as early as 1935. In 1942, the city took over the system, arguing that they could raise more funds than the private company to modernize the lines.

Streetcars in Cleveland would continue only for another decade. Ridership steadily declined as car ownership soared. Lines closed throughout the 1940s, with only five still running by 1953: East 55th Street, Superior Avenue, West 25th Street and Clark and Madison avenues.

The last streetcar ran on January 24, 1954. It was on the Madison line from Public Square to West 65th Street and Bridge Avenue. That one last ride was free.

LEFT *A streetcar transports passengers through downtown Cleveland in the 1930s.*

FAR LEFT *Streetcars drive through Public Square on Superior Avenue in the early 1900s.*

OPPOSITE *Streetcars and cars share Cleveland's main boulevard, Euclid Avenue, near Public Square in downtown Cleveland in 1911.*

Chamber of Commerce Building DEMOLISHED 1955

What does a growing, industrious city need to take it to the next level? A new Chamber of Commerce. So thought the leaders of Cleveland in the 1890s when they commissioned their building to be constructed on Public Square. But the city's leading businessmen didn't just want any Chamber of Commerce. They wanted an impressive structure that would stop people in their tracks and make them take note that Cleveland was a city on the rise. Or, as they put it, "an object lesson" for future buildings in the area.

So city leaders decided to hold a competition. Famed architect William R. Ware, who taught at MIT and was a leading proponent of Beaux-Arts design in America, was asked to help choose the winner. Much to the dismay of Cleveland architects, the Boston firm of Peabody & Stearns was chosen. Those who made the choice had to defend it against criticism that a local firm should have been picked to design a building meant to promote the talent of Cleveland, but they proceeded with the Boston architects.

They got a building as magnificent as they had hoped. The Neoclassical Beaux-Arts structure showed a grand face to Public Square, with four huge granite eagles standing on pedestals at street level and eight sculptured caryatids over the entranceway.

Opened in the spring of 1898, the building earned raves beyond Cleveland. "The difficulty of investing a facade like this with distinguishing character is a very real one when floor upon floor, each of about the same height, has to be provided for," said the June 1898 *Building News*. "The architects in the instance now illustrated have very ingeniously overcome the inevitable monotony so frequently observable in elevations where the conditions of several floors are similar, and Messrs. Peabody and Stearns have inspired their facades with breadth and dignity by pleasingly contrasting the strongly marked horizontal lines of the base with the vertical lines of the main portion of the fronts." The journal went on to praise the building as "at once modern and architectural in style, its effect being obtained without following any exact period or recognized historical mode."

The "object lesson" was topped with an imposing, ornate loggia supported by a series of

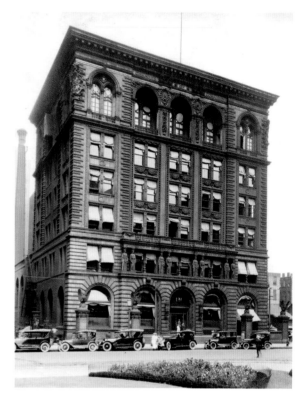

arches. The archways on the top and bottom levels of the building nicely complemented those on the neighboring Society for Savings, an 1889-built Burnham & Root skyscraper. Together, the two grand buildings on Public Square sent a message that Cleveland was a prosperous, soaring city.

So prosperous in fact, that the Chamber of Commerce had 1,100 members when the building opened. They didn't just concern themselves with growing the Cleveland business community, either. In its first decades in the Chamber of Commerce Building, the group also helped to develop the Group Plan for Cleveland's civic center buildings in the Mall area.

But the Great Depression hit Cleveland and the local business community hard. By the 1930s, membership was declining and the group was having financial troubles. They sold the masterpiece they had commissioned to the Cleveland College of Western Reserve University in 1939, who used it

until 1953. After standing empty for two years, the former showpiece was demolished in 1955, with only the eagles from the entranceway salvaged and sent to stand at the entrance of a farm in Geauga County. In 1991, the Society Tower skyscraper, today the Key Tower, was built on the site. It is the tallest building in Cleveland.

ABOVE LEFT *The 1898 Chamber of Commerce Building was located to the right of the 1889 Burnham & Root Society for Savings skyscraper, presenting a grand face to Public Square.*

ABOVE *The Chamber of Commerce Building in 1923, a booming year for the city of Cleveland, which was then the fifth largest metropolis in the country.*

RIGHT *The builders of the Chamber of Commerce Building wanted it to be an "object lesson" for future development in the city.*

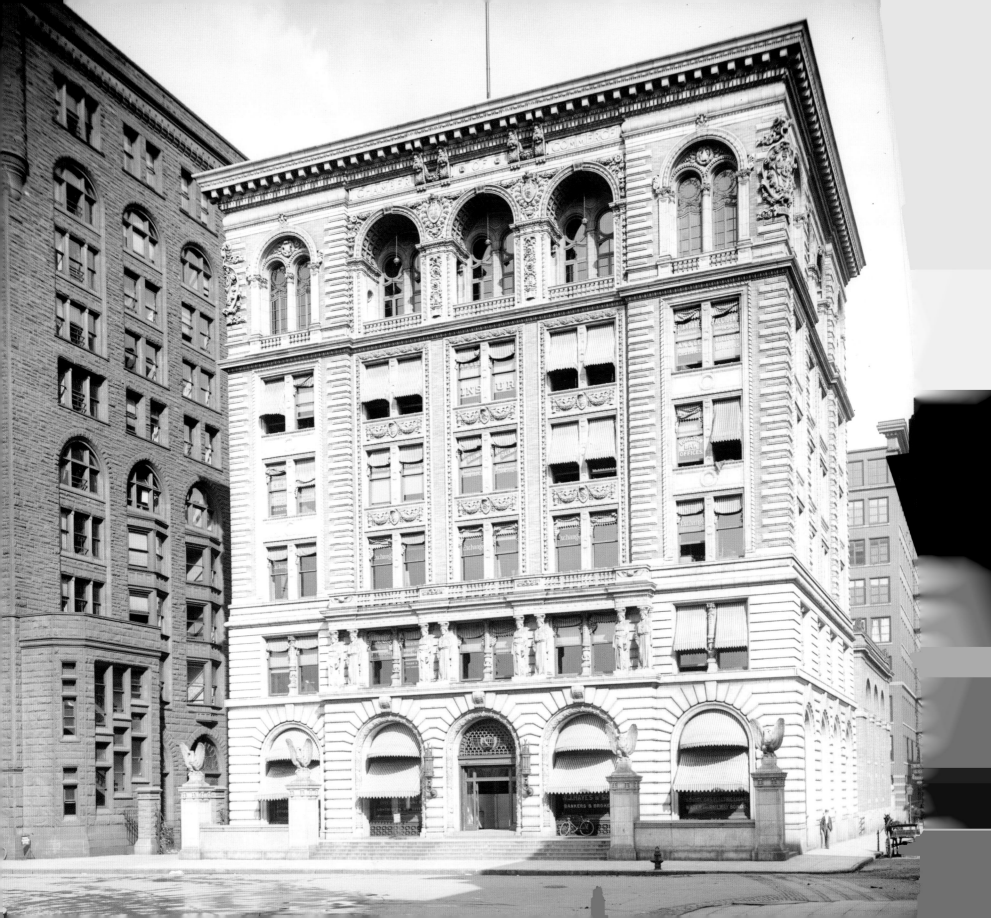

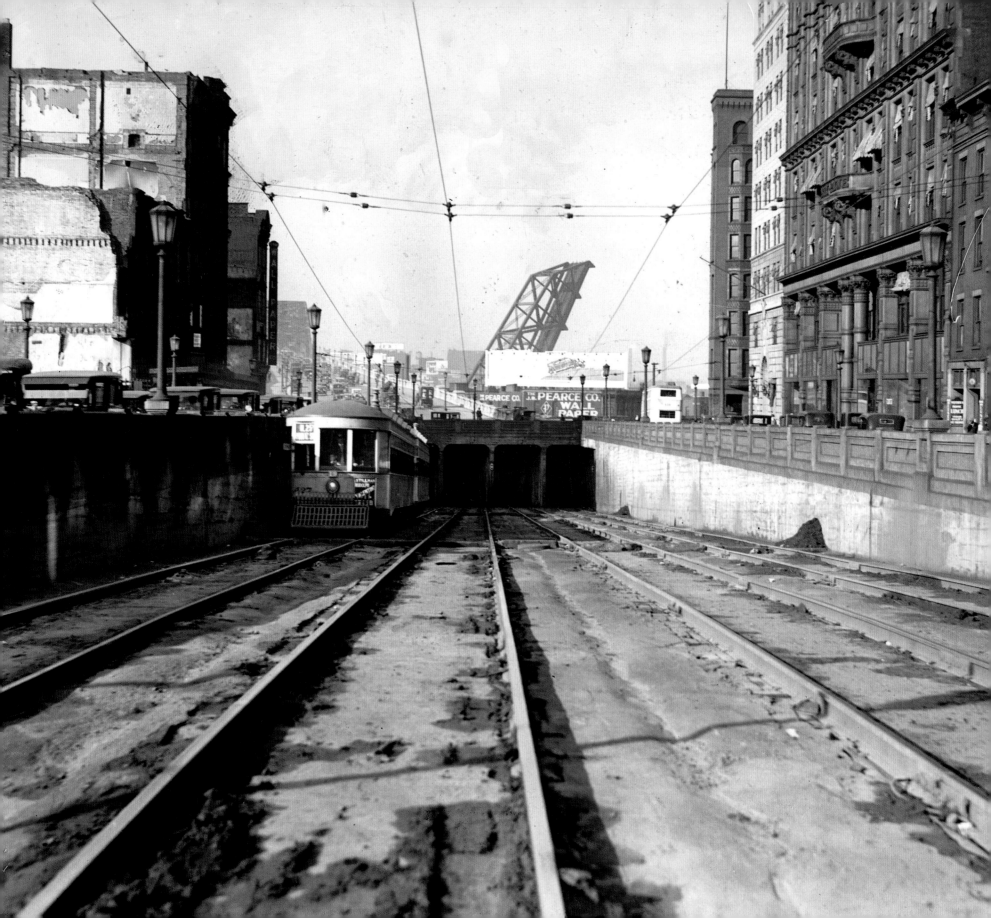

Detroit-Superior Bridge Subway CLOSED 1955

Thousands of commuters drive over one of Cleveland's most interesting ruins every day with little thought to the history beneath their wheels: the abandoned subway station and streetcar tracks just beneath the busy Veterans Memorial Bridge—formerly the Detroit-Superior Bridge—

that connects the west side to downtown over the Cuyahoga River.

The subway lines were opened at the same time as the high-level 3,112-foot compression arch steel Detroit-Superior Bridge in 1917, the first bridge tall enough to not have to be raised to allow passing boat traffic. The top level was for cars and trucks. The lower level was for streetcars, and was built after controversy about having streetcars on the top ensued in the Committee on Municipal Art and Architecture during the construction phase. It was a good thing. By 1930 more than 70,400 cars were crossing each day, earning it the title of the "nation's busiest bridge."

There were subway stations at both ends of the bridge, which streetcars entered and exited at West Sixth Street and Superior Avenue downtown and West 25th Street and Detroit Avenue on the west side. Six sets of tracks were intended, but there only ended up being room for four. The busy, attractive West 25th Street station had a large rotunda and circular marble stairway.

For decades, the streetcars transported thousands of Clevelanders a week. But when the Cleveland Transit System shut down the streetcar lines in 1954 in favor of buses, it meant the end for the bridge subway level. The city toyed with the idea of opening the lower level to car traffic, sending a car through on January 23, 1954 as an experiment. After a few months, however, cars on this level were deemed unsafe by the County Engineer due to the lack of ventilation and crowding around the support columns.

The ramps were closed over in November 1955, sealing the tracks and stations into place like an urban time capsule. Intrepid explorers can still venture into the ruins—where little has changed in 50-plus years—through a "secret" passageway inside Massimo da Milano Italian restaurant on the west end of the bridge at West 25th Street. Archways covered in peeling paint and crumbling concrete line the tracks where the streetcars once ran in the nearly mile-long catacomb-like space. Majestic steps ascending to the former West 25th viaduct-side entrance lead to nowhere, and a rusting fare-box sits unused.

In the late 2000s, the Ingenuity arts festival took over the site for a weekend each summer, exposing the buried-in-plain-sight treasure to unaware Clevelanders. The County Engineer's office leads tours once a year, too. But for the most part, the lower-level sits unused and unknown—except for those who might happen to look up as they pass the corner of West 25th Street and Detroit and notice the small tiled Art Deco "Subway" sign next to the former Forest City Savings & Trust Co. door.

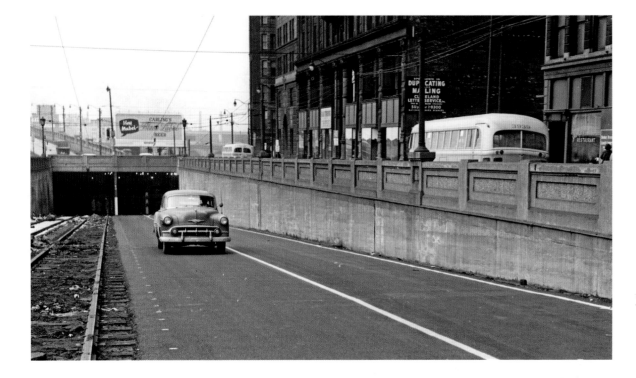

ABOVE LEFT *A U.S. Navy sailor waits for a streetcar on the lower deck of the Detroit-Superior Bridge in 1946.*

LEFT *A car makes a test drive through the Detroit-Superior Bridge subway-level on February 5, 1954, following the closure of the streetcar line. The level was deemed unsafe for auto traffic due to poor ventilation and crowding around the columns.*

OPPOSITE *A subway car exits the Detroit-Superior Bridge subway-level in 1935, heading into downtown. The J.M. Pearce Co. Wall Paper building is visible in the background.*

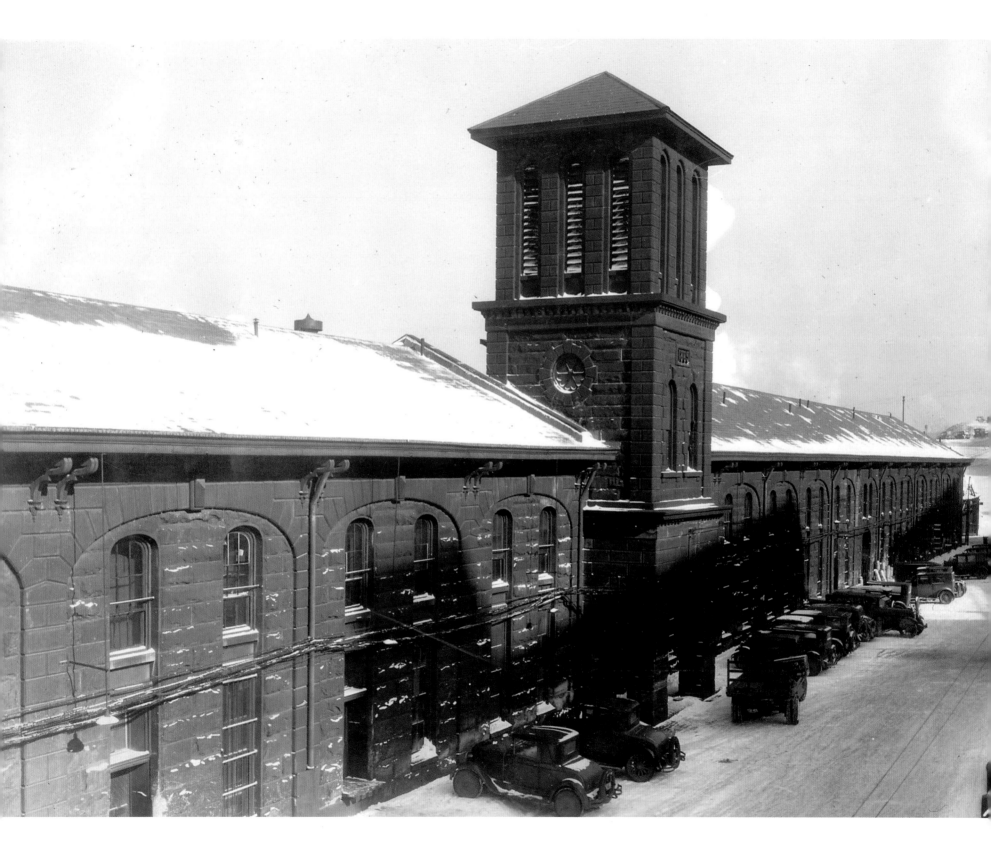

Union Depot **RAZED 1959**

Before the Terminal Tower, there was the Union Depot. Cleveland's original transportation hub united all of the railroads serving Cleveland under one roof. Located near Lake Erie from Bank Street (West Sixth) to Water Street (West Ninth), the depot played a key role in Cleveland's daily life, and late 19th-century growth.

There were actually two buildings on the same location called the Union Depot. The first was built in 1853, at a cost of $75,000. Consisting of multiple wooden sheds for individual rail lines, the depot served the Cleveland, Columbus and Cincinnati Railroad, the Cleveland and Pittsburgh Railroad and the Cleveland and Toledo Railroad, which eventually became part of the Lake Shore and Michigan Southern Railway. Just a decade after construction, however, a fire ripped through the depot burning down most of the sheds. But that wasn't the end. It was a new beginning.

In 1864, the city began to rebuild a better and bigger Union Depot on the same location. Much bigger. The second iteration of the depot, opened in 1866, was the largest building under one roof in the country at the time. Even when larger stations opened in New York, Cleveland's depot was the largest station between New York and the Mississippi.

Measuring 603 by 180 feet, the depot was made of Berea sandstone and iron and featured a 96-foot tower on the southern facade. At a cost of $475,000, the new structure was far more modern, and expensive, than its predecessor.

In just a few years, the new and improved Union Depot began to have a big impact on the city. Its central location between New York and the south, and its many lines traveling both east and west, helped make the city a hub after the Civil War.

President Lincoln also passed through Union Depot on two momentous occasions. In 1861, his inaugural tour brought him through Cleveland on his way to Washington, D.C. His funeral train procession came through four years later on its way to Springfield, Illinois.

As Cleveland's population and economy grew, its large, efficient transportation hub played a central role. This growth was also its undoing.

By the 1900s, the Union Depot was already becoming out of date. It was deemed too small for the number of people using the station, and number of trains coming through Cleveland. Citizens of the prosperous city began to ask for a third, even bigger depot to be built. Plans for a bigger station were made, but never came to fruition due to World War I.

Instead, the wealthy Van Sweringen brothers—owners of the Nickel Plate Railroad and builders of the Shaker Heights Rapid Transit—convinced most of the railways using the depot to switch to the Cleveland Union Terminal they were building at Public Square.

When the new terminal opened in 1930, the Van Sweringens had persuaded all but one of the railways to move. Only the Pennsylvania Railroad kept chugging through the Union Depot, until September of 1953. The empty building was razed in 1959.

OPPOSITE *Cars and trucks parked outside Union Depot at the foot of West Ninth Street on a snowy 1930 day.*

BELOW *When the second Union Depot opened in 1866, it was the largest building under one roof in the country. The building near Lake Erie was 603 by 180 feet.*

BELOW LEFT *An early 1900s view showing trains lined up between Union Depot and Lake Erie.*

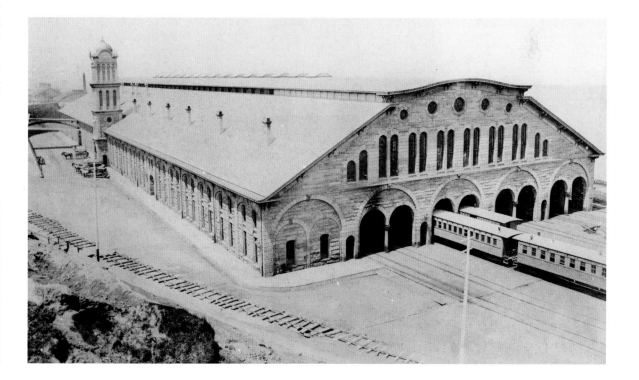

Standard Brewing Company SOLD 1961

There was no more favored way for a Cleveland fan to cool off on a hot summer day watching the Indians at League Park or Municipal Stadium than with a frothy Erin Brew.

Known as "Erin Brew, the Standard Beer," it was one of two signature beers made by the west side brewery that opened on Train Avenue in 1904. The other was Standard's Czech Old Bohemian beer—proof that Cleveland's diverse immigrant groups were well represented at Standard. Erin Brew, which reflected the founders' Irish heritage, was also called "Ehren Brau" to appeal to German beer drinkers. Its motto, however, was purely Gaelic: "Erin Brew, Erin Brah" (Ireland brew, Ireland forever).

At the time it opened, Standard was one of many small breweries in Cleveland. In 1910, there were 26 within the city of 500,000, including Gehring, Schlather, Star, Fishel, Bohemian, Cleveland, Columbia, City, Gund, Leisy, Pilsener and the Diebolt Brewing Company.

Standard was the creation of saloon owner Stephen S. Creadon and business partner John T. Feighan. Creadon felt small saloon owners like himself were being gouged by local brewers, and decided to take matters into his own hands in 1903.

He and Feighan purchased a former flour factory on the city's west side and formed Standard Brewing, with local saloon owners as the stockholders.

It was immediately successful, with Standard sending a fleet of horse-drawn delivery carriages throughout the city daily.

Standard Brewing's management proved crafty during Prohibition, making ice cream, soft drinks and near beer. The years after Prohibition and World War II were even better. The brewery's sponsorship of the Indians brought Standard's name into homes across the city. Radio and TV ads hooked to the Tribe, including during the team's World Series-winning 1948 season, led Standard to become the top-selling beer in the city.

Standard Brewing also began to expand to neighboring Michigan, New York and Pennsylvania. By 1950, the brewery launched a $5-million expansion that included new bottling and canning plants and cold storage and fermentation plants. By then the company was brewing 550,000 barrels a year and had more than 400 employees.

By 1961, with the beer industry shifting to big national chains from locally owned breweries, Standard was sold to New York's F. & M. Schaefer Brewing Company. It failed to make a profit,

and turned around and sold to Philadelphia's C. Schmidt & Sons, Inc. in 1964. Schmidt continued brewing in the Train Avenue facility until 1972.

Erin Brew did get one last call. In 1988, businessmen Craig Chaitoff and David Lowman attempted to bring it back with a new venture called Cleveland Brewing Company. Oddly, it was based in Pittsburgh. Backers of the beer included a who's who of Cleveland Irish, including Congressman Edward Feighan, great-grandson of the Standard founder.

The new Erin Brew never caught on, and was gone in just a few years—a far shorter life than its namesake.

RIGHT *The Standard Brewing bottling plant on Train Avenue in 1950. The west side Cleveland brewery opened in 1904. A sign for its most famous beer, Erin Brew, can be seen in the background.*

BELOW *The Standard Brewing horse team and beer wagon still made its way through Cleveland neighborhoods as late as 1927.*

BELOW LEFT *An employee uses a can-sealing machine on an Erin Brew assembly line in 1950.*

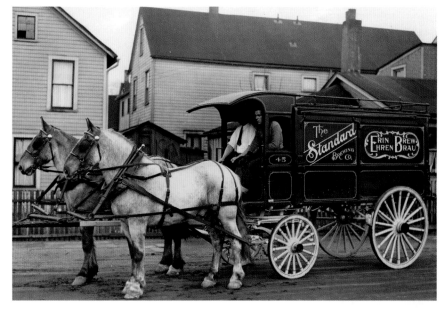

Alpine Village CLOSED 1961

There was never a dull night at Herman Pirchner's Alpine Village. Who could be bored with yodeling, "beer hefting" and entertainers from Cab Calloway to Jimmy Durante and Henny Youngman? Not to mention pretty girls in dirndls, goofy sing-alongs and a menu that ranged from oysters to goose liver, sauerkraut juice and "breaded filet mignon on toast."

There was more drama at Alpine Village, opened near Playhouse Square at 1614 Euclid Avenue in 1932, than there was in the theaters some nights. No wonder. The Village was led by an uber-showman, Austrian immigrant Herman Pirchner, who worked the venue in lederhosen and an Alpine cap, the clothes of his Tyrolean youth.

Pirchner arrived in Cleveland just five years earlier. Although it was during Prohibition, that didn't stop the flamboyant Austrian from brewing bathtub beer for local German social clubs. But although the government didn't scare him the mob did, and his brewing days were over. Pirchner soon got into the hospitality business full-time. He opened the Alpine Shore Club on East 185th Street and Lakeshore Boulevard, but by 1931 wanted a more high-profile space.

It wasn't long until he opened Alpine Village in the theater district. It quickly became the place to go before, or after, a show for a stein or schnitzel in the bucolic beer hall inspired by his homeland. The huge space had beer-hall-style seating with long wooden tables, surrounded by a second-floor gallery. Picturesque mountain scenes decorated the walls, and there was a ski-lodge-like bar on the main floor.

Entertainment in the big open space ranged from folk dancers and yodelers—on stage and in the audience—to some of the biggest names of the day in the supper club area. These included jazz stars, pop singers and comedians such as Cab Calloway, Jimmy Durante, Pearl Bailey and Perry Como. Pirchner also helped book many of these A-list names to the Great Lakes Exposition of 1936 and 1937, where he had an outpost.

The hottest stars to walk through the Alpine Village doors didn't perform at the club, though. Instead, Frank Sinatra, Bob Hope and Fred Astaire partied upstairs in Pirchner's exclusive Eldorado Club.

Pirchner himself would entertain the crowd by "beer hefting"—stacking and balancing 25 to 56 steins of beer on his hands, then running and sliding from table to table to pass out free drinks. The restaurateur made Ripley's "Believe It or Not" for his balancing act in 1933. Pirchner's shtick also included presenting souvenir rolling pins to new brides in the audience and leading goofy sing-alongs of the German ditty "Schnitzelbank." (Out of the club, he was just as entertaining, participating in everything from professional wrestling to riding the back of Karl Wallenda across a tightrope in a 1950 circus.)

The menu, while certainly German accented with plenty of schnitzels and sausages, also listed many fine dining favorites of the day, from Boston sirloin steak ($3) to crabmeat cocktail ($1) and creamed chicken ($1.70). "Dinner" was served before 9:30 p.m. "Supper" was later. There was a $2 minimum per person; $2.50 on Saturdays.

Alpine Village remained popular throughout the 1940s and '50s, but as suburban flight and changing tastes led to Playhouse Square's precipitous decline, Alpine Village followed. Pirchner filed for bankruptcy and the Village doors were closed in 1961. The building was razed for a parking lot in 1996.

Herman Pirchner remained a popular Cleveland character for several more decades, however, running a store and travel agency until he passed away at age 101 in 2009.

OPPOSITE *Alpine Village floor show performers Carolyn Waytt and Olga Godec wore traditional dirndls to entertain crowds on the restaurant's new elevated stage in 1942.*

BELOW *"Hail guest! ...We ask not what thou art, If friend, we greet thee hand and heart, If stranger, such no longer be, If foe, our love will conquer thee," read these postcard advertisements, written by Herman Pirchner.*

BELOW LEFT *Herman Pirchner carries 56 16-ounce beer steins in this 1940 photograph. He called it "beer hefting."*

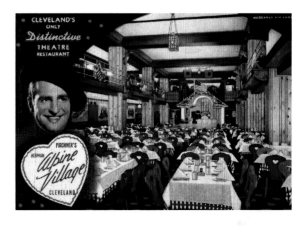

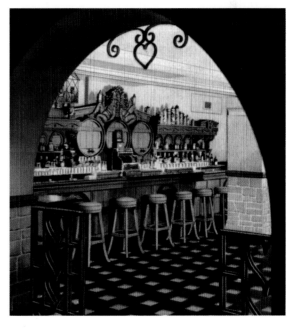

Hollenden Hotel CLOSED 1962

The names of Cleveland's grand hotels linger in the city's collective memory: Hotel Winton, Hotel Statler, the Allerton and the Alcazar. They evoke a more glamorous, prosperous, cosmopolitan era. And a wilder one, too.

No name evokes that era more than the Hollenden Hotel, opened June 7, 1885 at Superior Avenue and East Sixth Street. Celebrities performed in the chic Vogue Room, mobsters made deals in the suites, United States presidents spent the night. There was even a sensational kidnapping story.

The Hollenden was the dream of real estate developer Liberty E. Holden, who used an Anglicized form of his name for the property. Architect George F. Hammond, who studied Beaux-Arts architecture at MIT, was the designer.

When it opened, the eight-story Hollenden was the talk of the town. The modern Neoclassical masterpiece had electric lights; 1,000 rooms, including 100 with private baths; restaurants; clubs; a barbershop and even a theater. Crystal chandeliers illuminated the public spaces, which were lined with wood-paneled walls. In 1926, the hotel grew even larger when it received a $5 million update and annex on the east side.

As Cleveland's grandest hotel, the Hollenden became a draw for the biggest names of the times. Presidents McKinley, Theodore Roosevelt, Taft, Wilson and Harding stayed the night and dined in the luxurious Crystal Ballroom. The dining room was the location for a campaign speech by Senator John F. Kennedy on September 25, 1960—the eve of his breakthrough debate against Richard M. Nixon.

The founders of the National Football League checked in, too, signing the charter for the league in 1922.

A more salacious league also met in the Hollenden's elegant environs. Infamous mobster Moe Dalitz, one of the founders of modern Las Vegas, kept a suite at the hotel until 1945, where he would hold meetings with associates in the Mayfield Road Gang and Cleveland Syndicate.

Decades earlier, a terrible crime also brought attention to the Hollenden. On March 18, 1909, eight-year-old Willie Whitla was kidnapped in Sharon, Pennsylvania. The boy's attorney father paid the $10,000 ransom, and after four days Willie

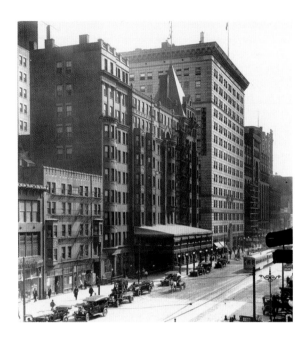

was put on a streetcar in Cleveland and sent to the Hollenden Hotel.

A singing legend with Ohio roots, Dino Crocetti of Steubenville, got his start singing in the Hollenden's elegant Vogue Room—$35 a week to front the Sammy Watkins Orchestra in 1940. It was a fateful gig for the young crooner. Watkins told him his Italian name had to be changed … Dean Martin was born.

With its white linen clothed tables surrounding a stage in the back, the Art Deco-style room lived up to its reputation as "Cleveland's smartest rendezvous." Guests to the Vogue Room received a token with the phrase, "Never a Dull Moment." Martin and others made sure it met its promise.

The Vogue Room was one of several clubs in the sprawling hotel. There was also the whimsical Show Boat Room, in which the big band played on a stage shaped like a riverboat. The Parisian cocktail lounge was the perfect backdrop for Cleveland's most elegant characters.

Even the barbershop was remarkable, a huge, gilded Art Deco space where local movers and shakers would talk over shaves in the morning. But just as men no longer go for shaves and couples

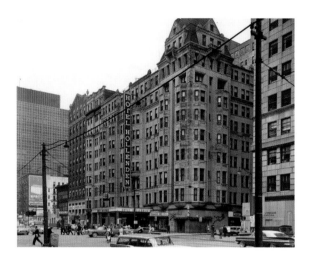

stopped going downtown to dance the night away, changing times took a toll on the Hollenden Hotel. Occupancy declined as Cleveland's prominence waned. Public spaces grew dated. By the time 600 Superior Corporation bought the Hollenden in 1960, only about 350 of the 1,000 rooms were in use.

Just two years later, this once glorious centerpiece of downtown was demolished to make way for the Brutalist 14-story, 350-room Hollenden House. It opened in 1965 and made much ado about being the first downtown hotel to offer Showtime for free. The Hollenden House lasted far fewer years than the Hollenden Hotel, though. A victim of once-again changing times, it was demolished in 1989.

ABOVE LEFT *The Hollenden Hotel, located at Superior Avenue and East Sixth Street, was part of a hopping entertainment district in the early part of the 20th century.*

ABOVE *By 1960, the once glamorous Hollenden Hotel was well past its prime, destined to be torn down in 1961. Visible at the left of the hotel is the Kennedy-Johnson campaign headquarters. Senator Kennedy delivered a speech in the hotel on September 25, 1960.*

RIGHT *Cleveland's grandest old hotel, the Hollenden, circa 1900. The Neoclassical masterpiece had electric lights, 1,000 rooms, restaurants, clubs, shops and even a theater.*

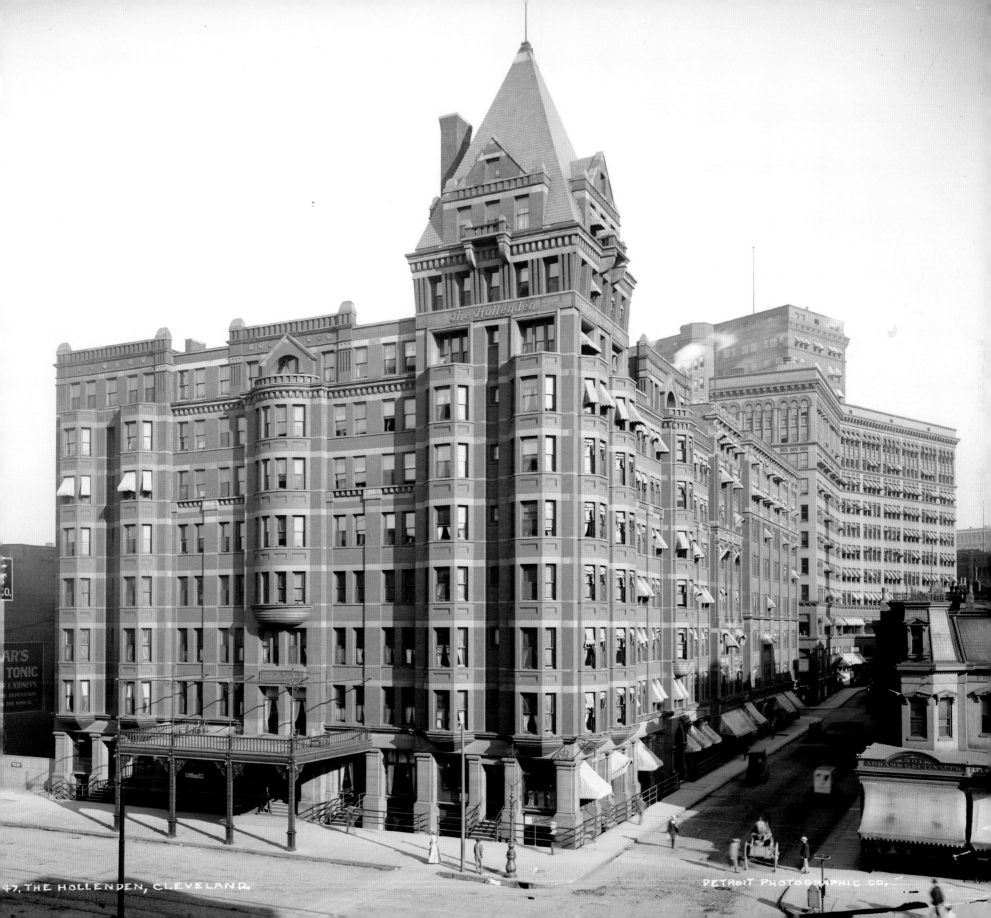

AR'S
TONIC
R & KIDNEYS.
REPUTATION
THE WORLD.

The Hollenden.

ABRAMS & GREENWALD

47. THE HOLLENDEN, CLEVELAND. DETROIT PHOTOGRAPHIC CO.

1953 Central Armory, O.N.G. Cleveland, O.

Central Armory DEMOLISHED 1965

Built in 1893 to house National Guard units, the Gothic castle-like Central Armory was a backdrop for some of Cleveland's most poignant and important moments. In 1917, the Fifth Regiment of the Ohio National Guard mustered there to parade to the Union Depot railroad station, showing off before they became the 145th Infantry and left to fight in World War I. Parents and wives and children watched men line up for roll call for decades in the imposing building before heading off for military service. Following the attack on Pearl Harbor, Naval Reserve guards even surrounded the building to protect it.

In the early days, the cavalry lined up at Central Armory for exercises. Later, trucks from the Army's Quarter Master Corps Motor transport school were stationed there. Cleveland's Central Armory even served as an unemployment registration center during the Great Depression, with lines of hundreds snaking out the doors of the grand structure at Lakeside Avenue and East Sixth Street.

Designed by Cleveland architects Israel Lehman and Theodore Schmitt with both protection and space for storage in mind, the armory was a massive, fortress-like Gothic-style stone building that resembled a medieval Italian castle with turrets on the corners and a modified rose window above the arched entrance. Small, high windows and a skylight allowed light into the space. A large bell tower on the corner at East Sixth Street and Lakeside Avenue could summon troops, or the public, if necessary. Inside, the building was one enormous hall that could serve as an area for troops and weapons, or in times of peace for performances, exhibitions, concerts and meetings. It was 122 feet wide, with a balcony suspended on iron rods from the girders. Bleachers around the perimeter provided seating for spectator events. The basement included a rifle and pistol firing range for practice.

The armory was the site of many good times, too. In 1896, it was home to the biggest party thrown in the city to that date: the Cleveland Centennial celebration. The festivities included an appearance by former Ohio governor and presidential candidate William McKinley, and a message from President Grover Cleveland. John D. Rockefeller did not attend, but a spokesperson announced his donation of $300,000 to create what became Rockefeller Parkway at the Armory. A Roman Catholic priest and Jewish rabbi spoke, and the Cleveland Light Artillery fired off 100 guns during the celebrations.

Other celebrations at the armory over the years included the Industrial Exhibition of 1909, which showcased the wares of the flourishing industrial town inside the armory and on a temporary bridge built between it and what is now Cleveland City Hall on Lakeside Avenue. Recreational basketball and professional wrestling events were also held in the hall in its later decades. Boxing was always a big draw at the venue; Cleveland's first championship match was held there in March of 1898, a 20-round draw.

Over the years, the armory began to see more expos and shows, especially after World War II when it came to be considered out of date as a military facility. The building that had played such a significant role in Cleveland history was unceremoniously demolished in 1965. The site is now occupied by the Anthony J. Celebrezze Federal Office Building.

LEFT *Troops drilling in front of Central Armory during World War I. Units would parade to Union Depot railroad station to head off for Europe after mustering.*

OPPOSITE *The imposing, castle-like armory was built in 1893 to house National Guard units. The large bell tower on the corner at East Sixth Street and Lakeside Avenue was its defining feature.*

Sterling Lindner Davis Company CLOSED 1968

The biggest Christmas memory—literally—for several generations of Clevelanders is no doubt the Sterling Lindner Davis tree. Make that trees. From 1927 until their closing in 1968, this popular Euclid Avenue department store set up an annual holiday tree that towered anywhere from 50 to 73 feet tall in their atrium, adorned in tinsel and lights and their huge signature ornaments. It took a lot of decorations. A 1952 Norway spruce was said to take 1,000 yards of silver tinsel, 60 pounds of tinfoil icicles and 2,500 ornaments. Volunteers spent more than 600 hours decorating.

Taking the streetcar or bus downtown to see the tree at Sterling Lindner Davis, one of six major department stores that made Euclid Avenue the Cleveland version of Fifth Avenue in the first half of the 20th century, was a tradition. But this department store that had roots back as far as 1845 was popular year-round for its personalized Red Hat shopping service for businessmen, its oriental rugs, travel agency, fine furniture, "homemakers headquarters" and fashion-forward Parisian designs.

Sterling Lindner Davis, which resulted from the merger of the Sterling & Welch Company, the Lindner Company and the W.B. Davis Company, was the oldest of all the Euclid Avenue stores. It was an outgrowth of the 1845 Thomas S. Beckwith Dry Goods, which became Beckwith, Sterling and Company in 1867. This store for carpets and upholstered goods became a popular destination for the wealthy of Millionaires' Row in the late 1800s. By 1909, then called Sterling & Welch, it was the fourth largest store in Cleveland.

In the 1920s, Sterling & Welch began its oversized Christmas tree tradition. By the 1940s, however, Sterling & Welch was considered dated and was floundering, until 1949 when the store was purchased by the newly merged Lindner & Davis Company. Each store brought a strength to the merger: Sterling was known for its rugs and furniture; Davis's strength was men's and athletic clothing, as well as its stylish hair salon; and Lindner was known for its cutting-edge women's fashions, home décor and tea room.

The newly created Sterling Lindner Davis Company soon moved into the location that would be most fondly remembered by Clevelanders, the old Higbee's building at 1255 Euclid Avenue. With its huge, four-floor atrium, it was perfect for the tree.

At this location the store introduced several new promotions, including its own Easter Bunny, "Lindee," in 1951. Another spring extravaganza featured a 1952 display of more than 3,000 Dutch tulips. In 1953, they amped up the Christmas game, with Santa Claus arriving in a Jaguar. Other high-profile promotions included bringing in ponies and sponsoring contests in which the winner could become an Indians bat boy.

Sterling Lindner—the name "Davis" was dropped in 1958—was the first department store in Cleveland to sell color televisions, too. The sets by Raytheon cost an astronomical $1,200.

Unlike other department stores that began to open branches in the new malls springing up outside of downtown, Sterling Lindner never diversified. By the 1960s, shoppers began to desert downtown for the suburbs and all the tinsel in the world couldn't save the long-running store. Sterling Lindner closed in 1968, survived by thousands of Christmas ornaments dispersed to vintage stores throughout the city.

RIGHT *The Euclid Avenue facade of the Sterling Lindner Davis store during construction in 1949.*

FAR LEFT *The 1959 Sterling Lindner Davis Christmas tree. The huge holiday trees, on display from 1927 to 1968, were said to reach as tall as 73 feet.*

BELOW LEFT *Society ladies drink tea at a 1928 Lindner Company Garden Party, near racks of women's clothing.*

BELOW *Children ride an indoor Christmas carousel at Sterling Lindner Davis in 1949.*

WE'RE TAKING THE CORNER ON FASHION IN CLEVELAND

The New Home of...
Lindner Davis

The LINDNER CO.
The W.B. DAVIS CO.

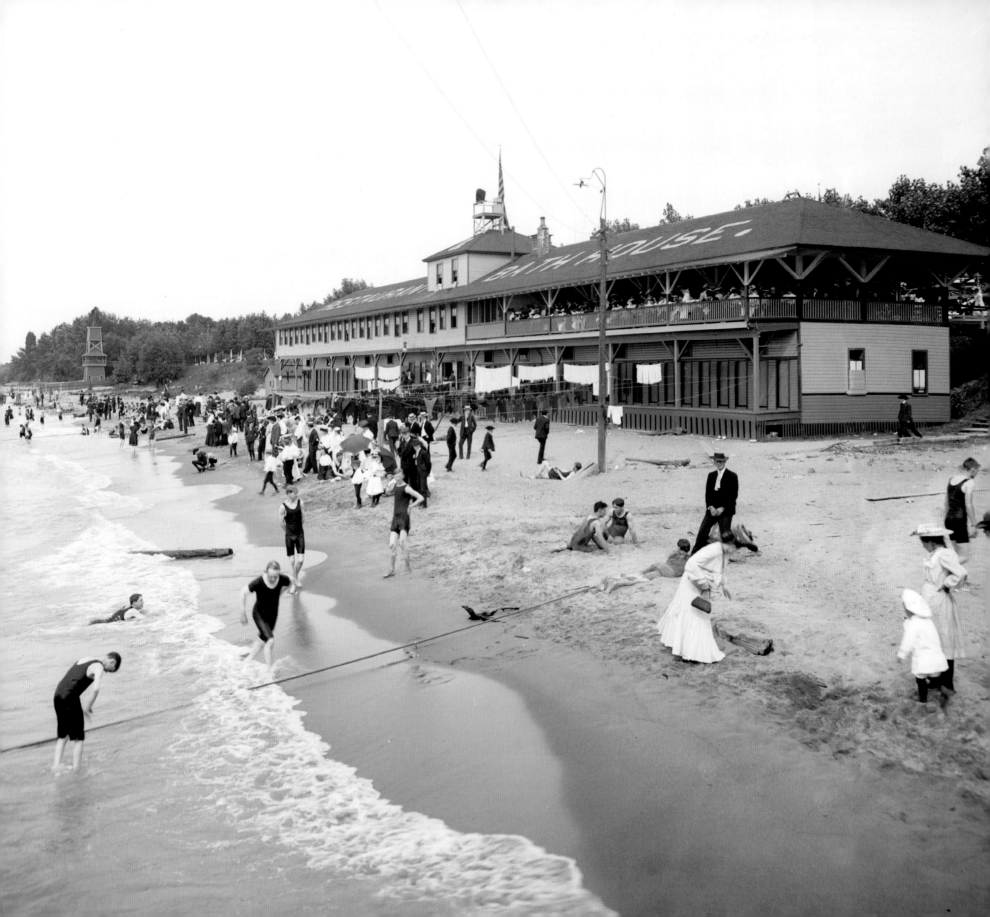

Euclid Beach Park CLOSED 1969

There are few places Clevelanders are more nostalgic for than Euclid Beach Park. Located on the shores of Lake Erie eight miles east of downtown, Euclid Beach was more than an amusement park. From the Rocket Ships to the dance hall and the famous custard and carousel, Euclid Beach spanned the city's rise and decline and was a summer tradition for eight decades. But this iconic playland almost didn't make it past year five—until a popcorn maker came up with a recipe for success.

Modeled after New York's Coney Island, Euclid Beach opened in 1895 on 90 acres at East 156th Street. The lakeside venue had a concert hall, beer garden, gambling, bathhouse, vaudeville acts and a handful of rides such as the Switchback Railway roller coaster.

It wasn't an easy birth for this iconic park. By 1900, Euclid Beach was considered a failure, losing $20,000 a year.

Enter the Humphrey family. The proprietors of a popcorn stand in the park, the Humphreys took over management in 1901 with a five-year lease for $12,000 per year. The family's first move was to make the park more of a family destination. That meant no more beer, and no admittance even if you were seen drinking beer in the bar across the street. They also added new bathing facilities, even bathing suit rentals, and a daring spinning swing over the water.

Visitors—who mostly came by streetcar—were lured by the new beachfront, rides and the ornate dance pavilion. "One fare, free gate and no beer" became the slogan of the park that was open from April through October.

In 1910, Euclid Beach installed what would become the park's most beloved landmark, the carousel. Designed by the Philadelphia Toboggan Company, the 58 prancing wooden horses and two chariots became the park's biggest draw.

Another early favorite, the New Velvet Coaster, opened in 1909 and kept crowds screaming until 1965 under its final name, the Aero Dips.

The classic Flying Turns took off in 1930. The toboggan-like ride was popular for allowing women to sit on their date's lap, risqué for the time. The Rocket Ships launched that same year. The space-themed ride consisted of three silver bullet-shaped rockets suspended from cables that sped above the ground. It, too, soared until the park closed. Even today Clevelanders can take rides in a rentable ship that has been retrofitted for the road.

But Euclid Beach was about far more than rides. The beach was always a huge draw, especially when an elegant new bathhouse opened in 1925. It's impossible to know how many Clevelanders had their first date at the dance hall. Even more Clevelanders claim to still be scared by memories of the robotic Laughing Sal fun house doll.

Companies, political parties and armed forces

regiments held annual outings in the park, too. During World War II, Euclid Beach thrived with Clevelanders in search of an afternoon respite.

Despite the fond memories, Euclid Beach Park wasn't welcoming to all. Through the 1940s, African-Americans were only allowed in on certain days and were not allowed to go into the dance hall and swimming areas. This led to a series of protests in 1946 that began when an interracial student coalition attempted to visit. They were evicted, leading to picketing—including by World War II veterans in uniform—and a riot on September 21 that culminated in a fight between park police and city police.

Euclid Beach survived another 20-plus years after that, luring new generations to the rides and dances and famed Euclid Beach vanilla custard at the Dairy Whip stand. But as Cleveland's fortunes fell in the 1960s, so did Euclid Beach.

In 1963, daily bus service from Public Square was cut. By 1965, the park was forced to demolish some rides and sell the Great American Racing Derby to Cedar Point to raise funds. The end was near for the once celebrated destination.

Declining attendance, lake pollution and racial tensions led to Euclid Beach Park's 1969 closure. The iconic carved archway from 1921 is all that remains on the site, though the Western Reserve Historical Society restored the carousel in 2014. Visitors to the Cleveland History Center in University Circle can take a spin back in time on one of the original horses.

Euclid Beach Park lives on in other ways, too. You can still buy a custard made from the original recipe by descendants of creator Nathan Weber on Cleveland's west side. Humphrey's Popcorn Balls are sold in stores across the city. And if you're lucky you just might see one of the remaining Rocket Ships taking a spin around town.

LEFT *With its 58 prancing wooden horses, Euclid Beach Park's carousel, made by the Philadelphia Toboggan Company, was the park's most beloved ride. It has been restored and now spins at the Cleveland History Center.*

FAR LEFT *The Hippodrome theater at Euclid Beach Park.*

OPPOSITE *A day at the beach, circa 1905. The bathhouse and water rides were big draws at Euclid Beach Park.*

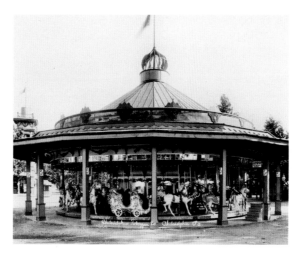

Allerton Hotel SOLD 1970

Cleveland's first "bachelor hotel" opened with much fanfare in November of 1926. Rather than rent by the night, such hotels catered to the needs of the modern working man, with every convenience offered in a luxurious setting close to the humming city center. The Allerton fit the bill.

It was the seventh bachelor hotel built by the New York Allerton Company, designed by the Morgantroyd and Ogden Company architects. This 550-room, 16-story hotel at East 13th Street and Chester Avenue featured a swimming pool, squash courts, tennis courts, rooftop patio, ballroom and billiard room at the time of its opening. The swanky health club offered "salt glow and sunlight rays." The basement even included a "closet club" where male guests could rent space to hang their extra suits or tuxedoes.

No expense was spared in building the Allerton. The floors in the lobby were done in marble, and the walls were walnut. The lower levels featured a cafeteria and a 150-seat coffee shop, which stayed open until 2 a.m., and even a drugstore. The skyscraper's roof had a year-round solarium and garden area open in warmer months. Classical music concerts were held in the garden.

It was the top-level lounge, though, that attracted the attention of most Clevelanders. The swanky cocktail bar lured Cleveland high-society, politicians and businessmen and was even said to be a mob hangout. Entertainment ranged from dance parties to tea parties.

The luxurious Allerton Pool was also quite the social scene. Not only was it used for swimming; with dinner and drink service available on floating tables, it was a splashy nightspot. Located off the lobby, the 60-by-25-foot pool was surrounded by a visitors' platform and mezzanine with steam rooms, a massage area and Turkish baths. "It's a habit with hundreds of Clevelanders to swim in the Allerton Pool, so much so that we're now signing up a good many splash parties and regular swim night groups," read an ad at the time. "Why not organize such a party among your friends?"

The Allerton also hosted several private clubs and fraternities, including the Big Ten Men's Club for college graduates. For a fee, these groups rented out space for meetings, and were then allowed to use the Allerton's amenities.

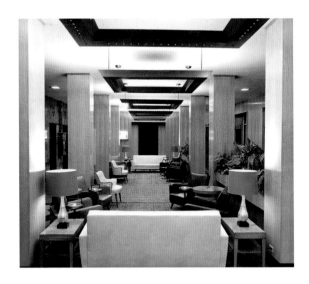

True to its original mission, ads at the time of the Allerton opening targeted bachelor businessmen. One featured two men in robes in front of a bathroom sink, with one telling the other how a friend brags of living near "everything." "He must live at The Allerton," says his pal. Other ads called the Allerton a hotel where a bachelor could "live in nine rooms and only pay for one." Rooms began at $1.50 per night.

Despite such ads, the Allerton wasn't exclusively male. Four floors were reserved for female guests— perhaps another enticement for the male clientele. Staff members made sure no men entered these floors, however, and vice versa. More women made the hotel home in the 1940s, when the WAVES took it over as a barracks and infirmary.

The Allerton reverted to private ownership after World War II, but it never quite recaptured the glamour of the prewar years. By the 1960s, the once fashionable address had become a cheap hotel trying to attract overnight guests in the oversaturated Cleveland hotel market.

The Manger Hotel Chain bought the Allerton in 1953 and was forced to sell it in 1970. The hotel briefly became the Gaslight Inn before it too closed in 1971. The building was converted into low-income housing, and the gym, amenities and spectacular pool demolished.

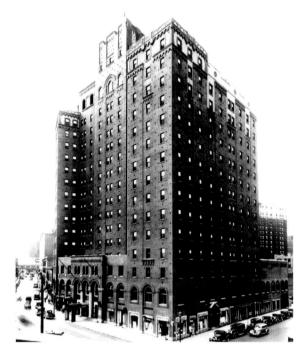

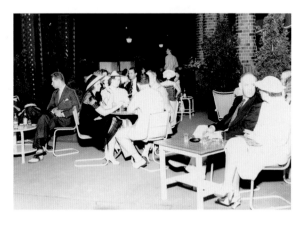

ABOVE LEFT *Remodeling in 1952 gave the inside of the Allerton Hotel a mid-century modern vibe.*

TOP *The Allerton Hotel towered over Chester Avenue and East 13th Street in 1947.*

ABOVE *A chic crowd gathers at the rooftop lounge in 1938.*

RIGHT *Cars whiz by the Allerton on East 13th Street in 1946. By this time it was no longer a "bachelor hotel."*

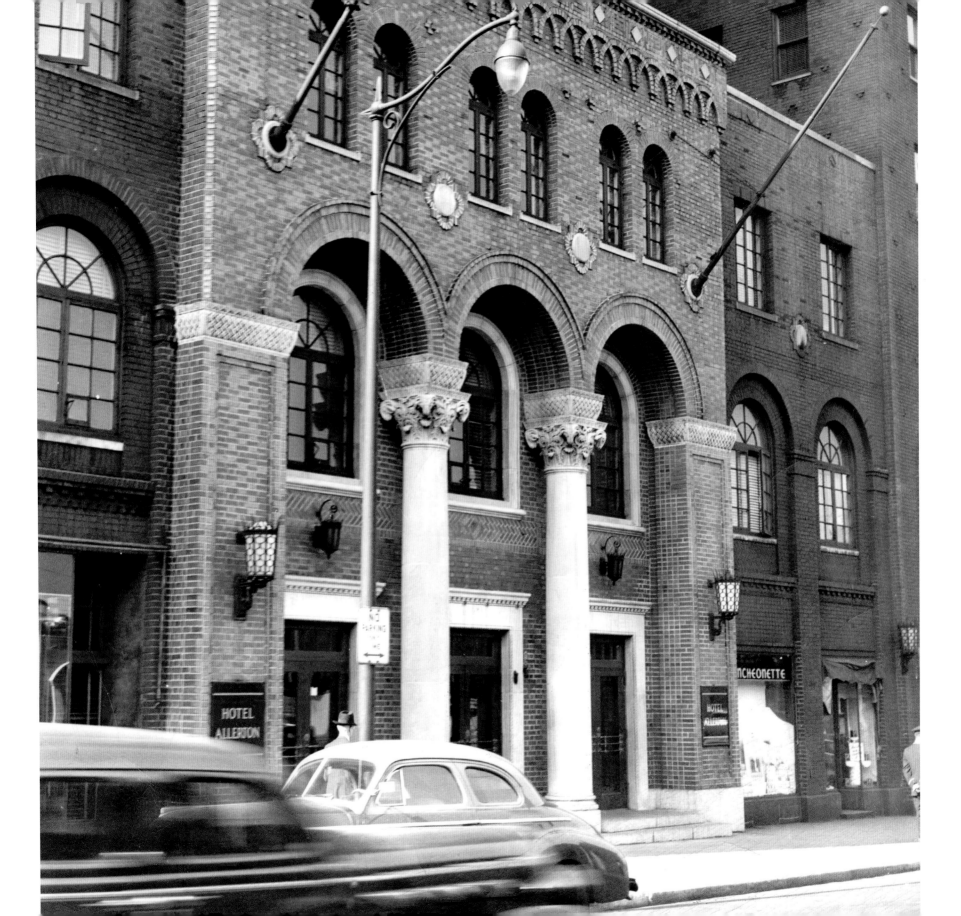

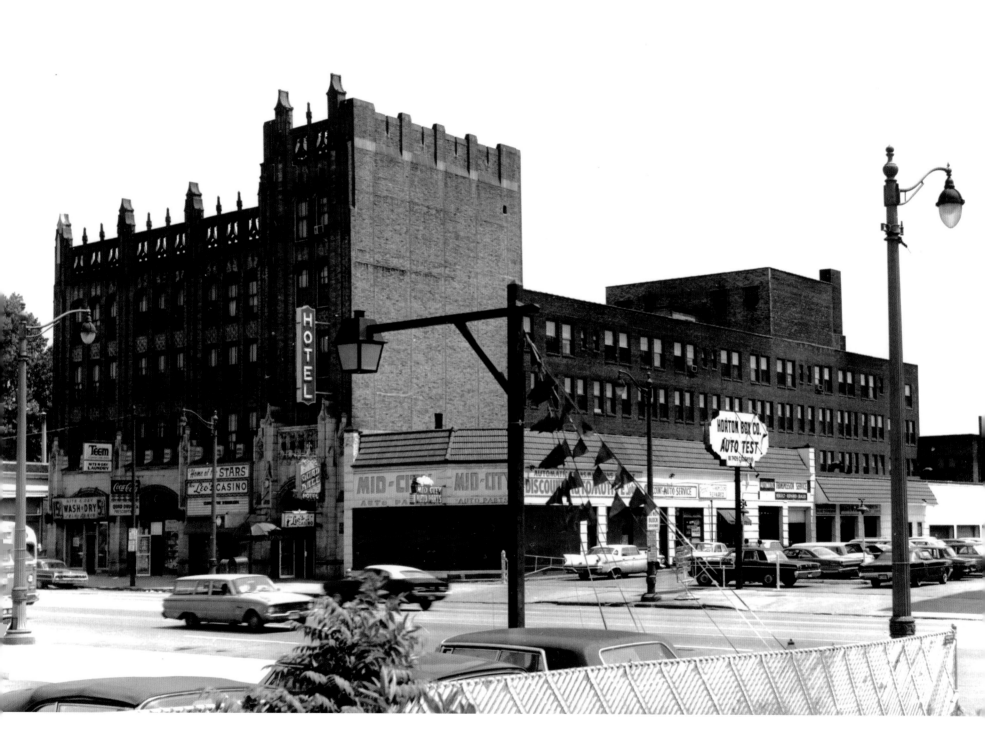

Leo's Casino CLOSED 1972

Otis Redding played his last show ever at Leo's Casino—the night before his fatal plane crash in 1967. The long-gone Cleveland nightclub is more remembered for its many firsts, though. The Euclid Avenue venue was the first club in town to introduce Motown and R&B to Clevelanders. The first club in town to bring in musical greats such as Aretha Franklin, Smokey Robinson, Stevie Wonder, Nina Simone, Ray Charles, the Temptations and the Supremes. And the first racially mixed nightclub in segregated Cleveland—surviving and thriving even after the Hough Riots tore apart the area.

It was all about the music when Leo Frank first opened his eponymous venue at East 49th Street and Central Avenue in 1952. Frank wasn't concerned with community building, just bringing in good artists. At first, it was a jazz club, with many of the brightest names of the era headlining, from Dizzy Gillespie to John Coltrane.

When that Leo's location burned down in 1962, Frank was forced to move. He took on a business partner, Jules Berger, and moved to a much larger location in the lower level of the old Quad Hall Hotel at 7500 Euclid Avenue. Opened in 1925, the magnificent, soaring, Gothic building was an upscale club home for men in its early days. By the time Leo's Casino moved in, it was just a regular old hotel in an aging inner-city neighborhood. Its glory was faded … until Leo's brought it back.

Leo's Casino could now fit 700 music fans, which was a very good thing. As the sounds of the era flowed from jazz to R&B, Leo's got in on the ground floor of the new music. It was the first club in Cleveland to book Motown acts heading south from Detroit, bringing in some of the biggest names in pop music history—and full houses to match. Admission was just $2, and Leo's usually had three shows a night from Thursday to Sunday. So many Motown greats took Leo's stage, it almost seemed like a branch of the famed Motor City label. Most of them made $2,000 for a week of gigs.

The club itself had a cozy feel, with low ceilings, black walls, red carpets and small 18-inch tables surrounding the low stage—though those were often pushed back to make room for dancing. Underage patrons had to wear yellow leis.

Comedian Dick Gregory was one of many funnymen to visit Leo's, along with superstars like Redd Foxx and Richard Pryor. Gregory, also known for his civil rights activism, called it "the most integrated nightclub in America."

In the summer of 1966, the integrated club found itself in the midst of the nearby Hough Riots. Where just blocks away rioters were tearing apart the impoverished Hough neighborhood and the National Guard was trying to restore order, at Leo's hundreds of black and white fans waited peacefully to see three sold-out shows by the Supremes on the steamy night of July 24. The first two sets went off without a hitch, but though there were no problems at the club, the police shut the third show down as they continued to establish calm in the area.

Leo's reopened one month later, with a set by Ray Charles. The club continued on a good six years after that, finally done in by the success of the music it helped grow: Motown artists could play much bigger venues for much more money by the early 1970s. Frank sold his share of the club to Berger in 1970, and Leo's Casino closed for good in 1972.

The aging Quad Hall building was later demolished—but that wasn't the end for Leo's Casino. The historic nightclub was declared a Rock and Roll Hall of Fame landmark in 1999. A plaque was erected at 7500 Euclid Avenue, and in attendance at the ceremony were former Leo's emcee Freddie Arrington, singer Martha Reeves and 71-year-old Leo Frank himself. "Unbelievable," said Frank at the time. "I'm so grateful they did it while I'm still alive." He died two weeks later.

OPPOSITE *Leo's Casino opened in 1963 in the lower level of the 1925-built Quad Hall Hotel at 7500 Euclid Avenue on Cleveland's east side. By 1970, many of the Motown stars who had graced its stage were moving on to bigger venues.*

TOP RIGHT *A gorgeous young Aretha Franklin took the stage at Leo's Casino in November of 1966.*

RIGHT *The Supremes brought Clevelanders together with songs like "You Can't Hurry Love" during the violent July 1966 days of the Hough Riots.*

Cleveland Arena CLOSED 1974

It was built as a venue for hockey, but the Cleveland Arena will go down in the history books for a far more pop-culturally important reason: it was the site of the world's first rock concert on March 21, 1952. Thanks to the Moondog Coronation Ball, the 1937-built hall became an international music landmark. But in the beginning, it was all about hockey.

Cleveland Barons owner Albert C. Sutphin first saw the need for the arena in the late 1930s. The sport had become so popular in Cleveland that his AHL team had outgrown its home at the 2,000-seat Elysium in the Doan's Corners area. The downtown arena would have 10,000 seats and more modern facilities for the team and fans. When floor seating was available it could fit as many as 12,500. The arena cost $1.5 million, and opened at 3717 Euclid Avenue on November 10, 1937. Opening night featured an Ice Follies extravaganza. The Barons had their first match a week later.

Inside, the arena was a no-frills space that could easily be converted for varied events and shows. Outside, the marquee had swooping Art Deco flair. It was topped by an eight-foot neon hockey player in the 1960s.

Over the years, the arena hosted a slew of different types of events, from circuses to boxing, wrestling and rodeos. Professional basketball was big at the arena. Sutphin's little-remembered Cleveland Rebels of the Basketball Association of America played their 1946–47 season there. The Cincinnati Royals of the NBA even used the venue as a home court, playing 35 games from 1966 until the Cleveland Cavaliers were founded in 1970. The arena was the home for the nascent Cavs for their first four seasons.

The World Hockey Association Cleveland Crusaders played in the arena from 1972 to 1974, too. And the venue Sutphin built is remembered as the site of a 1947 boxing championship in which fighter Jimmy Doyle was killed by a punch from Sugar Ray Robinson.

But it was the Moondog Coronation Ball that really put Cleveland Arena in the spotlight. The event was hosted by legendary DJ Alan Freed, who planned it with Record Rendezvous owner Leo Mintz and concert promoter Lew Platt. Freed promoted it heavily on his radio show of the same name, which was turning thousands of area teens onto the new music. The bill included Paul Williams

and the Hucklebuckers, Tiny Grimes & the Rockin' Highlanders, The Dominoes, Danny Cobb and Varetta Dillard. Tickets were $1.50 in advance, $1.75 at the door.

More than 20,000 jubilant fans came to party. In true rock 'n' roll fashion, most of them crowded into the venue and the show slated to go till 2 a.m. was shut down after Williams' first song due to rowdiness and over-crowding. The *Cleveland Press* reported that a "crushing mob of 25,000" showed up, with "hepcats jamming every inch of the Arena floor."

The Cleveland Arena continued on for another two decades after that, though no night since reached the drama of March 21, 1952. The justification for Cleveland's claim to the Rock and Roll Hall of Fame was closed in 1974 when Cavs owner Nick Mileti opened the Richfield Coliseum. Three years later it was demolished.

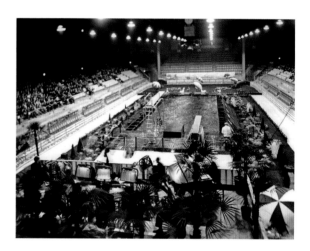

ABOVE *The Cleveland Arena was able to host aquatic shows, like this 1938 extravaganza with a portable swimming pool surrounded by tables and an orchestra.*

LEFT *Cleveland Arena, pictured in 1937, could be converted into an ice rink, concert hall, basketball arena and boxing venue. Its most famous event was held the night of March 21, 1952: the Moondog Coronation Ball.*

RIGHT *Hockey had become so popular in Cleveland by the 1930s that Barons owner Albert C. Sutphin built the 10,000-seat Cleveland Arena, pictured in 1938, for his team.*

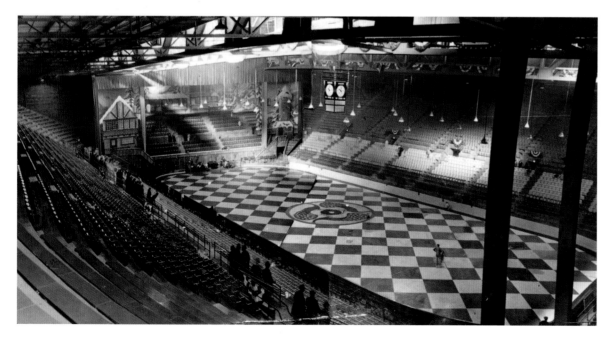

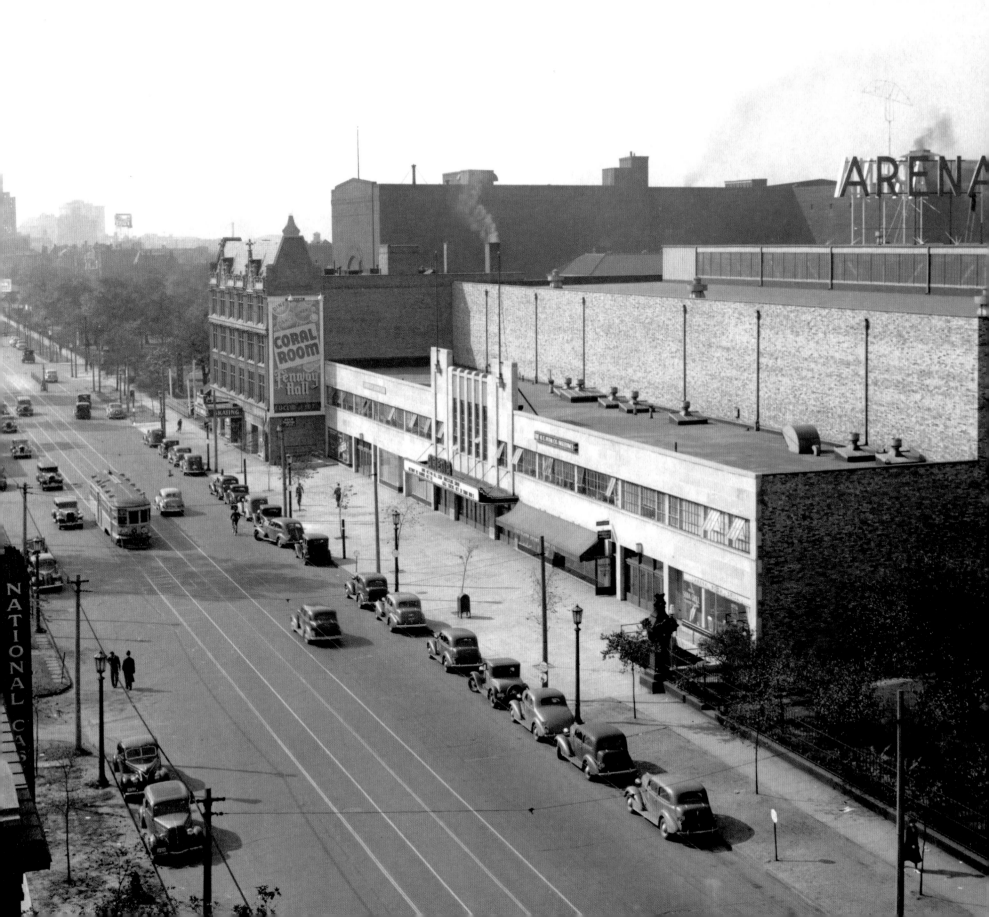

St. Agnes Roman Catholic Church

DEMOLISHED 1975

Cleveland's most beautiful Roman Catholic Church can only be seen in the pages of history books. St. Agnes Church at Euclid Avenue and East 81st Street was said to be the most lovely in town. But that didn't save it from the wrecking ball in 1975. Nor did the church's outreach programs in the neighboring Hough area. When a fire ripped through the St. Agnes complex in 1973, it was deemed not worth the expense of renovating and demolished a little more than a year later.

It was a sad ending for a church established almost 100 years earlier. Meant to serve upper-class parishioners who lived in the posh Hough area, no corner was cut when the showpiece church was built. It was actually the second church on the site; a smaller, less ornate St. Agnes church and school had been constructed in the 1890s. But it was soon decided a bigger church must be built—a church that would reflect the prosperity of the parish and its members. Many Catholic residents of Millionaires' Row attended St. Agnes.

Construction began in 1914 for the church designed by John T. Comès. The Pittsburgh architect was known across the country for his Catholic church designs, including Christ the King Cathedral in Atlanta. Commissioned by the pastor, the Rev. Gilbert P. Jennings, Comès' goal was to create a building as glorious as its purpose. French Romanesque in style, St. Agnes featured a stunning rose window in the front, located over recessed doors and three carved arches in the facade. It was built of grey Bedford stone, with marble floors inside. The roof was made of terracotta tiles. Inside, marble arches followed the nave, and the apse was decorated with elaborate frescoes. Large stained-glass windows lined each side. A towering belfry stood outside the church.

In a book-length critique of St. Agnes in 1920, *New York Times* reporter and critic Anne O'Hare McCormick said Comès' design fully realized the pastor's goal to build a church that would "meet squarely all modern and practical requirements, that would retain the flavor and spirit of the best Romanesque traditions and yet give to Cleveland a church of some distinction and originality,

expressing the ancient and modern continuity of the Church, and also the power of her adaptability to the language of the day."

St. Agnes did indeed prove to be adaptable as the area around the church began to change in the 1950s, with many affluent parishioners leaving for the eastern suburbs. Non-Catholics were welcomed into the school, and in early 1962, the Diocese of Cleveland placed the parish under the direction of the Missionary Servants of the Most Holy Trinity, a group that served African-American and Latino Catholics.

The 1966 Hough riots in the predominantly African-American neighborhood took a heavy toll on St. Agnes. The church was only slightly damaged, but the neighborhood's spirit was worse. St. Agnes worked to heal that through community outreach programs and ministry efforts. Along with nearby Calvary Presbyterian Church, St. Agnes created a group dedicated to rebuilding houses damaged in the riots, and building low-cost new houses.

The terrible fire that tore through the grounds of St. Agnes in 1973, completely destroying the school, sealed its fate. Within a year, the diocese determined it would be too expensive to repair and update the huge church with its shrinking congregation. St. Agnes was decommissioned and its artwork sold off. The building was demolished in 1975—except for the belfry, a reminder of another era that still towers over Euclid Avenue today.

ABOVE LEFT *The Cleveland Catholic Diocese sold off St. Agnes's artifacts and furnishings when the church was demolished. This Pietà sold for $800 in 1975.*

ABOVE *The inside of St. Agnes was as lovely as the exterior, with marble arches and an apse decorated with elaborate frescoes.*

OPPOSITE *St. Agnes Roman Catholic Church was designed by John T. Comès, known across the country for his Catholic church designs. The French Romanesque-style St. Agnes Church was dedicated in 1916.*

U.S. Coast Guard Station ABANDONED 1976

The U.S. Coast Guard Station was built for function and protection at the mouth of the Cuyahoga on Lake Erie in 1940—but it is remembered for its beauty and design. The architectural jewel designed by J. Milton Dyer, who also designed Cleveland City Hall, was the city's first Art Moderne building.

At the time of its opening, the station was described as the "finest" and "most beautiful in the nation," as well as "the most modern" Coast Guard building. It was constructed on landfill at the end of a 1,000-foot pier on Whiskey Island at a cost of $360,000. Made up of three separate buildings, the station included a two-story structure with living quarters for 22 crew plus a senior officer, a communication room, a rec room and a mess hall in addition to the working areas. The 8,000-square-foot boathouse had three slips and attached docks, and there was a three-car garage.

More than 500 Coast Guardsmen from across the nation attended the August 1940 dedication, which also marked the 150th anniversary of the Coast Guard service. Admiral Waesche was the guest of honor, and fêtes were held at the Union Club and Cleveland Yacht Club. Opening festivities included capsize and resuscitation demonstrations, and beach apparatus drills. Motion pictures were played at the station.

Dyer's building embodied the Art Moderne aesthetic with its long, sleek horizontal lines that, appropriately, recalled a ship. Also called Streamline Moderne, this was the perfect style for a nautical building. Done all in white with a flat roof and smooth walls, the station featured a 60-foot tower and both square windows and openings that curved with the building. Doors and entryways were also curved. The boathouse was especially modern, with cut-out walls that swept down toward the water. It was all constructed out of concrete, with steel casement windows. The officers' areas and mess hall had ceilings decorated to mimic the interior of a ship.

By the 1970s though, this Moderne masterpiece was considered to be out of date. In 1976, the Coast Guard moved its base to East Ninth Street, closer to the urban core, and the city took over the property. It has been abandoned ever since—with the exception of a short-lived period as a water-quality testing facility and disco in the late 1970s.

Located in such a remote, inaccessible area, many Clevelanders do not even know of the historic station's existence, despite it being listed on the National Register of Historic Places and as a designated Cleveland Landmark. Flooding and other water and elemental damage destroyed the roof and many of the interior spaces, which vandals wiped clean of all wiring and utilities.

Today the former station is just a shell, with walls surrounding nothing. There have been a number of SOS calls to save the historic structure, the latest being a campaign by the Cleveland Metroparks and Great Lakes Brewing Company. But for now, the abandoned structure sits empty and deserted at the end of its pier.

TOP RIGHT *A Coast Guard flag-raising ceremony at the station on Whiskey Island during World War II, 1943.*

RIGHT *The Coast Guard Station operated at the mouth of the Cuyahoga from 1940 to 1976. It included an 8,000-square-foot boathouse with three slips and attached docks.*

OPPOSITE *An aerial view of the U.S. Coast Guard Station in 1964 highlights the rounded corners and long, sleek lines of J. Milton Dyer's Art Moderne buildings.*

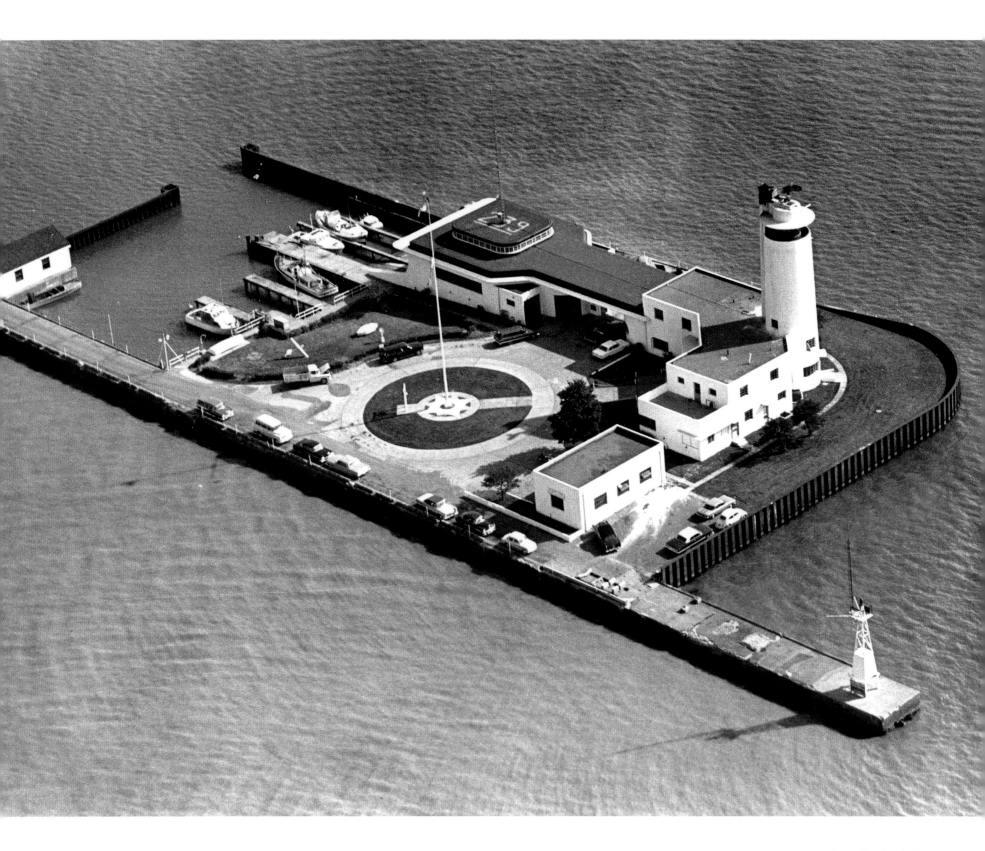

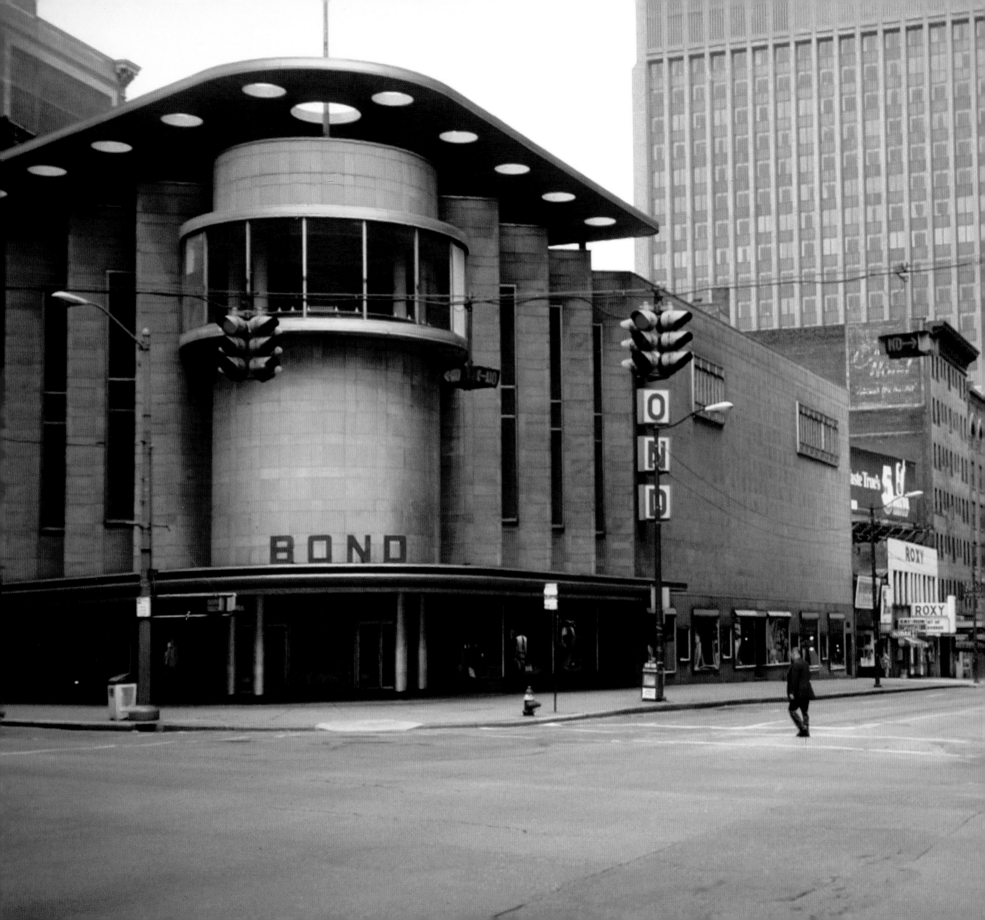

Bond Store DEMOLISHED 1978

The striking four-story Bond Store at East Ninth and Euclid was considered the height of modernity when it opened in 1947. It was certainly one of the most dramatic looking buildings in Cleveland history. So it was all the more tragic when it was torn down just three decades later to make room for the rather generic National City Bank complex.

Inspired by film and musical architecture of the 1930s and World's Fair pavilions, the elegant Art Moderne building was made of pink granite and featured a cylindrical corner, floating canopy roof with decorative circular border holes, and a swooping staircase and mirrored columns in its four-story interior. It was designed by the famed local firm of Walker and Weeks. Though known mostly for its classical style, the group had begun experimenting with more modern styles in its later years. The store was only Cleveland's second Art Moderne building, after the U.S. Coast Guard Station that opened on Whiskey Island in 1940.

The Bond Store was built on the site of the former Hickox Building, which the Bond Clothing Company had occupied since 1920, selling suits and other men's clothing. Bond first became known for its $15 men's suits and eventually had more than 100 outlets across the nation selling ready-to-wear men's clothing. But changing lifestyles during World War II, an era of more working women and fewer men outside of uniform, led them to add women's clothing to their racks.

The company eventually decided it needed an updated building for its flagship Cleveland store, one that would suit its outfits for the modern man and woman. Though Bond had been headquartered in New York since 1937, the company still had a strong Cleveland presence and this new building reflected its commitment to its hometown. In 1945, Bond began to demolish the 1890-built Hickox Building, and by 1947 opened its glamorous Moderne masterpiece. Walker and Weeks architect Herbert B. Beidler had to make the building corner cylindrical due to the intersection's acute angle—a necessity that accentuated the modern look of the inside, too. Outside, the pink granite was complemented with plaid terracotta, aluminum and steel. Sawtooth windows meant shoppers could step out of the crowds on the busy sidewalk and admire the sophisticated window displays.

The Bond Store's striking outside colors vibrantly reflected the Hollywood glamour of the inside. With its floating staircase and columns that extended to the top all the way from the main floor, shoppers felt they were in one large room. Perhaps a room where a Busby Berkeley musical number might break out at any minute, so theatrical was the interior.

The colors inside were even more spectacular than those on the street. The store was done in a total of 52 pastel shades with walls trimmed in aluminum, and colored lights as well as fluorescent lights and spotlights to create drama.

As they climbed the stairs with their glass and aluminum railings, guests passed an elaborate mural to the "Goddess of Fabric." A third-floor solarium with a floor-to-ceiling display window in the women's department provided street views for ladies who wanted to lounge on the leather couches and take a shopping break. Models often showed off the latest fashions to passers-by through these same windows, attracting the attention of women looking to shop and men just enjoying the view.

In 1975, the Bond Clothing Company was sold to a foreign investment group, the beginning of the end for the once dominant chain. Three years later, the corner building that had been the epitome of modernity on East Ninth and Euclid was demolished to make way for National City (now PNC) Center.

OPPOSITE *The Bond Store in 1978, the year of its demolition. When it opened at the corner of East Ninth Street and Euclid Avenue in 1947, the Art Moderne store was considered the epitome of sophisticated shopping.*

BELOW *The swooping lines, floating staircases, aluminum trim and 52 pastel colors of the interior of the Bond Store were inspired by film and musical architecture of the 1930s.*

Short Vincent

Short Vincent spanned only one city block. But no street has a bigger, splashier reputation when it comes to Cleveland history than the one that once ran between East Sixth and East Ninth streets.

Vincent Avenue, as it was officially named, was just 485 feet long. But those were happening feet. The entertainment district included bars, strip clubs, shops, all-night diners, restaurants, taverns and assorted dens of iniquity.

Short Vincent reached its zenith in the 1930s, but the district was a destination for night crawlers long before that—as early as the 1880s when the Hollenden Hotel was built. With the 1,000-room hotel's back entrance on Vincent Avenue, smart restaurants, bars and shops opened to cater to the many guests. By the 1920s, the street had developed quite a reputation for its taverns, where travelers, gamblers, women of the night, mobsters and others gathered.

By the 1930s, a night out on Short Vincent was like stepping into a slightly dangerous, but oh-so-fun film noir. It was lined with snazzy neon signs featuring cocktail glasses and dancing girls, and filled with pretty ladies, expensive cars and more than a few cops. The wild entertainment strip was home to legendary venues such as the Frank Ciccia's Barbershop, the Taystee Barbeque, Coney Island hot dogs, Mickey's Show Bar and Kornman's Restaurant, known for its steaks and free bus rides to ballgames. The south side of the street was the more scandalous one, known for Freddie's Café and the French Quarter strip clubs. Jean's Funny House, located at the end of Short Vincent, had something for everyone: by day it sold toys and joke books, by night it hosted 25-cent peep shows.

Just around the corner, the Roxy burlesque house on East Ninth Street lured revelers to Short Vincent, too. Featuring the top va-va-voom names of the era, including Irma the Body, Ann Corio, Lili St. Cyr, Blaze Starr and Tempest Storm, the club became the star of Cleveland's downtown nightlife scene in the 1930s and 1940s. In its later years, its descent into hardcore X-rated films mirrored Short Vincent's decline.

The street's most famous—or perhaps infamous—addresses were those of Frolics Bar and the Theatrical Grill. Opened in 1937 by Morris "Mushy" Wexler, the Theatrical was known for its celebrity performers, and celebrity crowd of high-society scenesters, mobsters and athletes. One of Cleveland's most powerful crime figures, Alex "Shondor" Birns, did business out of the long-running club.

With its neon marquee featuring scantily clad showgirls riding horses, Frolics Bar was the subject of more than a little police interest over the years. It was far from the only Short Vincent establishment to attract the attention of law enforcement, though. Raids were not rare, and in 1964 the city shut down Mickey's Show Bar, calling the club known for its gambling a "nuisance."

By that time, Short Vincent was already in its decline, which for this street meant the reverse of most areas: it was being cleaned up, with all the tawdry edges and wild fun washed away. By the early 1960s, most of the north side was demolished for the Central National Bank Building. The south side, known for its girlie bars, was razed in 1977 and 1978—the same time as the Roxy—for the National City Bank Center. Only the Theatrical Grill lived on, finally closing in the 1990s.

RIGHT *A night out on Short Vincent in the 1960s usually included a stop at Frolics Bar.*

FAR LEFT *A policeman checks up on the goings-on at Frolics Bar in March of 1964.*

BELOW LEFT *The entertainment was no longer "continuous" at Mickey's Show Bar in 1965. It was forced to close a year earlier, deemed a "nuisance."*

BELOW *The Roxy Burlesque sat right around the corner from Short Vincent on East Ninth Street.*

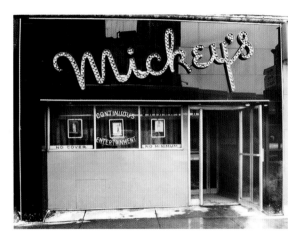

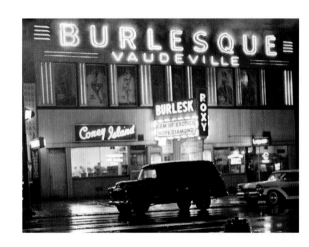

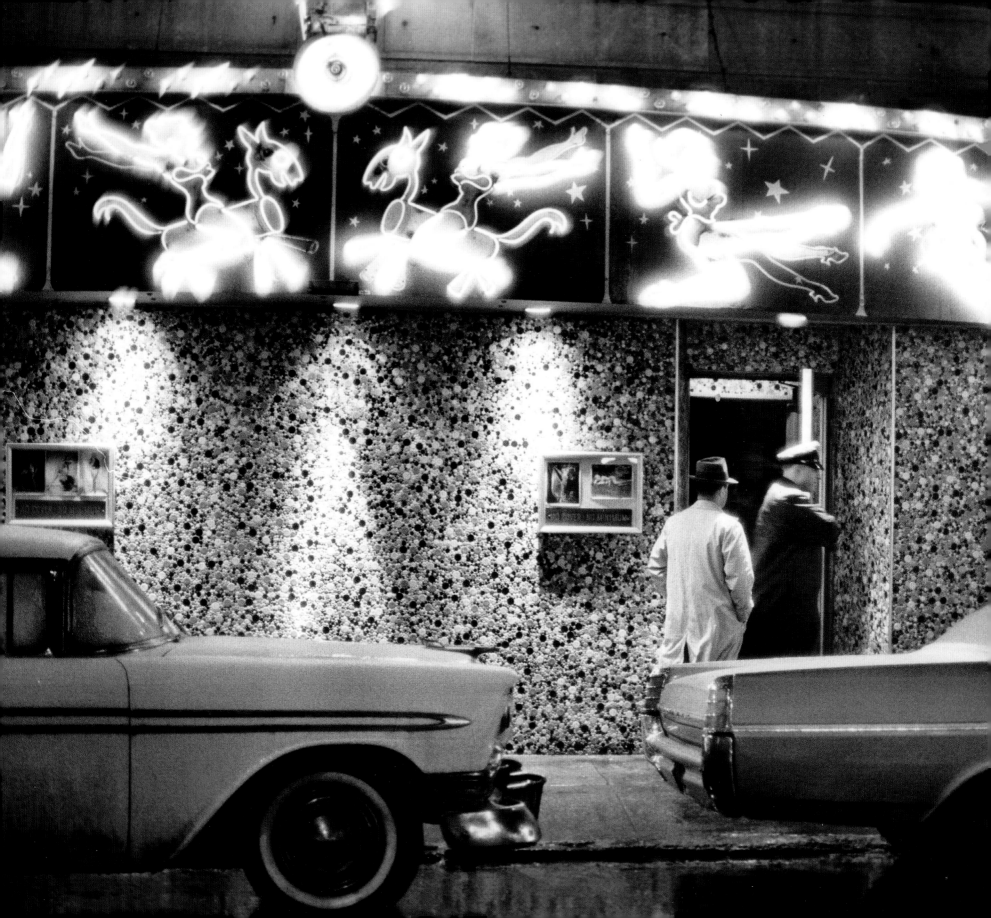

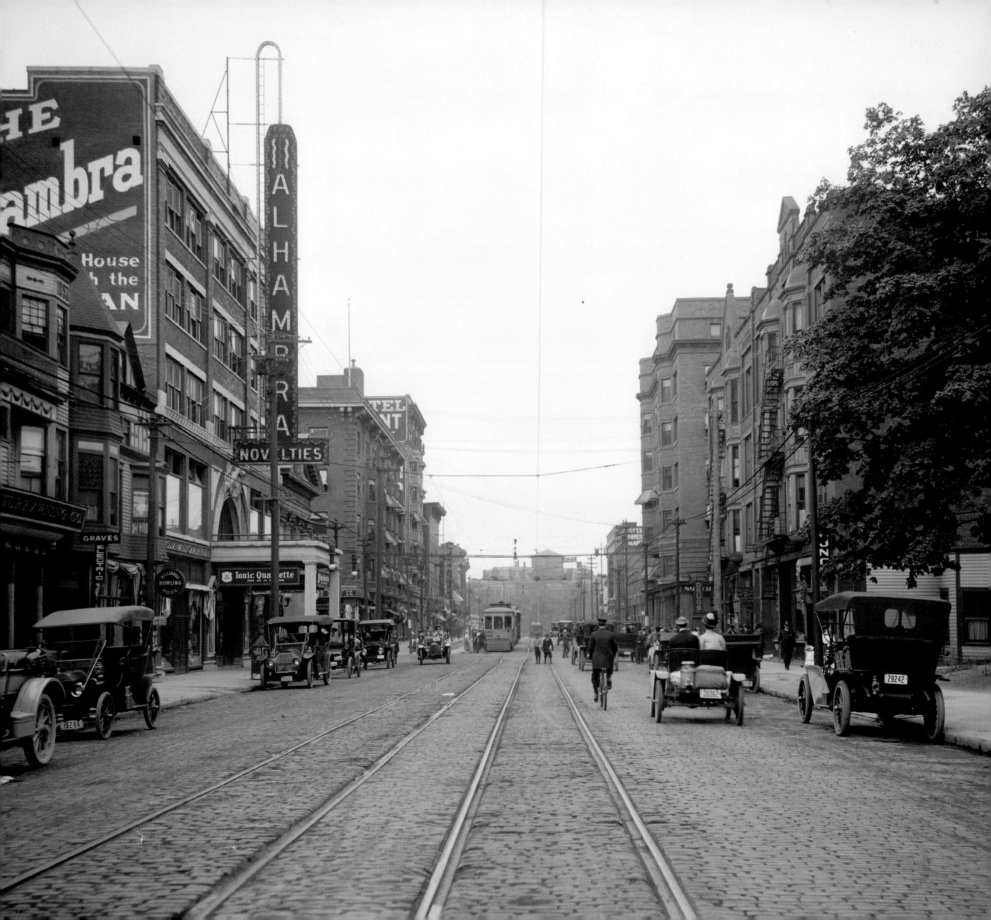

Doan's Corners DEMOLISHED EARLY 1980s

Cleveland once had a second downtown. Doan's Corners, as it was called, was the neighborhood around the corner of Euclid Avenue and East 105th Street. It was named after early settler Nathaniel Doan, who ran a hotel and tavern in the stagecoach stop at Euclid and East 107th in the early 1800s. By the time the area became part of Cleveland in 1892, it was a bustling hub of hotels, shops, taverns, a cemetery and a post office.

A little more than a decade later, the most famous era of Doan's Corners was launched with the 1911 opening of the opulent Alhambra theater for "high class music and moving pictures." This was followed in 1921 by the opening of Keith's 105th Street Theatre.

With its vibrant nightlife, residential hotels, restaurants and exclusive shops, Doan's Corners was becoming the most sought-after address in Cleveland. There were jazz clubs and ballrooms and bowling alleys and nightclubs and cabarets and five movie theaters—and even the enormous Elysium indoor ice rink. The best-known theater was the 3,000-seat Keith, all the rage for its vaudeville shows and double features as well as being the house where Bob Hope honed his comedy chops. It was a gorgeous theater, with rose velvet covering the walls and seats, and a gilded lobby done in ivory. It kept showing movies until 1967.

The Alhambra, the other big draw in Doan's Corners, was much more than a movie theater. The complex also included a bowling alley, pool room and apartments. The posh Alhambra Lounge was famous for its late-night dining scene—and its owner, infamous gangster Alex "Shondor" Birns. It was demolished in November 1976.

Other famous venues in the hub included the Esquire Lounge, the Club 100, the Fenway Hall Congo Room, the Majestic Ballroom, the Circle, Towne Casino and the Trianon. Doan's Corners became the center of Cleveland's jazz scene by the 1930s, with the action centered around Lindsay's Sky Bar at 10551 Euclid Avenue, open from 1934 to 1952. Miles Davis, Billie Holiday, Louis Armstrong, Dizzy Gillespie and Count Basie were among the acts who performed in the neighborhood.

But Doan's Corners wasn't just a going-out destination. By the 1920s, it had become a sophisticated urban neighborhood with a plethora of living quarters. Residential hotels included the Doanbrooke Hotel, the Commodore, Fenway Hall, the Park Lane, the Tudor Arms, the Sovereign Hotel and the Wade Park Manor on East 107th Street. Opened overlooking the Cleveland Museum of Art in 1923, the 11-story Georgian Revival manor was called "the newest move in Cleveland's progress toward complete metropolitanism" by the *Town Topics* society paper in 1921.

Following World War II, Doan's Corners carried on as an entertainment and residential district. But by the 1950s, suburban flight began to take a toll. Even as residency declined, the area continued as a hot nightlife destination for another decade— until the riots in the neighboring Hough and Glenville areas scared many suburbanites away from the city.

Doan's Corners did have a second chance at life, though, when African-American businessman Winston E. Willis bought up many of the properties in the blighted area in the late 1960s and early '70s. Willis opened several businesses, including the Scrumpy Dump Cinema (a destination for Blaxploitation classics such as *Super Fly* and *Foxy Brown*) and Winston's Place Fine Dining—as well as several X-rated theaters. There were also arcades and clothing stores and barber shops.

Though he briefly revived the area, by the early 1980s Willis had run into trouble with the law and neighboring Cleveland Clinic, who acquired much of his property in a controversial move. What remained of Doan's Corners was demolished for the Cleveland Clinic and W.O. Walker Industrial Rehabilitation Center.

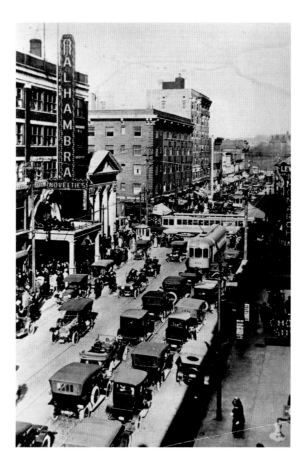

ABOVE *Businesses in Doan's Corners in 1956 included the Alhambra theater and bowling lanes, Fanny Farmer, Miles Shoes, F.W. Woolworth and a Cleveland Trust location.*

LEFT *Today there is no trace of Cleveland's second downtown, so filled with life in the 1920s.*

OPPOSITE *By the early 1900s, Doan's Corners had become a bustling nightlife hub. The Alhambra entertainment complex, opened in 1911 and demolished in 1976, was one of the most popular venues.*

White Motor Company FILED FOR BANKRUPTCY 1980

Thomas White's sons knew better than dad. The founder of the White Sewing Machine Company thought cars were a passing fad. Fortunately, Rollin, Windsor and Walter White were more forward thinking. Inspired by a faulty Locomobile steam car Thomas White had purchased, recent Cornell University graduate Rollin invented his own auto boiler in 1899. He convinced his father to let him use a small corner of the sewing machine factory to build a car, and by 1900, the brothers rolled out the White Steamer automobile.

It sold well. It took some persuading, but the brothers eventually convinced their father to diversify. In 1906 they launched the White Motor Car Company. Their factory was based near the Cuyahoga River on Canal Street in the Flats. They later opened a large plant on East 79th Street.

White was truly a family oriented operation in its early days. The factory had a library and low-cost general store, and the White brothers hosted frequent social events, from picnics at Euclid Beach Park to orchestra and jazz concerts.

White's steam-driven cars took off. In 1907, President Theodore Roosevelt brought one to the White House for the Secret Service to use. President William Howard Taft was also a fan, purchasing a 1911 White for $4,000. He liked that the steam the car produced prevented photographers from getting too close. All in all, the White company produced more than 10,000 steam automobiles.

By 1911, the company was converting to gasoline-powered cars like the rest of the industry. They continued to make cars, but their gas-powered models were never as popular as their steam engines. During World War I, the company began to make trucks for the military and domestic use. After the war, they quit making cars to concentrate on trucks. White also successfully diversified into the tractor and farm equipment market, using parts originally made for their trucks. Following World War I, they were selling 10 percent of all trucks purchased in the country.

The Great Depression took a heavy toll on the company, however. White was briefly forced to merge with Studebaker, and harsh new management following Walter White's death led to the formation of one of America's first automobile labor unions. The company was the subject of a strike in 1935, at which time new president Robert Black tried to repair labor relations. He even gave workers baseball equipment to play with on the picket line.

Black was a visionary when it came to business. During World War II, he led the company to become major producers of trucks for the military, employing the wives of men sent off to fight.

Following World War II, they became even more dominant, purchasing several other truck manufacturers, while keeping their headquarters in Cleveland. White even had a starring role in Hollywood: it's a White semi that James Cagney plans to steal from a California factory in the classic *White Heat*.

Eventually, decades of expensive mergers and poor management coupled with the 1970s recession took a toll on White. They tried to merge with their sister company, the nonunion White Consolidated Industries in 1970, but the deal was blocked by the federal government.

White filed for bankruptcy in 1980. All the White factories were bought by Sweden's AB Volvo in 1981, except the aging Cleveland plant. White sold this one separately in 1983 and White Motor Company was broken up in 1985 after a five-year bankruptcy process.

RIGHT *After World War I, White quit making cars to concentrate on trucks and farm equipment, as seen in its assembly room on East 79th Street and St. Clair Avenue.*

LEFT *An aerial view of the White Motor Company in the mid-20th century shows how much the factory dominated the residential area in which it was located.*

BELOW *The flag flew proudly on the White service building at East 79th Street and St. Clair Avenue in the 1970s.*

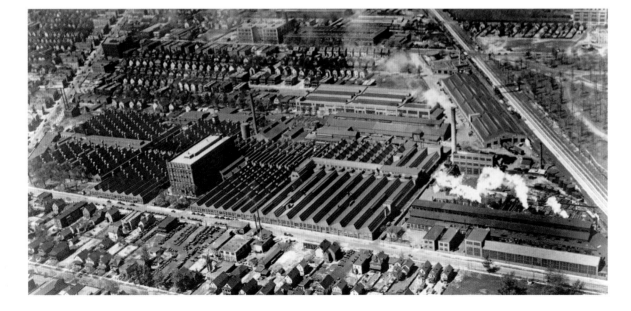

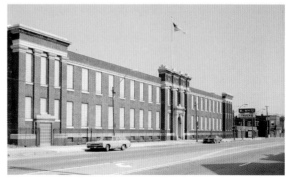

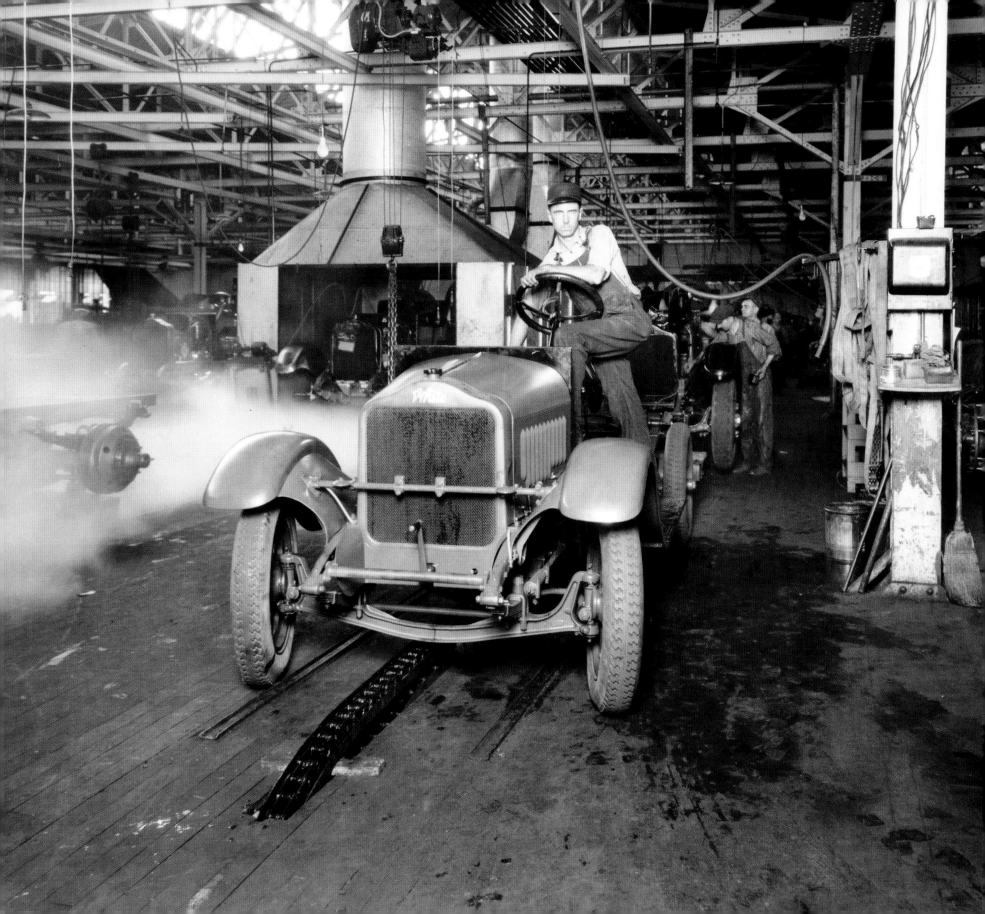

Clark Avenue Bridge DEMOLISHED 1980

There is an etching titled "Cleveland – Steel Mills seen from Clark Avenue Bridge, 1927" in the Cleveland Museum of Art by German-American artist Anton Schütz. Despite the plumes of smoke rising from the stacks, it is a happy, almost bucolic piece, in keeping with Schütz's portrayals of modern, progressive American cities. Beyond the bridge there are neat factory buildings, and trees and trains and a skyline. It is a painting of industry and progress and growth, and, very specifically— as the onion domes of St. Theodosius Russian Orthodox Cathedral and the skyscrapers beyond the factory attest—it is a painting of Cleveland: manufacturing and immigrants and a burgeoning downtown.

Schütz discovered what Clevelanders had known since 1916 when the Clark Avenue Bridge opened after four years of construction. There was no better view of the city, in all of its glory and its flaws, than from this epic steel-truss construction. Also called the Clark Pershing Bridge, it soared over the Cuyahoga River and industrial Flats, providing a panoramic view of Cleveland's industrial center.

But the Clark Avenue Bridge wasn't just built for looks. It was a bridge with a great purpose: connecting the east and west sides of town over the Cuyahoga Valley, and connecting the industry in the Flats with the city. The city began making plans for it as early as 1901, at the urging of south side citizens.

Considered the longest spanning bridge in the country at the time, it had a total length of 6,687 feet. It was made of 10,000 tons of structural steel; 100,000 tons of landfill; 35,000 yards of concrete; 31,000 square feet of concrete piles; 200,000 tons of wooden piles; and 700 tons of reinforcing bars. It was built in three sections. The west end connected Clark Avenue to West Third Street. In the middle, this joined a series of trusses over the B&O Railroad tracks next to Quigley Avenue. The east section, which went over the river, spanned from West Third Street to Pershing Avenue. The cost of the bridge was $1.5 million.

At the time of its opening, it was hailed for connecting the southwest and southeast sides of the city. "Long span over the Cuyahoga Valley will aid greatly in development of Flats and will fill long felt want of southside," proclaimed a

1916 *Plain Dealer* headline. The bridge, which had lanes for cars, trucks and streetcars, was considered especially beneficial for the growth of industry in Cleveland. "A greater development of the manufacturing district in the Cuyahoga Valley is expected to come with the completion of the bridge," noted the same article.

More than 60 years later, the same industry that the Clark Avenue Bridge helped spur was its downfall. Corrosive air pollution, too many layers of asphalt and the daily grind of gigantic tractor-trailers coming and going to the factories and mills took a heavy toll on the bridge by the 1970s. By that time, a trip across the bridge was literally a ride through the darkest, haziest days of polluted 1970s Cleveland. Schütz's inspiring view would have been completely obscured.

The crumbling bridge was closed by the city in 1978, deemed structurally unsound. It was mostly

demolished in 1980, though parts of it stood until 1985. Demolition wasn't easy, as the bridge crossed over gas and steam lines at Republic Steel and crews had to be very cautious not to set off an explosion. At first there was talk of building a new Clark Avenue Bridge, but high cost and the opening of the nearby I-490 bridge made that idea obsolete. The bridge's enormous supports still loom over Clark Avenue and Quigley Road, a monumental reminder of another era.

ABOVE *Cleveland in the 1970s was a dirty, polluted place, as this Environmental Protection Agency view of the Clark Avenue Bridge almost obscured by smoke makes clear.*

OPPOSITE *The Clark Avenue Bridge was closed in 1978 and demolished in 1980, after being deemed structurally unsound. Demolition was slow, as the bridge passed over gas and steam lines at Republic Steel.*

Warner and Swasey Observatory CLOSED 1980

There may be no more tragically beautiful ruin in the Cleveland area than this 1920 observatory once owned by Case Western Reserve University. Today covered in ivy and graffiti and strewn with broken glass atop an overgrown hill in the impoverished city of East Cleveland, the Warner and Swasey Observatory on Taylor Road was once a shining symbol of progress and technology.

The observatory was a gift to the university— then the Case School of Applied Science—from amateur astronomers Worcester Warner and Ambrose Swasey, who made its 9.5-inch refractor telescope at their factory on Carnegie Avenue at East 55th Street in 1894. The Taylor Road building was designed by Cleveland's prominent Walker and Weeks firm.

At the time of its opening it was considered a top-notch research and teaching facility, with stellar views to the heavens thanks to being 270 feet above the level of Lake Erie and far from the city lights. In 1941, it was outfitted in a second dome with an even more powerful 24-inch Burrell Schmidt telescope made by Warner and Swasey. A

library of astronomy and a public lecture hall were also added at the facility.

Many important studies were carried out at the Taylor Road observatory, including one that proved the Milky Way was a spiral galaxy. A star system named SS 433 was discovered by two Case Western astronomers from the facility in 1977. Scientists at the observatory also made important discoveries about red giant stars in the Milky Way.

By the 1950s, however, light pollution from the encroaching city meant the scientific telescopes were no longer reliable for research and the facility was moved 30 miles east to Geauga County. The East Cleveland location stayed open with a 36-inch telescope for the time being, used mostly for public viewing. In 1979, the Geauga facility was also closed, and the Burrell Schmidt telescope moved to Arizona. The college decided to close the Warner and Swasey Observatory for good in 1980, and the original refractor telescope was moved to Case Western Reserve University's campus in the city. The college finally sold the East Cleveland

building in 1983, to a cable television company that went out of business.

The observatory has sat empty since then, with the distinguished building gradually slipping further and further into decay. A group of local artists tried to save it in the early 2000s, to no avail. It was later purchased by a real estate developer who had plans to renovate and convert it into a private home in 2005. He went to jail for mortgage fraud before any progress could be made on the abandoned building. The original Warner and Swasey refracting telescope has fared better. Students and researchers can find it in a small dome atop Case Western Reserve University's Albert W. Smith Building, where it has sat, still in use, since 1986.

ABOVE *In 2016, the Warner and Swasey Observatory sat abandoned and covered in graffiti and ivy and strewn with broken glass and debris.*

LEFT *In 1941, the Warner and Swasey Observatory was outfitted with its second dome, a more powerful telescope and a public lecture hall.*

RIGHT *Two years before it closed for good, the Warner and Swasey Observatory in East Cleveland was already looking neglected in 1978—though it still had working telescopes.*

Cowell and Hubbard Company CLOSED 1981

For more than a century, Cowell and Hubbard was the jewelry store Clevelanders went to when they were shopping to impress. Engagement rings, wedding gifts, fine watches and finer china were among the upscale offerings at the downtown store. Though Cowell and Hubbard had several locations, their most fondly remembered building opened in the theater district on Euclid Avenue in 1920.

The famed store had its roots all the way back in 1861, when George Cowell and his son Herbert opened a silversmith shop at the intersection of Superior Avenue and Bank Street (now West Sixth). Named H. Cowell & Co., they were known for their jewelry, clocks and watches in addition to silver. In 1879, the firm became Cowell and Hubbard when jewelry salesman Addison T. Hubbard joined. By that time, though, the "Cowell" of the title referred to George's son Samuel; both George and Herbert had passed away.

Hubbard eventually convinced Cowell that they needed to expand the store that was flourishing as Cleveland grew. In 1894, Cowell and Hubbard moved to the new Garfield Building on Euclid Avenue and Bond Street (now East Sixth). "The Garfield Building on Euclid Ave., at the corner of Bond Street, is an earnest reminder of Greater Cleveland, but still more so is the earnest and spacious jewelry and art emporium that was opened to the public yesterday by Cowell & Hubbard Co.," said the *Plain Dealer* newspaper of its opening. "Its reputation will extend as to possessing the finest retail jewelry store west of New York City." Indeed, Cowell and Hubbard was eventually named the sole Cleveland-area representative for Tiffany & Co.

Soon, even the Garfield Building space wasn't sufficient for the growing business. In 1920, Cowell and Hubbard opened the luxurious space that would become synonymous with their name at 1305 Euclid Avenue, in the Playhouse Square area. They employed 75 people at the time of opening. "Nowhere, in either America or Europe, will the public find a more beautiful, harmonious place to purchase fine jewelry or rich cut glass," read an advertisement at the time. They also began to sell office furniture and business equipment. Other ads from 1920 promoted their sterling silver flatware, ice cream sets in sterling, English and French china and

dinner gongs. The opening reception of the Cowell and Hubbard building was said to have exhausted the city's flower supply. Cowell and Hubbard occupied the large main floor, which was divided into departments. Extravagant window displays of silver and crystal and rings and necklaces wooed passers-by on the street. The jewelers also leased space in the building to sellers of ladies' shoes, furniture and other vendors.

The company flourished on Euclid Avenue for another four decades. But as downtown declined, Cowell and Hubbard was sold just a few years after their centennial to Philadelphia's Bailey, Banks & Biddle, in 1964. The Zale chain purchased Bailey, Banks & Biddle just a few years later. In 1981, declining sales and crime in the largely deserted theater area led them to close the downtown landmark—120 years after its founding. But the Cowell and Hubbard name lives on. Famed Cleveland chef Zack Bruell took over the space at 1305 Euclid Avenue in 2012 and opened a fine dining restaurant that pays homage to its predecessor with the same name.

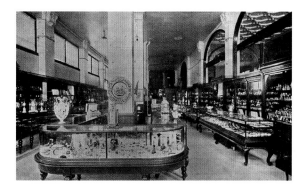

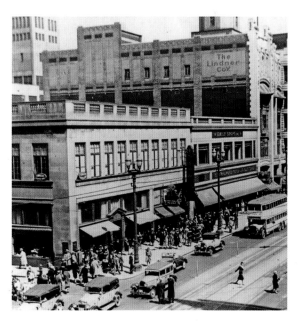

ABOVE LEFT *By 1964, the area around Cowell and Hubbard on Euclid Avenue was already in decline.*

TOP *The jewelry department of the Cowell and Hubbard location in the Garfield Building was filled with expensive treasures.*

ABOVE *In 1929, the area around Cowell and Hubbard on East 13th Street and Euclid Avenue was filled with well-dressed shoppers out for a day in the city.*

OPPOSITE *Cowell and Hubbard's elegant space in the Playhouse Square area, seen here in 1922, was the epitome of upscale shopping in Cleveland.*

Hippodrome Theater DEMOLISHED 1981

"They paved paradise and put up a parking lot…" The cogent words of Joni Mitchell's 1970 classic "Big Yellow Taxi" could easily be used to describe the loss of Cleveland's Hippodrome Theater. Said to be the most beautiful of all Euclid Avenue venues, this theatrical paradise was demolished in 1981 for, yes, a parking lot. There are few sadder chapters in Cleveland cultural history.

Opened in 1907 at 720 Euclid Avenue in an 11-story office building, the 3,500-seat Hippodrome was designed by Cleveland architect John Elliot, who also designed the Engineers Building near Public Square. At the time of its opening, it was the second-largest stage in the United States, after the Hippodrome in New York. The enormous auditorium had two balconies, luxury boxes on the side and an elevator. The stage was large enough to host opera, ballet and vaudeville shows. The Hipp was known for its excellent acoustics and luxurious interior. The ornate proscenium extended 45 feet beyond the stage, acting as a megaphone and dazzling with gold geometric and floral ornamentation that ran throughout the building. Grand crystal chandeliers provided lighting. The theater was so big that there were marquees and box offices on both Prospect and Euclid avenues. It cost $800,000 to build.

But the Hipp dazzled with more than size. Equipped with hydraulic jacks that could lift the stage to four different levels, the theater could even feature water shows in an 80-by-40-by-10-foot, 455,000-gallon water tank. Opening night featured a spectacle to end all spectacles, with horses jumping off the second-floor balcony into tanks during the musical *Coaching Days*. Fortunately, there were stables for animals among the 44 private dressing rooms in the theater—ones that included treadmills for horses.

Only slightly less spectacular were shows by greats of the era such as Al Jolson, Enrico Caruso, Sarah Bernhardt, W.C. Fields, the Russian Ballet and New York's Metropolitan Opera.

The basement area featured a restaurant, so theatergoers could make a night of it. One of Cleveland's first Chinese restaurants, the New Nanking, took over the 13,000-square-foot space previously occupied by the Russet Cafeteria in 1948.

As talkies became popular, the Hipp was renovated in 1931 by the RKO movie studio. The changes included making the stage smaller and adding a mezzanine. Seating reached 4,000, making it the largest first-run theater in the country. Just two years after the renovation, the owners, hard hit by the Great Depression, were forced to sell to Warner Bros. In 1951, the theater was acquired by the Telenews chain. The Hipp remained a movie theater for the next four decades. Their biggest seller ever was the 1964 James Bond movie *Goldfinger*, which earned $50,000 in a single week; ticket prices were just $1.50 for adults, 50 cents for kids.

Gradually, as the area around the theater slid into seediness, the Hipp went from first-run releases to a second-run grind house. By the time the Hippodrome closed in 1980, the air-conditioning was broken and hadn't been fixed, and bent springs were sticking out from the seats. It was the last major movie house downtown.

Despite its rich pedigree, there was no Hollywood ending for the Hippodrome. The theater and office building were acquired by federal judge and real estate investor Alvin I. Krenzler in 1972. In 1981, the once glorious Hippodrome was demolished to make way for a parking lot.

RIGHT *In 1924, the Hippodrome was known as the most luxurious theater in Cleveland. Al Jolson, Enrico Caruso and Sarah Bernhardt were among the stars to grace the gilded stage.*

BELOW LEFT *The Hippodrome stage was large enough to host opera, ballet and vaudeville shows. The ornate proscenium extended 45 feet beyond the stage, enhancing the theater's excellent acoustics.*

BELOW MIDDLE *Alfred Hitchcock's* Strangers on a Train *headlined the Hipp in 1951. It had been converted into a movie theater in 1931.*

BELOW *The sex-farce* Candy *topped the bill in 1968. Though downtown Cleveland was already in decline, Euclid Avenue was still busy with shoppers and theatergoers. Next to the theater, a Richman Brothers' store can be seen.*

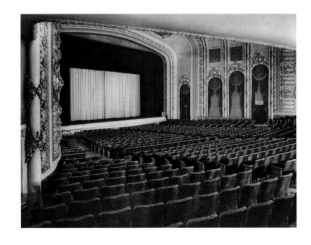

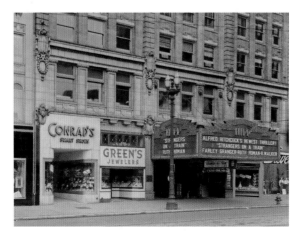

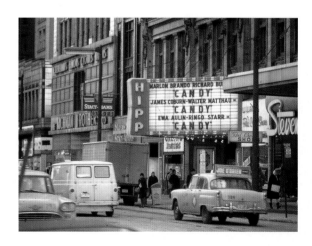

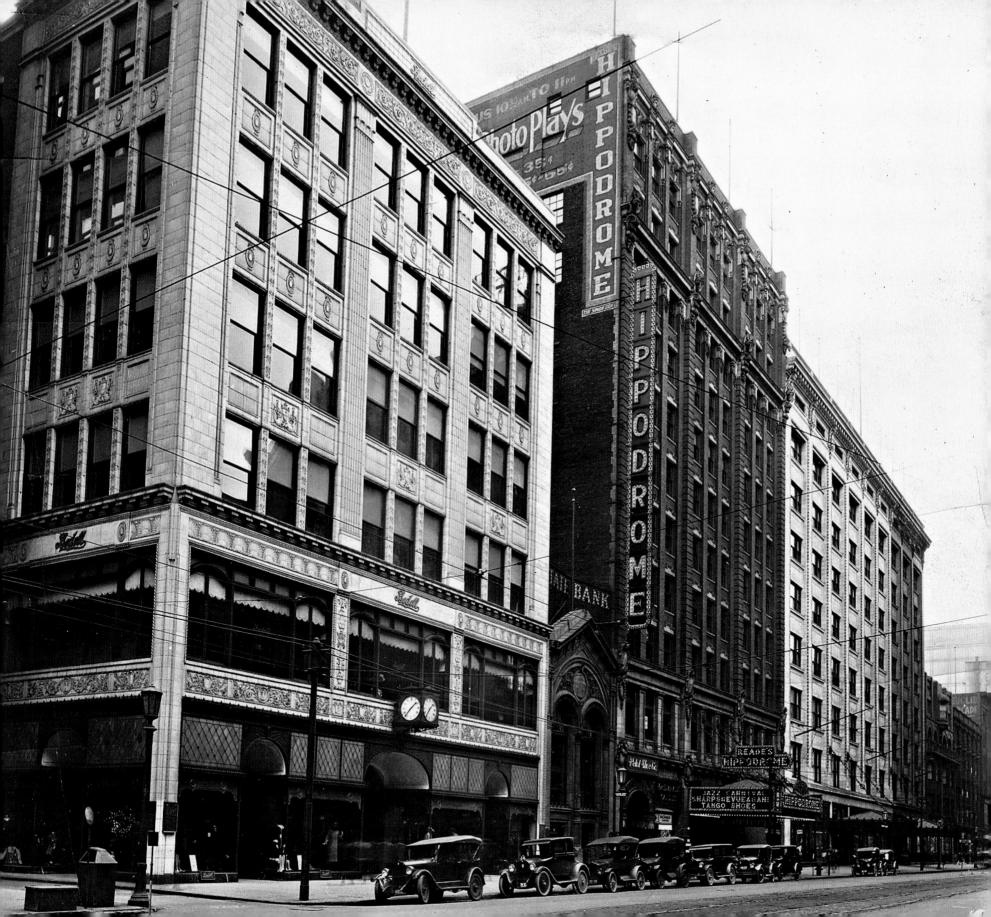

Cuyahoga and Williamson Buildings

DEMOLISHED 1982

It was a double whammy of the worst sort when two of Cleveland's most famous Public Square buildings were demolished in 1982 to make room for the Sohio skyscraper.

The older of the two, the Cuyahoga Building, was an architectural gem on the eastern quadrant between Euclid and Superior avenues. It had entrances on both the square and Superior. It was designed by the renowned Burnham & Root firm of Chicago in the Chicago-skyscraper style, one of three buildings in Cleveland by the legendary firm (along with the Society for Savings and Western Reserve buildings). The eight-story structure constructed in 1892–93 was the first steel-framed building in Cleveland. The exterior was terracotta, with intricate stone and metal archways.

The Cuyahoga's tenants were almost as famous as the building itself. Mayor Tom L. Johnson had an office in the building for a while, as did the Cleveland Illuminating Company. The lower level was home to Schroeder's Bookstore, one of the city's most famous literary haunts. It closed in 1979 after 71 years in business.

The Williamson Building was erected a few years later, from 1899 to 1900. Even taller than the Cuyahoga, this skyscraper stood 17 stories. Built on the site of the former Samuel Williamson homestead, it was the second Williamson Building.

The first burned down in 1895. The Williamson skyscraper was designed by New York's George B. Post and Sons, who also designed the Cleveland Trust rotunda and the Statler Hotel.

Once the gateway for Euclid Avenue, the grand, Neoclassical structure next to the Cuyahoga Building had marble floors and walls, an immense arched entrance and bronze elevator doors. It was the tallest building in the city when constructed. The steel frame was covered in light-colored brick and terracotta, and featured multiple storefronts at street level, the most famous being Cunningham Drugs. The interiors were done in Italian marble and mahogany. At some point later, the arches were changed for more modern, rectangular doorways.

Like the Cuyahoga, the Williamson Building had many high-profile tenants, including the Cleveland Stock Exchange, Federal Reserve Bank of Cleveland and the Cleveland Trust Company. Safety deposit boxes and vaults were located under street level for security.

In 1944, the Williamson Company purchased the Cuyahoga Building, and the structures were joined through an arcade connecting the lobbies on the ground level, designed by Walker and Weeks.

Just as they lived together, the Cuyahoga and Williamson buildings died together. Considered dated by the 1980s, two of the city's most architecturally significant buildings were demolished in 1982 to make room for the rather nondescript Sohio Building, which had become the British Petroleum Building by 1987, and the Huntington Bank Building by 2011. The dramatic demolition was shown live on local TV.

OPPOSITE *Public Square was dominated by the towering Williamson Building, center right, and Cuyahoga Building, center left, in the early 1900s.*

BELOW LEFT *The Cuyahoga Building was designed by Chicago's famed Burnham & Root firm.*

BELOW MIDDLE *The Williamson Building, opened in 1900, was considered the gateway to Euclid Avenue.*

BELOW *The 1982 joint demolition of the Cuyahoga and Williamson buildings was broadcast on all of the local Cleveland TV channels.*

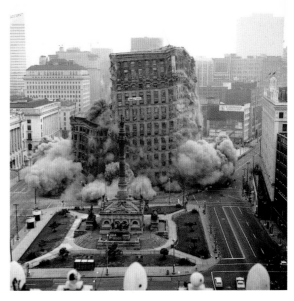

Variety Theatre CLOSED 1984

Thanksgiving 1927 was a dramatic day on the west side of Cleveland. The holiday marked the opening of what would become one of the most beloved theaters in local history: the Variety Theatre at West 118th Street and Lorain Avenue.

The gala opening featured a screening of Clara Bow's *Hula* and "vaudeville divertissements" that were "New York-approved" according to advertisements. The silent film was accompanied by guest organist Edward Benedict and "the Variety's very own Harold Krell." *Hula* was followed by Dolores Del Rio's *The Loves of Carmen*.

Silent films and vaudeville acts took center stage in the Spanish Gothic theater designed by Cleveland architect Nicola Petti, who also designed the Cedar Lee Theatre in Cleveland Heights. With 1,900 seats, the Variety was the largest theater on the west side when it opened, featuring 1,550 seats on the lower level, and 350 in the small balcony. The walls were decorated with ornate plaster designs and glass prisms. An 8-by-9-foot Belgian chandelier and silk Chinese lanterns provided the lighting. Chairs were made by the American Seating Company and had carved end caps unique to the Variety. The luxurious theater cost $500,000 to build, including 10 storefront spaces on Lorain Avenue and 14 apartments.

The popular venue was originally run by the Variety Amusement Company, but was sold to Warner Bros. in 1929. The entertainment giant ran the Variety until 1954, when Wargo Realty bought if for $500,000. Community Circuit Theaters Co. ran the theater until 1976, when it was purchased by Russell Koz who oversaw the Variety until it closed.

The Variety's zenith may have been the 1950s and '60s, when Sunday afternoon matinees filled the auditorium with thousands of neighborhood children for screenings of *Sleeping Beauty*, *Old Yeller* and other family classics. All on the ground floor, though—kids weren't allowed in the balcony.

The Variety lost some of its luster by the 1970s and '80s, but it was no less busy. It became a second-run theater showing everything from the filmed-in-Cleveland *The Deer Hunter* to midnight cult films.

The once luxurious venue was also briefly used for amateur wrestling in this era, dubbed the "Wrestleplex."

Eventually, the Variety's projector booth went dark and owner Russell Koz turned the aging space into a concert club for metal and punk bands. Slayer, X, R.E.M., the Dead Kennedys and Motörhead all headlined the club in the early '80s. It was the British headbangers who got the venue shut down with a court order after a plaster- and neighbor-rattling show in 1984. The theater that opened with Clara Bow was closed by Lemmy.

The doors were locked and the Variety sat mostly untouched for the next three decades—the seats and lanterns and plasterwork decaying in place as years passed and water began to seep through the roof. Eventually, the electricity and water were shut off, and the Variety became nothing more than a musty, dust-covered time capsule of peeling paint and broken plaster. The apartments and storefronts were abandoned, too. The projection equipment made by Cleveland's Peerless company still sits in the crumbling booth.

Only now instead of showing films, the Variety is more often on film. It has become a popular subject for Midwestern "ruin" photography.

RIGHT *By 1976, the Variety Theatre had seen better days. The once elegant belle of the west side was showing mostly second-run films, and empty stores lined the front.*

BELOW LEFT *Tickets to Led Zeppelin's* The Song Remains the Same *were $2 at the Variety in 1976.*

BELOW MIDDLE *The Variety has become a popular destination for "ruin" photography. The Friends of the Historic Variety Theatre, who own the building, are hoping to raise awareness and funds to one day restore the theater.*

BELOW The Deer Hunter, *filmed in Cleveland, played at the Variety in 1979.*

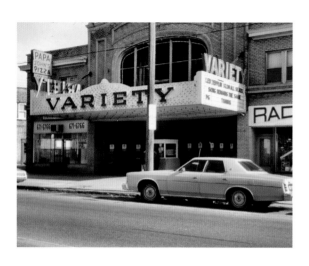

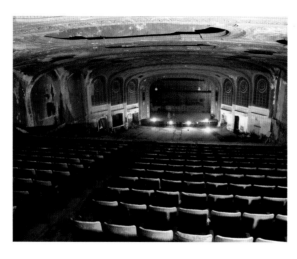

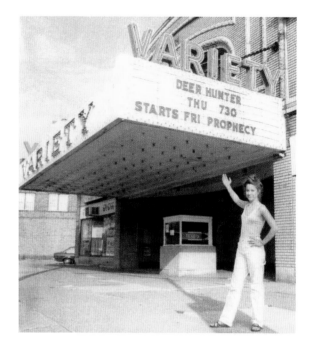

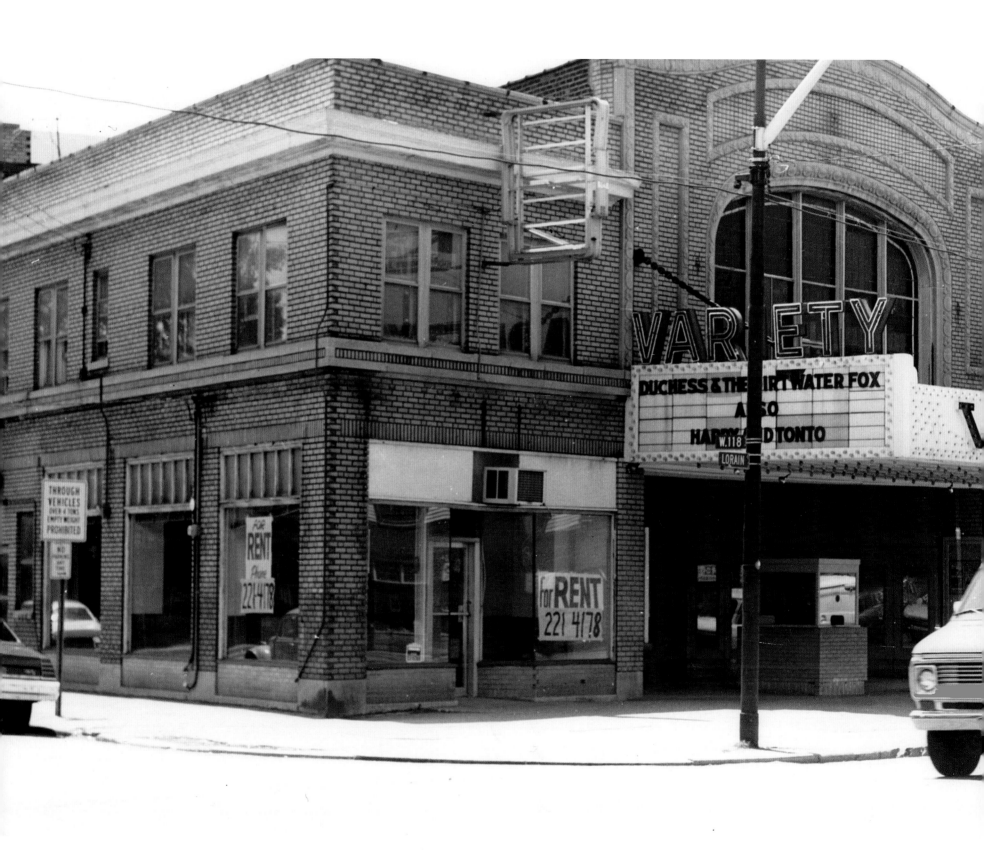

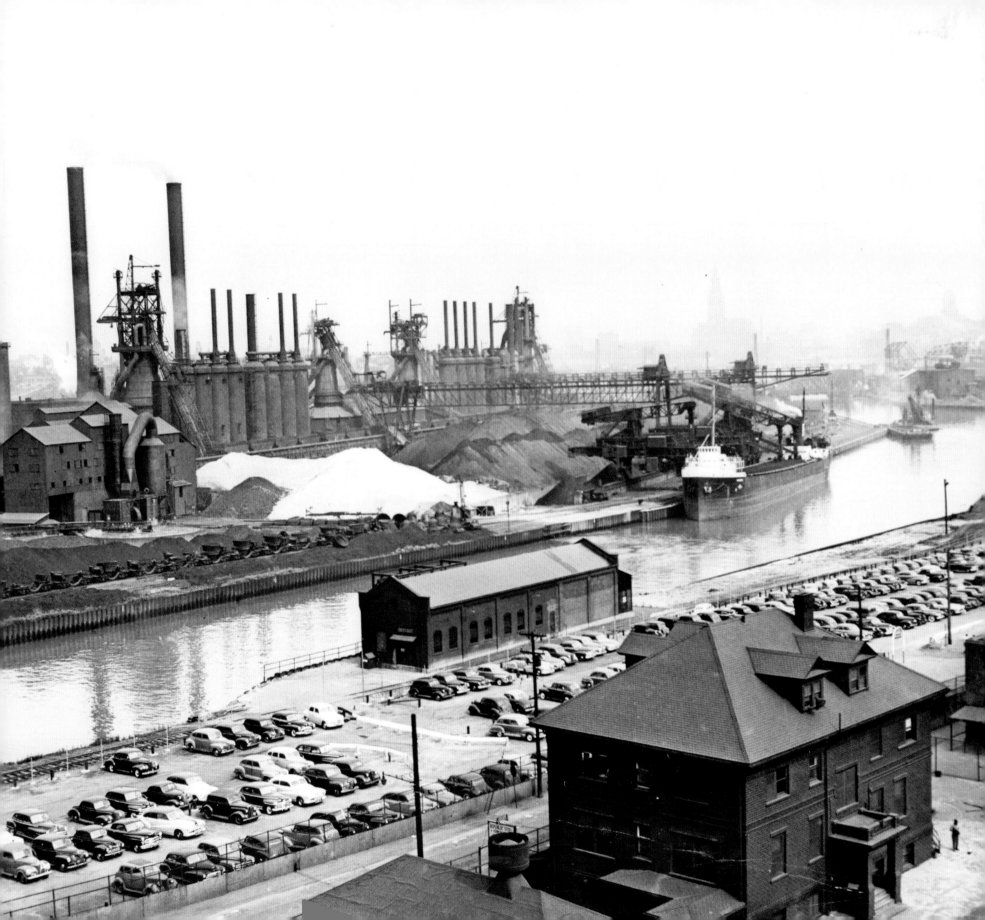

Republic Steel SOLD 1984

"**It was the** best of times, it was the worst of times…" Charles Dickens' words could easily apply to the era of Republic Steel in Cleveland.

The company founded in Youngstown in 1899 was headquartered in Cleveland since 1927, when it was taken over by Cleveland financier Cyrus Eaton with the goal of competing against the larger U.S. Steel. The earliest incarnation of the company in Cleveland was an amalgamation of Youngstown's Republic Iron & Steel Co., Cleveland's Steel & Tubes, Inc. and the Bourne-Fuller Company. Republic quickly established itself as the third largest steel producer in the country.

The impact on Cleveland was profound. The newly formed company was responsible for luring thousands of immigrant and Appalachian laborers to the city in the first half of the century. By 1935, through the acquisition of several smaller firms, Republic had three plants in the city: the Upson Nut Division on Carter Road, the Steel & Tubes Division on East 131st Street and the buildings most people think of when they hear Republic Steel, the Corrigan-McKinney strip mill, blast furnaces and steel works at 3100 East 45th Street in the Slavic Village area. Even today, this massive structure constructed in 1917 is a daily reminder of Cleveland's industrial past for Clevelanders passing by on Interstate 77 toward downtown.

Republic provided laborers with steady, if tough, jobs, and contributed to the build-up of neighborhoods such as Tremont and Slavic Village around the factories.

America's third largest steel corporation was also the subject of much labor unrest, however, especially in the 1930s. The anti-union corporation was the target of the Little Steel Strike of 1937, during which Cleveland Mayor Harold Burton and Sheriff Martin O'Donnell declared military rule and ordered the mills be protected from strikers by the National Guard. There were violent confrontations at Republic's Corrigan-McKinney plant and two Clevelanders died before the strikers returned to work.

It wasn't until World War II that the company was finally unionized—because Republic wanted government contracts. When the CIO union formed at the company in 1942, there were a remarkable 9,000 employees in Cleveland.

In the good times, Republic's mills ran 24 hours a day, seven days a week with three shifts. Workers could support a family, buy a house in the suburbs and even save a little—in short, they could live the American Dream, built on steel.

But by the 1970s, Republic Steel's decline mirrored that of companies throughout the rust belt. It just couldn't compete with cheap foreign steel imports and was forced to merge with LTV and the Jones and Laughlin Steel Corp. in 1984. Thousands of workers lost their jobs nationwide.

Nationally, a small part of Republic Steel lives on. In 1989, an employee stock ownership plan bought LTV's steel bar division and renamed it Republic Engineered Steel, or RES. In 2011, RES became a second, much smaller incarnation of Republic Steel. There are no locations in Cleveland, the city Republic helped build.

ABOVE *Six finishing stands on Republic Steel's continuous hot strip mill, erected in 1937.*

LEFT *The former Republic Steel offices at 3100 East 45th Street. Highly visible from I-77 today, the building has had a "For Rent" sign for years.*

OPPOSITE *In 1947, these four blast furnaces at Republic's plant in the Slavic Village area worked round the clock.*

Record Rendezvous CLOSED 1987

Hail, hail the birthplace of rock 'n' roll: Record Rendezvous. This landmark record store, opened in the shadow of the Terminal Tower on Prospect Avenue in 1938 by Cleveland businessman Leo Mintz, had a headlining role in the history of popular music.

Mintz, the assistant manager of an army surplus store, had the smart idea to open his store on the edge of the black and white areas of Cleveland. This way, he could sell records to both groups. He started off selling jukebox 45s for a nickel or dime. He was one of the first store owners to put his records in open display bins, so customers could page through them, not have to ask at the counter for a title. "The Vous," as it came to be known, was also one of the first record stores to feature listening booths and host in-store artist promotions.

Mintz started off selling jazz and big band records, but by the late 1940s he had broadened his bins to include R&B. He began to notice more and more white patrons dancing to the records—then called "race records"—in the aisles. But they weren't buying. Mintz set out to make the music more mainstream. In 1949, he convinced a then little-known DJ named Alan Freed to play these "race records" on his radio show at WAKR-AM in Akron. In 1951, Record Rendezvous began to sponsor Freed's radio show on WJW-AM in Cleveland. It was called the "Moon Dog House Party" after a blues record Mintz brought to the studio. "The Vous" went on to become the sponsor of the Moondog Coronation Ball on March 21, 1952 at the Cleveland Arena—the first rock concert in history.

Though Freed popularized the term on his show, it was Mintz who began to call these records "rock 'n' roll" in his store, after an old blues music slang for sex, coining a term for the music that transformed the 20th century.

Record Rendezvous' key role in the birth of rock 'n' roll made it the most popular music shop in town. By the 1960s, Mintz had expanded to five stores, including one at the new Richmond Mall; still, it was the flagship at 300 Prospect Avenue that was considered best. Suburban teens would take the bus downtown, mingling and browsing with kids from the neighborhood, checking out 45s and comparing favorites in the store that was

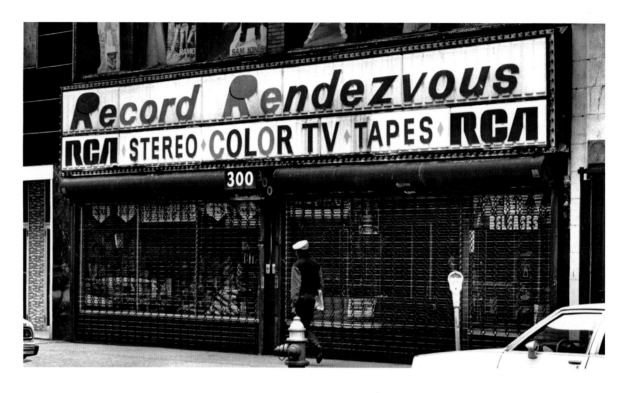

always packed wall-to-wall. Behind the colorful records painted on the glass facade, the store was a rendezvous of varied cultures and people, just like rock 'n' roll itself.

Mintz died in 1976, but his store on Prospect lived on until 1987, selling everything from gospel to punk rock. True to its roots, it remained a space where black and white music fans could meet, mingle and learn about new music. The trend-setting shop played a key role in the popularity of punk rock in Cleveland, too, in no small part thanks to having Pere Ubu guitarist Jim Jones on staff.

Though it played such a significant part in Cleveland's claim to the Rock and Roll Hall of Fame and Museum, the property at 300 Prospect Avenue has sat vacant and derelict for years—without even a placard or sign.

TOP *The birthplace of the term "rock 'n' roll" kept rocking on Prospect Avenue until 1987.*

ABOVE *Record Rendezvous was one of the first stores in the nation to feature listening booths so patrons could spin their 45s before buying.*

RIGHT *Located downtown on Prospect Avenue, Record Rendezvous was one of the few stores in town where black and white patrons mingled in 1940s and '50s Cleveland.*

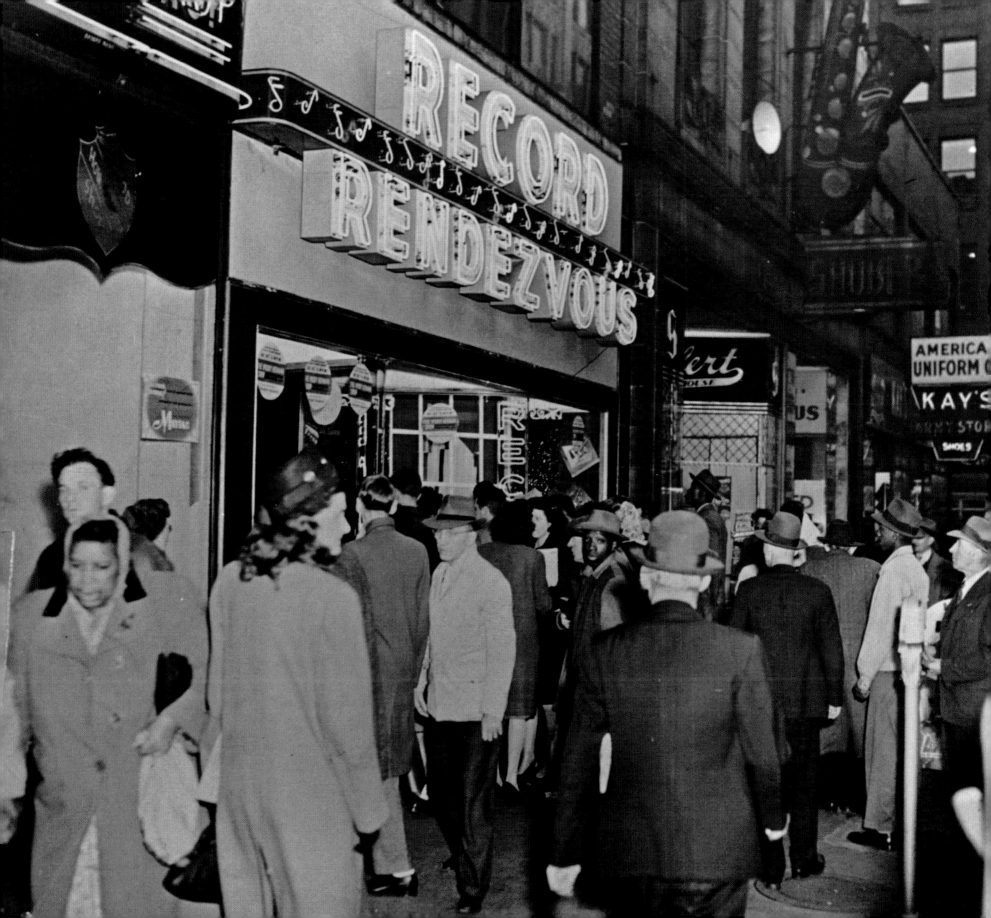

Engineers Building DEMOLISHED 1989

Founded during the Civil War in 1863, the Brotherhood of Locomotive Engineers is the United States' oldest trade union. It's a union that has made quite an imprint on Cleveland. Though first organized in the Detroit area, the headquarters were established in the industrial powerhouse on Lake Erie in 1869. It was in this city where the Brotherhood became the first union in America to build its own office building, the Engineers Building at St. Clair Avenue and Ontario Street.

For nearly three decades, the group had rented space in various downtown office buildings. But by the early 1900s, the Brotherhood was growing in numbers and power and decided to invest in a building of its own.

The epic Engineers Building opened in 1910 at 1365 Ontario Street. It was designed by the Cleveland architectural firm of Knox and Elliot, best known for the 1905-built Rockefeller building, still standing, and the 1907-built Hippodrome Theater, demolished in 1981. Unlike most of the buildings of the day, which were done in the popular Beaux-Arts and Neoclassical styles, Chicago-educated Wilm Knox and John Elliot were known for their devotion to Louis Sullivan's simpler "form follows function" style. Their high-rise steel buildings were tall and slender, with simple ornamentation.

The Engineers Building took one year and cost $1.4 million to complete. The 14-story steel building was crafted in unique U-shape, giving every office a window. The Ontario and St. Clair sides were covered in cream-colored terracotta, with friezes of classical heads. Elements around the doors and the flat roof were simple, mostly leaves and geometric forms.

Elevators and heating vents were covered in wrought-iron designs, while vined and floral plasterwork decorated the ceiling. A 1,250-seat auditorium was built for union events, with elaborate motifs of vines and shells on the proscenium. In later years, the elegant stage would garner attention for hosting punk and metal shows including an infamous 1982 concert by punk legends the Dead Kennedys.

In 1937, a 100-foot-long, 12-panel mural of the history of locomotion was added to the building. Tracing the journey from the Baltimore & Ohio's 1829 steam engine to the sleek streamliners of the

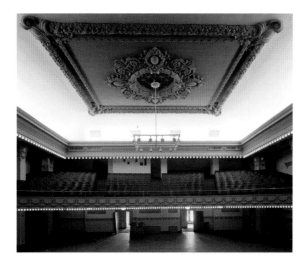

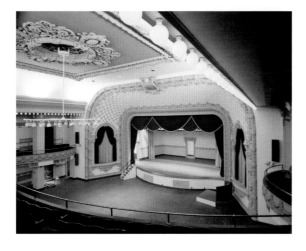

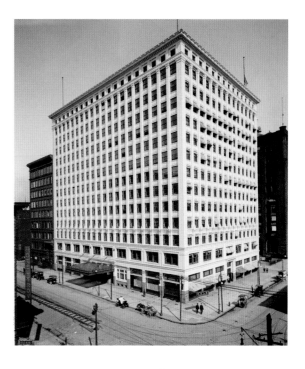

ABOVE *The Brotherhood of Locomotive Engineers, at St. Clair Avenue and Ontario Street near Public Square, was the first union in America to build its own building.*

LEFT / LEFT ABOVE *Inside the Engineers Building there was a 1,250-seat auditorium. It started out as a venue for union events, and ended as a hall for rock concerts.*

OPPOSITE *The Brotherhood of Locomotive Engineers Building at 1365 Ontario Street in 1989, the year it was demolished.*

1930s, it traveled across the tops of the marble and masonry walls.

Over its first few decades, the Brotherhood flourished, even hiring Knox and Elliot to build a second building across the street at 1370 Ontario Street. The Brotherhood of Locomotive Engineers Cooperative National Bank Building was completed in 1925 at a cost of $7 million. The Great Depression hit the union hard, though, and the bank closed. Its second building became known as the Standard Building, though the union retained ownership.

The Brotherhood also retained ownership of the Engineers Building until 1988, when the union sold it for $15 million to make way for the Marriott Society Center Hotel. Though it had been declared a Cleveland landmark in 1977, the Engineers Building was razed in 1989 after a study showing it could not be converted into a hotel. The Brotherhood moved its offices to the Standard Building that same year. The union worked out of that space until it sold the 21-story building for just $3.9 million in 2014, leaving downtown for the Cleveland suburbs for the first time in its history.

Standard Theatre CLOSED 1989

Cleveland's Standard Theatre embodied the sublime, the ridiculous, the tawdry and tragic during its eight decades on Prospect Avenue.

The once glamorous Standard opened in 1914 as a 700-seat family movie theater showing silent films with the accompaniment of a Wurlitzer organ. The first film was D.W. Griffith's *Home Sweet Home*. The audience included a contingent of Spanish-American War veterans.

The theater was located inside the 1905-built five-story P.C. O'Brien Building at 801 Prospect Avenue. The pressed brown brick commercial-style building was designed by Adolphus E. Sprackling, who was also the architect of the Hotel Euclid and the Anthony E. Carlin mansion on Millionaires' Row. (He was perhaps best known for being the victim of a sensational murder by a relative "in a row over how to cut salami" in 1934, however.) Over the years, tenants included everyone from luggage stores to the Ohio Communist Party and Newsboys' Protective Association.

The theater was designed by Cleveland engineer Myron Bond Vorce, and was located at the rear of the building. Commissioned by the Standard Drug Company, it included a mezzanine and lobby with crown molding festooned with fruit and ribbons. The relatively simple theater had a flat-arch proscenium with a large "S" in the center. Art Moderne-style seats were added in the 1930s.

The Standard was open from 9 a.m. to 10:45 p.m. daily, with Wurlitzer music at all showings, which were preceded by Keystone comedies in its early years. The Standard continued as a first-run theater for several decades. Sound was installed in 1930.

As residents fled to the suburbs in the 1950s and '60s, the Standard's popularity declined. By the 1960s it had devolved into a hard-core X-rated grindhouse. *Plain Dealer* movie critic Emerson Batdorff lamented the once grand theater's decline, calling it a place "where steamy sex holds sway in cheapies that keep the place filled with men sitting in checkerboard pattern." Where Mary Pickford once swooned, *Marital Fufillment* now brought in a mostly male crowd.

In the early 1980s, the Standard briefly closed, only to reopen as an "action" theater showing kung-fu and karate movies. Even these flicks couldn't kick new life into the Standard. It closed for good in 1989.

Though structurally sound and listed on the National Register of Historic Places, the P.C. O'Brien Building's last tenant left in 1995. It was demolished later that year—but not without an outcry in Cleveland. The building was owned by retired federal judge Alvin I. Krenzler, who tore it down to make the lot more palatable to potential buyers in the growing Gateway area. Krenzler, who also demolished the luxurious Hippodrome on Euclid Avenue in 1981, eventually built his own building on the site in 1997. It stood unoccupied until 2014.

ABOVE *The ornate wood and plasterwork in the P.C. O'Brien Building remained unchanged by time, even in the year of its demolition.*

LEFT *In its later years, the Standard Theatre had become an X-rated grindhouse, where "steamy sex holds sway," as one local reporter wrote.*

RIGHT *The Standard Theatre and P.C. O'Brien Building had declined to a sad state of neglect by the time the theater closed in 1989. The building itself closed in 1995, the same year it was demolished.*

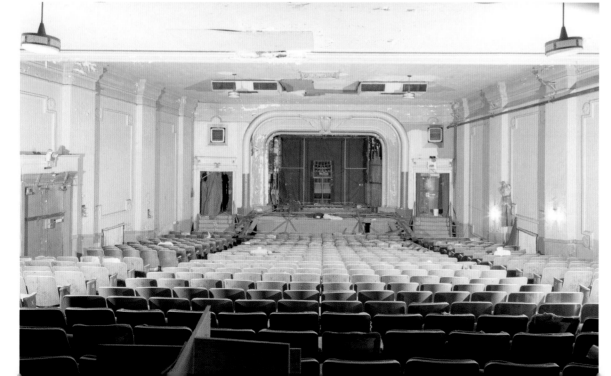

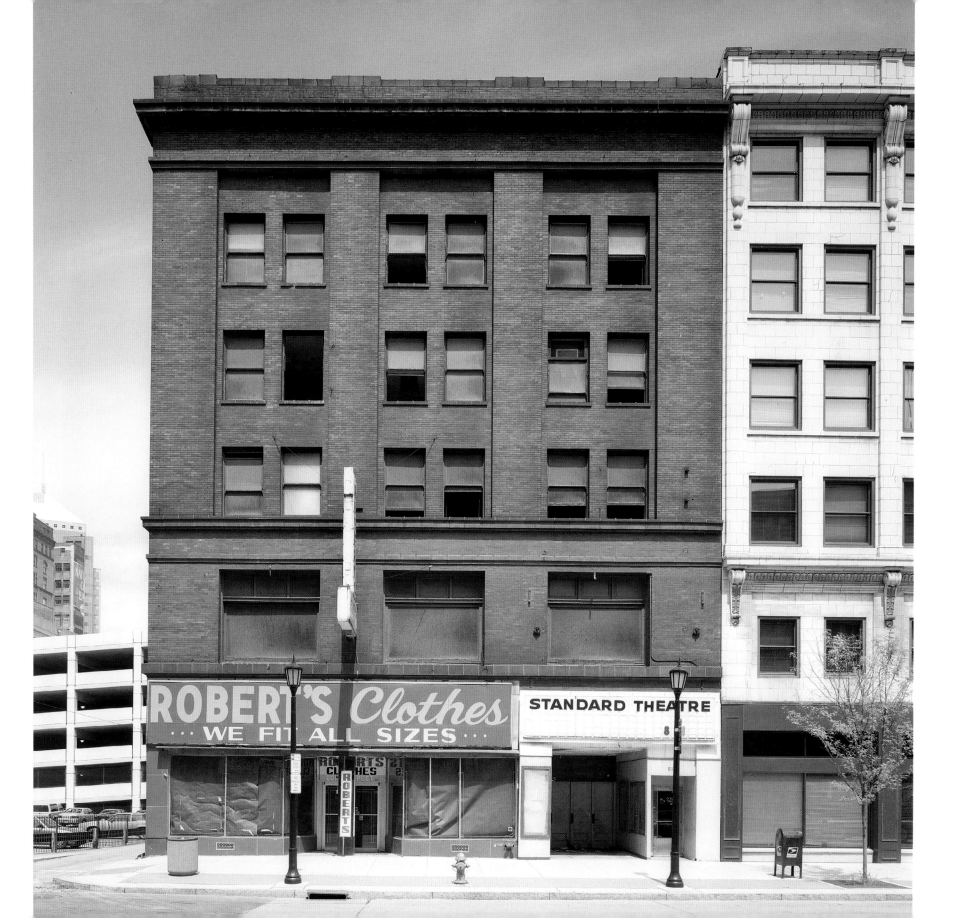

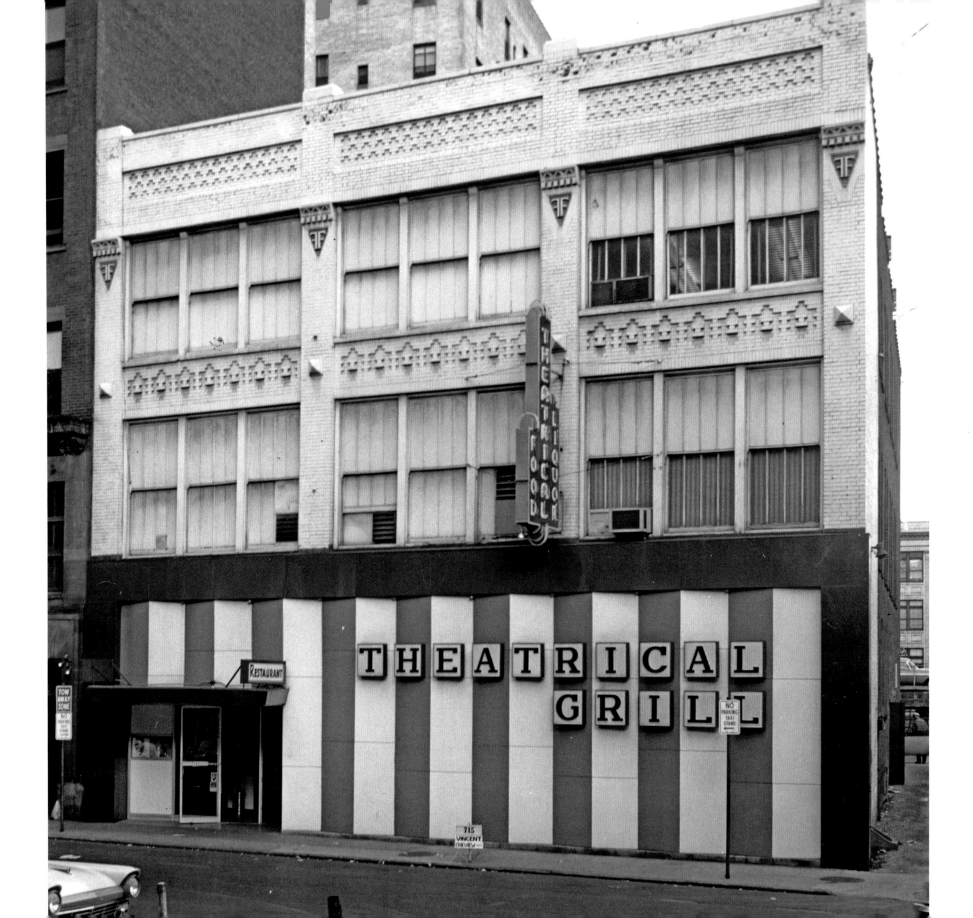

The Theatrical Grill SOLD 1992

Opened in 1937 on Short Vincent, the swanky Theatrical Grill hosted some of the biggest names of the day—including Frank Sinatra, Dean Martin, Oscar Peterson, Dizzy Gillespie, Milton Berle and Judy Garland. But it wasn't the names on stage that etched this legendary nightspot into the city's collective memory. It was the names of those who frequented the club opened in the late 1930s by Morris "Mushy" Wexler, a larger-than-life character who had made it rich by running the Empire News Service—a betting service for bookies.

Mobsters, lawyers, cops, athletes, union leaders, FBI agents and politicians all met and mingled at Wexler's restaurant, drawn by the colorful owner, a "no questions asked" atmosphere and the Lobster Romano and Chateaubriand served by tuxedoed waiters.

Marilyn Monroe was said to frequent the Theatrical when in town, as was Arthur Miller. It was also said to be the bar where the Yankees' Joe DiMaggio drowned his sorrows after the Indians stopped his 56-game hitting streak in 1941.

Perhaps the two biggest Cleveland names to grace the Theatrical were notorious mobster Alex "Shondor" Birns and Irish-American gangster Danny Greene. Birns, a partner with Wexler in the club's early years, used the locale as his personal and professional headquarters—holding court at the first table to the left in the stylish three-floor restaurant. He was known to lunch almost daily in the club that had a strict dress code in its early decades (only Cleveland Indians owner Bill Veeck got away without wearing a tie). Greene was also a regular at the bar, which was re-created for the 2011 biopic about his life, *Kill the Irishman*.

Italian mob don Jack Licavoli hung out at the Theatrical, too, even though he never drank. The Theatrical was a place to see, be seen and keep your ears open as much as it was a place to toss back a shot. Though Greene and Birns were both killed in car bombings in the mob wars of the late 1970s that earned Cleveland the reputation of Bomb City USA, there were no problems between the factions at the Theatrical. In was known as the Switzerland of Cleveland.

The Theatrical did have a problem in 1960 though, when the smart club burned to the ground in a mysterious fire. It cost Wexler $1 million to rebuild, but rebuild he did. The Theatrical reopened in 1961 with a swinging '60s vibe, including a low circular bar surrounded by bottlecap stools and pale leather semi-circular booths. The marquee had a jaunty, carnivalesque feel.

Nights to remember include the time in 1975 when an inebriated man drove his car through the front door and proceeded to get out and walk to the bar to order a drink. In 1961, Art Modell sealed a deal to buy the Cleveland Browns at the club—a seminal night in Cleveland history. And in 1972, former Cleveland Indians owner Nick Mileti celebrated in the Theatrical after saving the team from moving to New Orleans.

The second Theatrical continued long after most of the nightlife spots on Short Vincent closed in the 1970s. But by the 1980s it was a shadow of its former Las Vegas-like self. The mobsters had mostly killed one another off, and characters and celebrities had moved on. The nightlife scene had moved from downtown to the Flats area on the river, and the Theatrical stopped hosting live music in 1990. Two years later, the Wexler-Spitz family sold the club.

Buyer Jim Swingos, who had run another of Cleveland's most famous addresses, Swingos Hotel on Euclid Avenue, tried to breathe new life into the restaurant, renamed Swingos at the Theatrical. He was forced to close for good in 1998. The building where so many of Cleveland's who's who rubbed elbows and bought rounds was demolished for a parking garage.

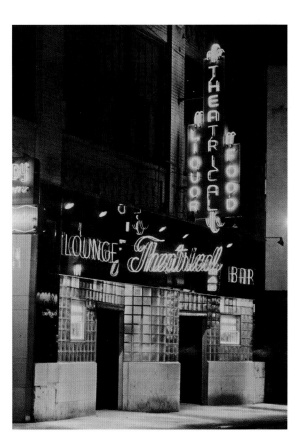

LEFT *In 1950, the swanky Theatrical was a favorite hangout of Cleveland celebrities, athletes and underworld figures.*

FAR LEFT *Following a massive 1960 fire, the Theatrical was completely rebuilt and reopened in 1961.*

OPPOSITE *The Theatrical Grill in 1960, before a fire claimed most of the original restaurant-club that opened in 1937 on Short Vincent.*

Higbee's BECAME DILLARD'S 1992

Higbee's department store was a downtown Cleveland shopping destination for more than 100 years. But the beloved store may be best remembered for its starring role in a little 1983 film that became an international classic: *A Christmas Story*; director Bob Clark's nostalgic tale of the Parker family's pre-World War II Christmas. Based on Jean Shepherd's memoirs, the story was set in Indiana, but much of Clark's movie about Ralphie Parker's dream of getting his very own official Red Ryder carbine-action, 200-shot Range Model was filmed in Cleveland. That included the movie's seminal scene, the "Santa Mountain" segment filmed inside Higbee's. There were also several scenes of festive shoppers filmed inside the store—done at night after Higbee's had closed for the day—and Higbee's famous holiday window displays figured prominently in Public Square scenes.

Higbee's, in fact, was the reason Clark's film starring Peter Billingsley was made in town: they sent out hundreds of letters to department stores across the country asking if they could be used for filming. Only Higbee's answered. No surprise. Even before the movie, the 11-story store at Public Square was a holiday favorite, treasured for its elaborate, mechanized window displays and the Twigbee Shop where young guests could enter a tiny door and shop in private for mom and dad. The 10th-floor Silver Grille restaurant was a favorite with all ages, known for its Maurice Salad, Welsh Rarebit and Shrimp Newburg, and children's meals such as creamed chicken served in little souvenir cardboard ovens.

Higbee's was founded in 1860 by Edwin Converse Higbee and John G. Hower as Higbee & Hower Dry Goods, near Public Square. By 1902, it was called The Higbee Company and eventually moved down Euclid Avenue to Playhouse Square, across the street from its main competitor, Halle's.

In 1929, the Van Sweringen brothers bought the store and moved it to its landmark location at Public Square by 1931—conveniently at the end of the Shaker Heights Rapid Transit line they had built into downtown from the wealthy east side suburb. Due to the Great Depression, the store did not fully reopen until 1935.

The luxurious Art Deco building featured wooden

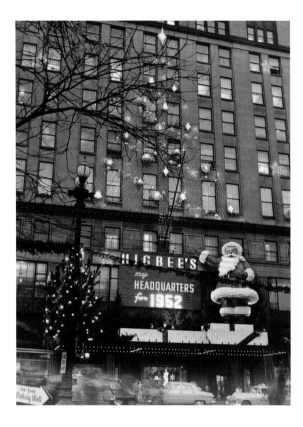

elevators to transport shoppers up and down through the immaculate space, from fine handbags and hosiery and men's dress clothing on the first floor; to designer collections and the gourmet shop on the Prospect level; to Miss Clevelander Dresses, the wig and stag shops on the second floor; up to china and notions on the fifth floor; the Connoisseur Gallery on seven; and all the way up to the Silver Grille at the top. The famous crystal chandeliers on the ground floor were not added until 1965.

By the late 1960s, like most of the other stores downtown, Higbee's sales and customer base had declined. But the forward-thinking company had opened suburban mall outlets and continued to do well. In 1984 the chain was sold, and in 1992 Dillard Department Stores rebranded it and closed several inner-ring stores. The downtown Dillard's carried on for another decade, finally closing in 2002, a shadow of its former self. Every holiday season,

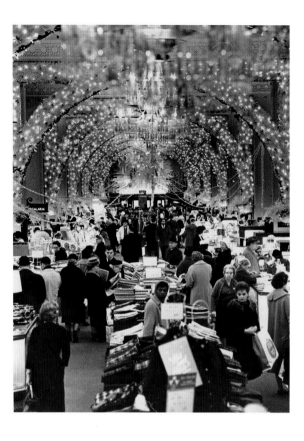

though, Higbee's lives on world-wide thanks to Bob Clark and little Ralphie Parker. And for those in the city, JACK Casino, which now occupies the Public Square building, re-creates several Higbee's windows in homage.

ABOVE LEFT *Christmas of 1952 was festive at Higbee's on Public Square.*

ABOVE *Higbee's will always be associated with Christmas in the minds of nostalgic Clevelanders—in part because of their elaborate displays, and in part thanks to the movie* A Christmas Story.

RIGHT *Shoppers still made the trek to come downtown from the suburbs to shop at Higbee's department store on Public Square in 1970—many by bus.*

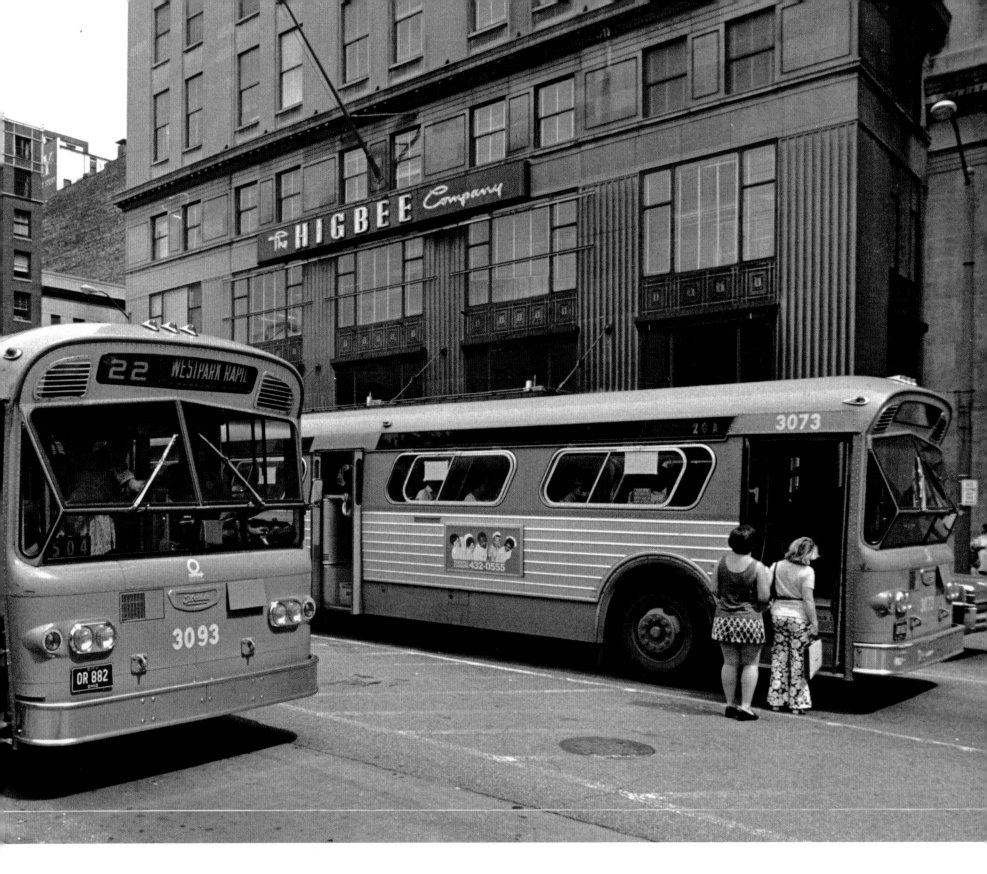

Hough Bakeries CLOSED 1992

If Cleveland had a taste, it would be white cake with a hint of almond and white flower-covered frosting, packaged in a white-and-blue box tied with a string. In other words, the taste of a Hough Bakery cake.

For nearly nine decades, this local chain was the go-to destination for special occasions, from weddings to birthdays to V-J Day. It wasn't a Cleveland party without a Hough Bakery cake. Or coconut chocolate bars. Or Orange Chiffon Ring. Or cheese Danish. Or petit fours, Old English-style hot-cross buns or dinner rolls.

Holiday times called for Hough, too. Their Easter daffodil cake with butter-cream icing and shaved lemon and pineapple, and bonnet-shaped Mother's Day cake done up with pink icing, were especially popular. Hough had Cleveland's menu covered.

The popular bakery had humble roots. The first shop was opened by Leonard A. Pile on Hough Avenue in 1903. The Scottish immigrant from Barbados had arrived in the city just a year earlier. Pile opened his first Hough Bakery with only four employees, but he had a recipe for success and reputation for quality that soon led to more branches throughout the city. By the 1920s, his four sons had entered the business, helping with the expansion. By the 1930s, they had their first suburban locations, in Cleveland Heights and East

Cleveland. The 1930s was also the era Hough Bakery launched its catering business, famed for towering wedding tortes and tasty canapés. By 1941, Hough had centered its operations in a larger corporate headquarters on Lakeshore Road on the east side of town. In 1952, the name was changed from Hough Bakery to Hough Bakeries, reflecting the growth.

Catering was the first of many expansions for the Pile family. The brothers formed the Hough Food Company to sell frozen foods in 1956. By the mid-1970s, the little bakery that started with four employees had expanded to more than 1,000, with annual sales of more than $12 million—that's a lot of bread. Hough's sweet and savory concoctions were sold in more than 70 locations, including more than 30 retail stores and branches in supermarkets and department stores. The stand inside the downtown May Company was especially popular, with crowds lining up every day for a glazed doughnut or sugar cookie.

But popularity wasn't enough to keep the sweet smell of success going. The family owned bakery never modernized and rising production costs meant Hough could not keep up with its competitors. Changing tastes and over-expansion also contributed to the financial troubles that led Hough to declare bankruptcy and close its 32

remaining stores and headquarters in 1992. Today the sweet taste of Hough lives on, though, at Archie's Lake Shore Bakery, where a former head baker re-creates some of the famous cakes—complete with the blue-and-white boxes—and internet forums where the quest for elusive recipes for Hough coconut bars, brown sugar brownies and other favorites continues.

OPPOSITE Jubilant shoppers line up to celebrate V-J Day with Hough baked goods in 1945.

BELOW LEFT By the 1950s, Hough Bakeries had multiple locations in town. By the mid-1970s, Hough goods were sold at more than 70 locations.

BELOW Hough owners Robert Pile and Kenneth Pile (left), baker John Odoski (center), with Lawrence Pile and Arthur Pile (right), decorate a Hough cake in 1945.

BOTTOM Hot cross buns were a hot seller in 1954.

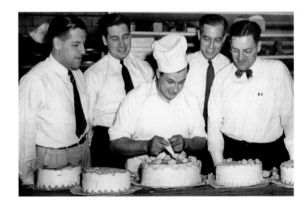

Huletts SHUT DOWN 1992

Hulett ore unloaders helped put Cleveland on the map as an industrial power, one 17-ton load at a time. It's no exaggeration to say that without the Huletts, Cleveland as we know it would not exist. But their epitaph is a sad story. The last two of the 93-foot iron behemoths sit gathering rust and broken into parts on Cleveland's Whiskey Island.

Invented by Cleveland construction engineer George Hulett in 1898, these 880-ton machines were created to mechanically unload lake ore carriers. The first successful Hulett was built in Conneaut, Ohio, in 1899. By the following year, the industrious machines began to spring up at ports all around the Great Lakes.

Before that time, unloading ore carriers was a laborious process, mostly done by hand. It could take up to a week to unload a single ship. The first Huletts were capable of shoveling up to 17 tons of ore, iron, coal or limestone at once. What before took a week could now take half a day. And, what before cost 18 cents a ton for labor now cost 5 cents.

By 1913, there were 54 Huletts working along the Great Lakes (they could not be used on ocean ships because they were not adjustable with the tides). At the height of their use, there were 77 Huletts on the Great Lakes, with 14 in Cleveland. U.S. Steel and Republic Steel had several Huletts each, and the Pennsylvania Railroad had four. These four, built in 1912, were the last standing.

It has been estimated that Huletts unloaded 100 million tons of ore during their mission on the Great Lakes. The steam or electrically powered machines worked by sending a carriage up and down two parallel tracks on the docks. Human operators known as "ore hogs" could use levers to move a giant scoop on a beam into the ship's hold and then into a bucket on the tracks, which would then be emptied into a stockpile or train car.

"The rapid and economical unloading and handling of iron ore is one of the special features of many of the lake ports, and prominent among the ore unloaders is the Hulett machine," wrote the *Engineering News* of this radical invention in 1905.

Huletts revolutionized the cargo-unloading process for ships and helped establish Cleveland as a steel and transportation hub. But their usefulness declined by the late 1970s, when most lake ships had become self-unloading. Huletts across the region were dismantled and scrapped. The last four in Cleveland, those belonging to the Pennsylvania Railroad in the Cleveland-Cuyahoga County Port Authority's Bulk Terminal on Whiskey Island, were shut down in 1992.

Though George Hulett's machines are listed on the National Register of Historic Places and designated as a Historic Mechanical Engineering Landmark in 1998, two of the final four were demolished by the Cleveland Port Authority in 2000. The other two behemoths were taken apart and left in place, with numerous groups over the years arguing for their preservation and re-assembly as a Cleveland landmark. For now, though, these eroding engineering marvels are a larger-than-life symbol of the rust-belt decline of the area they helped to build.

RIGHT *Huletts are used to unload a cargo ship in Cleveland, circa 1905. The Huletts accomplished in a half day what had originally taken a week.*

BELOW LEFT *A line of early Huletts on Cleveland's Lake Erie harbor. At the height of Hulett use, there were 14 hoists in Cleveland.*

BELOW *Huletts in action at the American Steel & Wire Co. in Cleveland, circa 1915.*

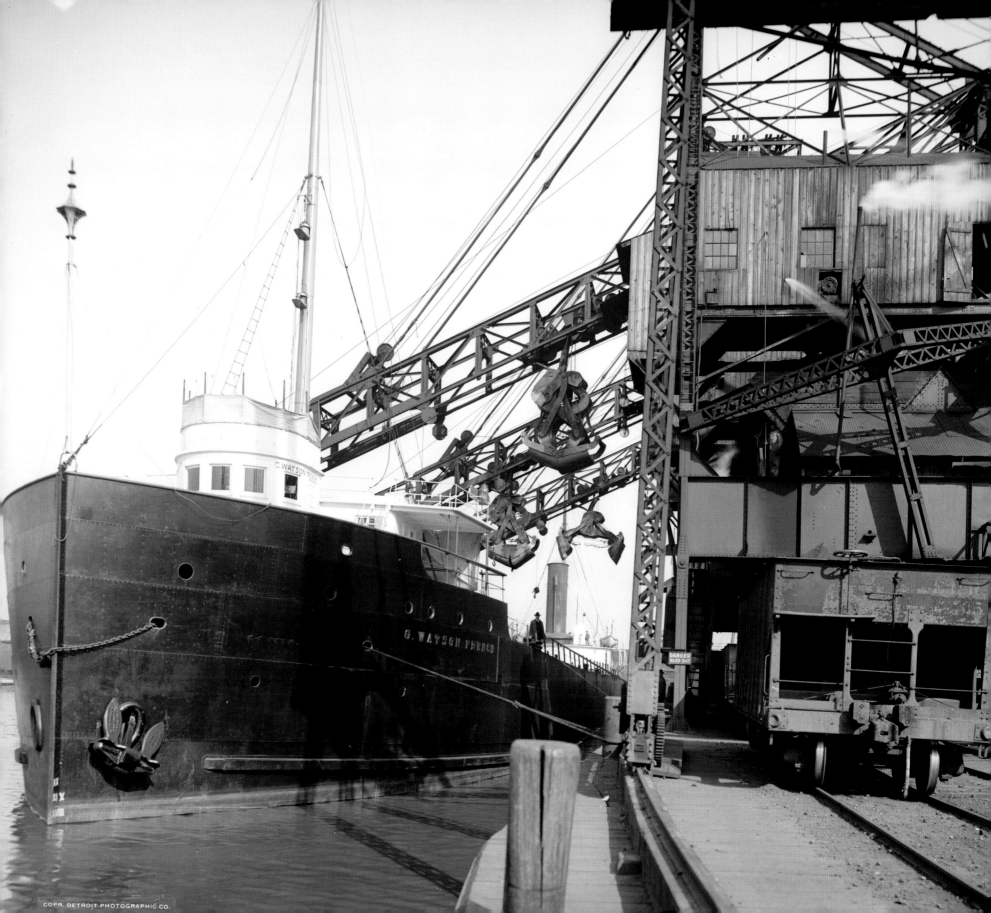

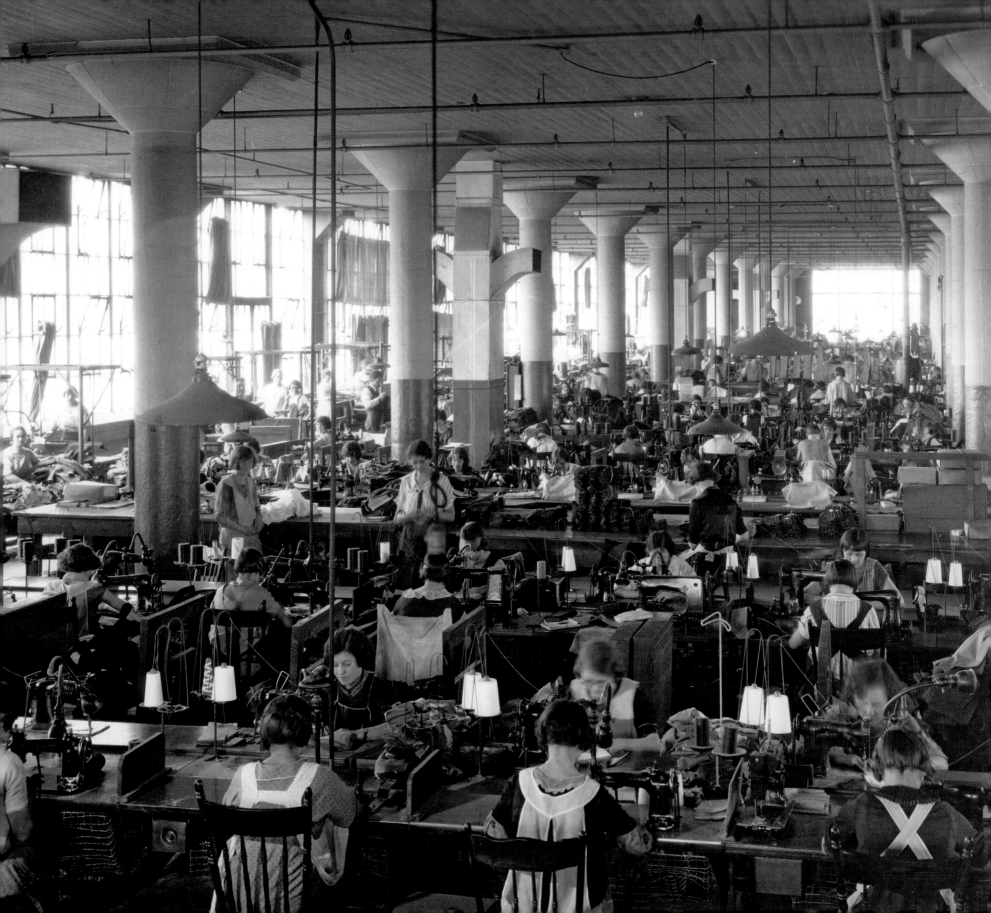

Richman Brothers Company CLOSED 1992

The Richman Brothers Company was once the largest garment manufacturer in the United States. It had the largest garment factory in Cleveland, too. But the huge company on East 55th Street proved that size wasn't the only thing that mattered. It was a forward-thinking, employee-centered company that lived the term "family business."

Richman Brothers was founded by Jewish-Bavarian immigrant Henry Richman Sr. and his brother-in-law Joseph Lehman in Portsmouth, Ohio, in 1853. Initially known as the Lehman-Richman Company, the small business moved to the big city in 1879. Lehman eventually left, and in 1904 the "brothers" became part of the company when Henry's sons Nathan, Charles and Henry entered the business and he retired. By 1907, the retail model that Richman Brothers employed till its last days was in force: it established retail stores to sell the suits that bore the company name. It was the first garment maker in the nation to do this.

The first Cleveland store opened selling Richman's $10 men's suits in 1907. At first, its garments were made by outside piece-work. But the suit business was hot in the early 1900s, and by 1916, Richman Brothers had opened up its own factory. And not just any factory: a massive complex on 17 acres on the edge of the garment district. Designed by Christian Schwarzenberg and the Gaede Company, the enormous U-shaped building had large windows on every wall to let in natural light for working, 15-foot-high ceilings, and 60-foot cutting tables, called the "world's largest." Roomy, well-lit spaces and air-conditioning were a novelty in an industry dominated by dank sweatshops. They were also signs of the respect the Richmans showed their employees throughout the company's existences.

A year after opening, Richman Brothers took a hiatus in 1918, when the federal government asked the brothers if their huge space could be used as a military hospital. They turned it over rent free.

After the war, the Richmans were back in business. And the suit business was booming. Already enormous when it opened, the factory was increased to 650,000 feet of workable space by 1927, on a total of 23 acres. At its busiest, the East 55th factory had 3,000 workers.

By 1930, Richman Brothers was calling itself the "World's Largest Manufacturers of Fine Men's Clothing." By 1950, it had 119 retail stores across the country selling suits, hats and furniture made in the Cleveland factory.

Richman Brothers was able to get such productivity out of workers by treating them well, management felt. The company was considered a front-runner in employee relations, granting paid vacation, paid maternity leave and stock options long before such things became common. A 1939 *Time* magazine article said employees got three weeks' paid vacation, a stipend if they were unable to work due to illness, and 10 weeks off with a $10 stipend after giving birth. The company also granted no-interest loans to employees, and never had a time-clock. There was a subsidized cafeteria where everything from soups and sandwiches to meatloaf and cake was served. Softball teams and other social groups were popular after-hours. Such treatment drew dedication from the staff. Attempts at unionizing by outside groups never got a foothold.

Later decades were more tumultuous for the company. After making acquisitions of several smaller businesses, Richman Brothers merged with the F.W. Woolworth Company in 1969. The company continued on for a few more decades, but revenue sharply declined as clothing trends changed. The company couldn't compete with cheap overseas imports, either. In 1992, Woolworth shut the door on the Richman Brothers factory and remaining retail stores. Since then, the hulking shell that once housed the biggest, perhaps most progressive, company in America has sat empty.

OPPOSITE *When it was opened in 1916, the Richman Brothers complex was a model of humane factory design, with natural light for working, 15-foot-high ceilings, large cutting tables and air-conditioning.*

BELOW *Today, the huge Richman Brothers complex stands abandoned and neglected on Cleveland's busy East 55th Street thoroughfare.*

St. Joseph Roman Catholic Church BURNED 1993

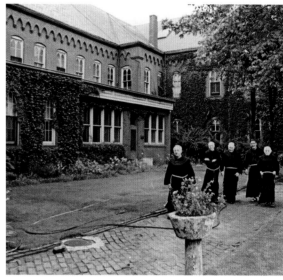

With its towering steeple, St. Joseph Roman Catholic Church on Woodland Avenue greeted visitors to Cleveland for decades, no matter their faith. Located near Interstate-77 coming into the city from the south, the German Gothic building was impossible to overlook. Even before the highway, the "Cathedral of the East Side," as it was called, couldn't be missed by travelers on the busy Woodland thoroughfare.

One of the older parishes in Cleveland, the first St. Joseph church was erected at Woodland and East 23rd in 1862. It was a simple, wood-frame building, with a detached rectory and school on the property. By 1868, the Franciscan friars had taken over the church from the Cleveland Diocese and added a German-style friary and attached chapel. Just a few years later, the St. Joseph church that would be remembered by so many Clevelanders was built. It was designed by Cleveland's famed Frank Cudell and John Richardson, who also designed St. Stephen Catholic Church, the Jewish Orphan Asylum and the Perry-Payne Building.

Constructed from 1871 to 1873, St. Joseph was consecrated on October 5, 1873. The impressive steeple was not added until 1899. The style was German Gothic in a nod to the friars' background and the ethnicity of the surrounding community.

There were also a few Romanesque touches and an *au courant* Victorian-style roof. The outside was constructed in brick and stone, with narrow, arched stained-glass windows in alcoves in the front. Three entrances were topped with imposing Gothic arches. Inside, the woodwork was stunning, with elaborate carved oak furnishings in the nave and an altar that was hand-carved by the friars (and contained four relics of St. Ursula). There was a traditional choir stall with 32 chairs, carved wooden side shrines and oil paintings of St. Joseph and St. Francis.

From 1876 to 1879, the Franciscans also ran a college in a building on the site. This structure was later used as an elementary school. In 1893, a newer friary was built.

In 1899, St. Joseph became even more glorious with the completion of its soaring steeple, which housed four bells that could be heard ringing out for miles. The tower featured two small rose windows and narrow side-by-side arches.

The church was notable for more than its architecture, however. In immigrant-rich Cleveland, it was the first church to conduct services in the language of its parishioners: German, rather than English. Eventually, as the neighborhood changed and Italians and Poles and Slovaks and African-

Americans moved in and joined the congregation, English-language services were added.

But nothing could save the magnificent St. Joseph church from dwindling attendance as parishioners fled to the suburbs in the 1960s and '70s, spurred on by the construction of the nearby interstate. St. Joseph was closed and deconsecrated in 1986. Various campaigns led by church groups and ethnic leaders were attempted to get the landmark structure re-opened, until a February 1993 fire severely damaged the building and put an end to such discussions. The remaining statues, windows and artifacts were sold off, and St. Joseph was demolished later that year.

ABOVE LEFT *The inside of St. Joseph featured stunning woodwork, including a hard-carved altar that contained four relics of St. Ursula.*

ABOVE *Franciscan friars lived on the grounds of St. Joseph church, in a separate friary.*

RIGHT *St. Joseph towered over the near east side of Cleveland in 1991. Two years later it was severely damaged in a fire, and later demolished.*

Brookside Park

SPLIT BY I-71 1960s; TAKEN OVER BY CLEVELAND METROPARKS 1994

Long before the Cleveland Zoo was established at Fulton Road and Denison Avenue, the area was still home to some of the wildest fun in Cleveland history. Brookside Park was opened by the city in 1894. The 81-acre site in the Big Creek Valley featured walking trails, woodland groves, picnic areas, children's play areas and tennis and baseball grounds when it first opened as Brooklyn Park.

It was renamed Brookside Park in 1897, thanks to its many scenic brooks and lookouts over the valley. By that time, the park had been doubled in size by the city and was attracting huge crowds of west siders in search of a bucolic afternoon break. A natural amphitheater provided a perfect space for concerts such as the season-opening show by the Great Western Band in 1898.

By 1905, an elegant bathhouse had been built by a natural lake on the site, providing hours of cooling fun on a hot summer day. Man-made municipal pools would later be added to the park, making it a hot summer destination for decades. A small "swimming hole" was added in 1910. It was just four-and-a-half feet deep, but was swarmed by area youngsters.

The oft-reminisced-about Brookside Municipal Pool was added a few decades later. It was popular with bathing beauties and splashing kids from the 1930s to the 1970s. The huge circular pool had a raised platform a few feet above the water in the deep end where the better swimmers and teenagers would hang out. Being able to swim out to it was a milestone badge of honor.

As popular as the pools were, there was no bigger draw to the park than Brookside Stadium baseball amphitheater. There was no bigger draw in any city anywhere in 1914 and 1915 when the stadium hosted the World Amateur Championship, attracting 115,000 fans—to just one game. It was the largest crowd recorded in amateur sports history.

Though the park had been used for baseball as early as the mid-1890s, Brookside Stadium opened on May 2, 1909. Festivities included a 15-mile City Marathon that began at Gordon Park on the east side, and a performance by Minnie the Brookside elephant. Wooden benches packed with spectators lined the hillsides.

Despite grand plans to add enough seats for 100,000 fans, which organizers felt would help attract the 1912 Olympics, very little permanent seating was ever built at Brookside Stadium. Still, the bowl-shaped natural amphitheater regularly attracted crowds of 30,000 to 80,000—more than most Major League Baseball games.

Like two of Cleveland's other grand parks, Gordon Park and Edgewater, the decades after the 1950s were not kind to Brookside. Expansion of the Cleveland Zoo from the 1930s onward cut into the park. The zoo amphitheater now stands where west side kids once splashed in the pool.

The construction of Interstate-71 in the 1960s ran right through the park, cutting it in half and destroying much of the wooded areas. And Brookside Stadium gradually fell into disrepair as the popularity of amateur baseball waned and the city's population declined. In 1994, the Cleveland Metroparks took over what remained of the park and renamed it Brookside Reservation.

OPPOSITE *Mothers, children and bicyclists take to Brookside Park on a pretty day, circa 1901.*

BELOW *Being able to make it to the platform elevated above the deep end of Brookside Municipal Pool was a badge of honor in 1960s Cleveland.*

BOTTOM *An estimated 115,000 baseball fans were in attendance at Brookside Stadium for a championship game between Cleveland's White Autos and Omaha's Luxus team on October 10, 1915. The White Autos won 11–6.*

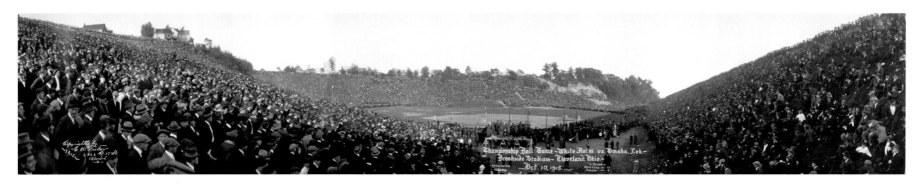

Captain Frank's Seafood House DEMOLISHED 1994

Special occasions were even more special when celebrated at Captain Frank's Seafood House for several generations of Clevelanders. Engagements, graduation dinners, birthdays, anniversaries and other big days were all on the daily menu at the iconic seafood house at the end of the East Ninth Street Pier.

Not that Captain Frank's was simply fine dining—with its kitschy nautical theme, it was also fun dining. It had one of the best addresses in town, with stellar views of Lake Erie and the city skyline. In its salad days it also had one of the city's best menus. No wonder the Captain kept reeling 'em in for decades.

Captain Frank's was opened on the pier in 1954 by Sicilian immigrant Frank Visconti. Formerly the owner of the Fulton Fish Market, Visconti began thinking bigger than just selling fish. He bought an unused boat depot on the end of the East Ninth Street Pier in 1953.

By 1954, the old terminal had been turned into a full service restaurant: Captain's Frank's Seafood House was open for business. From the menu to the fishy décor of trophy catches, nets and lobster tanks, it was all about seafood. Sure, the menu also included chops and steaks for less adventurous diners, but the options were overwhelmingly from the sea.

Despite being located on a freshwater lake, the food, like the New England-flavored décor, was mostly ocean fish and shellfish—pretty classy options for the time. An early 1960s menu included "Broiled, Stuffed Scampies in Garlic, Sherry Butter" ($2.50); "Broiled Live Maine Lobster with Butter" ($3.50); "French Fried Oysters with Tartar Sauce" ($1.70); and some local catches like "Broiled Lake Erie Trout with Lemon Butter" ($1.90).

Despite his upscale menu, the city was skeptical of Visconti's intentions at first. Mayor Anthony J. Celebrezze refused to grant him a liquor license, saying it would create a "honky-tonk" atmosphere on the pier. So for several years Captain Frank's was dry, which would probably come as a surprise to those who enjoyed late-night cocktails in the 1960s and later at the swanky bar. It wasn't until Captain Frank's closed and reopened after a mysterious 1958 fire that the license was granted, in part because Visconti invited as many politicians as he could to the grand re-opening—where he served them free alcohol.

Once Visconti had his license, Captain Frank's was busier than ever. The restaurant reached its pinnacle in the mid-1960s to the late 1970s. Captain Frank's was popular with everyone from young families at lunch to romancing couples and late-night partiers. An indoor waterfall installed after the fire and low lighting added to the classy vibe.

By the 1980s, Captain Frank's had begun its slow decline, however. Visconti died in 1984, and the new owners didn't have his same passion. The décor and menu grew stale—and sticky. The landmark did have one moment in the spotlight in this decade, though: a cameo in a scene on the pier in director Jim Jarmusch's 1984 classic film *Stranger Than Paradise*.

Captain Frank's lived on for a few years after Visconti's death, but it wasn't the same. The lights finally went out in 1989. The iconic building with its seafaring captain logo was razed five years later during the construction of the Rock and Roll Hall of Fame and Museum next to the pier—one Cleveland landmark sacrificed for the building of another.

ABOVE *"Captain Frank's Seafood House may be reached by land, sea, or air," read this 1965 ad. "While waiting for the finest and most delightful dinner on Lake Erie Shores Capt. Frank invites you for a ride on his yacht."*

LEFT *Captain Frank's location next to Burke Lakefront Airport sometimes led to some interesting traffic concerns.*

RIGHT *Situated at the end of the East Ninth Street Pier, Captain Frank's, pictured in 1973, had the best address in town.*

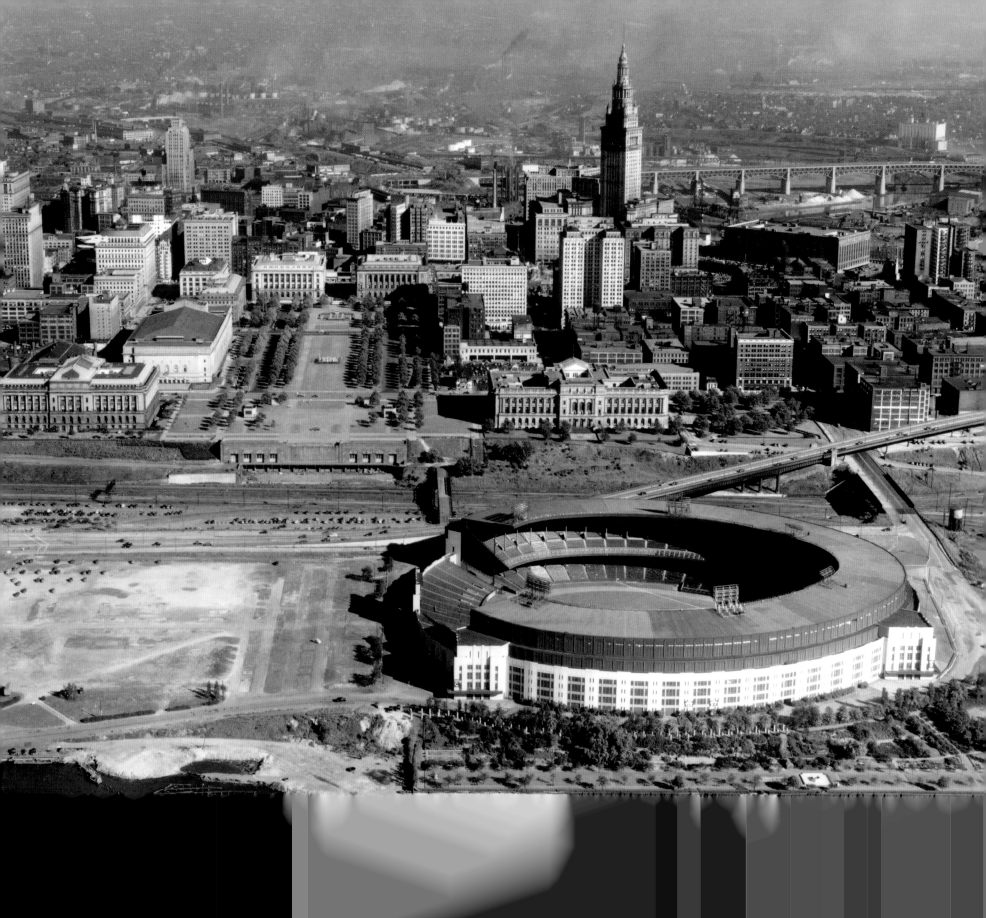

Cleveland Municipal Stadium DEMOLISHED 1996

Cleveland Municipal Stadium was home to football, baseball, boxing, concerts and more in its seven-decade lifespan. The Indians won pennants there; the Browns won titles; the Rolling Stones, Faces and Pink Floyd rocked the World Series of Rock in the late 1970s; and Ten Cent Beer Night went down in infamy. In other words, the 81,000-seat facility was home to many of the best times in Cleveland history. But that didn't stop the aging stadium from being demolished in the mid-1990s.

Muni Stadium, as it was called, opened with much fanfare in 1931. At the time, it was the largest outdoor stadium in the world. It cost $3 million, mostly paid for by a $2.5 million bond approved by voters in 1928. The stadium was designed by Cleveland's Walker and Weeks firm, which also built the Federal Reserve Bank and Public Hall. It was located right on the lake—something that would lead to many frigid winter afternoons and midge-filled summer nights. The huge, horseshoe-shaped stadium, open at the eastern end, was considered a masterpiece of design and civic involvement at the time. It was one of the first stadiums in the country built with public money.

The first event at the stadium was a boxing match between heavyweight boxing champion Max Schmeling and Young Stribling on July 3, 1931. It was a long night; Schmeling won by a TKO in the 15th round.

The Cleveland Indians played their first game at the stadium on July 31, 1932. They lost 1–0 to the Philadelphia Athletics. The Tribe didn't move to their new home full-time until 1947, continuing to play weekday games at League Park. Players had complained that the huge outfield reduced their home runs, and the Great Depression had led to such declining attendance that the smaller League Park seemed a better fit. In 1947, an inner fence was built to cut down the outfield size. Indians owner Bill Veeck was known to move the fence in and out to favor the Indians before such practices were banned.

In 1948, Muni Stadium was home to some of the most exciting moments in Cleveland sports history, the Indians' World Series championship series against the Boston Braves. The stadium also hosted the Tribe's losing 1954 World Series against the New York Giants. The Indians set three Major League attendance records during the 1948 season, including the largest regular season night game attendance: 72,434 for the first start of famed pitcher Satchel Paige.

These numbers were quite a far cry from the 30,000 to 40,000 the Tribe attracted to the venue

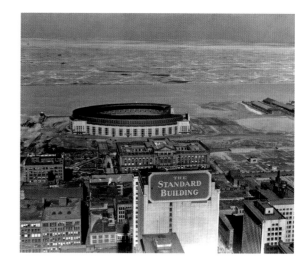

ABOVE *A 1936 aerial shot shows Municipal Stadium's proximity to Lake Erie.*

OPPOSITE *The Walker and Weeks–designed Cleveland Municipal Stadium was the crown jewel in Cleveland's lakefront when it opened in 1931. Pictured in 1946.*

BELOW *The Cleveland Browns played in Municipal Stadium from 1946 to 1995.*

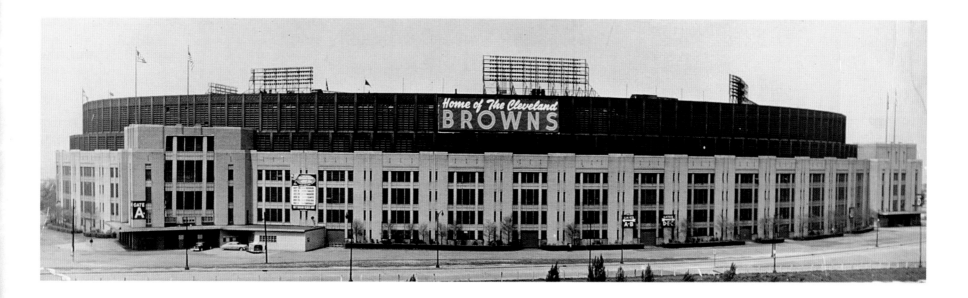

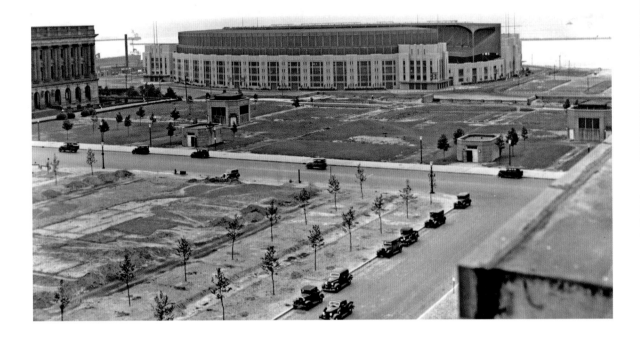

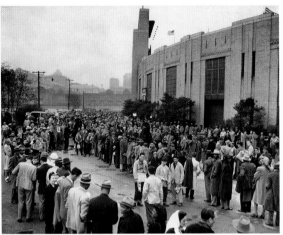

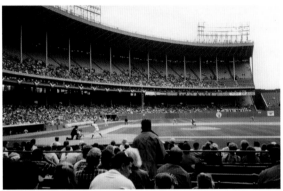

for their games from the 1960s onward. These weren't bad attendance figures, but they seemed paltry in the enormous venue.

Beer, not baseball, was a headliner on Muni Stadium's most memorable night. No date will be better remembered in Municipal Stadium history than June 4, 1974—also known as Ten Cent Beer Night. In an attempt to lure crowds, the team offered unlimited beers for a dime. To no one's great surprise, the crowds grew so rowdy the Indians were forced to forfeit the game.

The Cleveland Browns also had many memorable nights at Muni Stadium. Their first game was September 6, 1946, against the Miami Seahawks. They won 44–0 in front of 60,135 fans. Municipal Stadium was home to Browns' victories in AAFC Championship games in 1946, 1948 and 1949. The Browns were victorious in NFL Championships in 1950, 1954 and 1964—for the last time in their history.

The Browns and Muni Stadium also provided the backdrop for the Billy Wilder comedy *The Fortune Cookie*, filmed during a 1965 game against the Minnesota Vikings. The 1949 movie *The Kid from*

Cleveland, about the 1948 Indians, also featured several stadium scenes.

Rock stars were also in the spotlight at Municipal Stadium. The first concert was the Beatles on August 14, 1966—and it only got bigger from there. In the mid and late 1970s, the venue developed a national reputation for hosting the ground-breaking World Series of Rock, featuring everyone from Pink Floyd to the Rolling Stones, the Beach Boys, Yes, Rod Stewart, Blue Oyster Cult, Fleetwood Mac, AC/DC and others. The June 25, 1977 Pink Floyd show attracted a record-setting 83,199 fans. Municipal Stadium continued to host concerts into the '80s and '90s, including the 1995 opening concert for the Rock and Roll Hall of Fame and Museum.

It was one of the last big events in the stadium, which was literally falling apart by the '90s, with chunks of concrete breaking off. The Indians, who wanted a smaller stadium, had moved in 1993 following their last game. Former team owner and comedian Bob Hope sang his classic "Thanks for the Memory" as they made their exit.

Instead of renovating the site of many of the

most glorious moments in Cleveland history after the Tribe left, Muni Stadium fell victim to politics and was demolished after Browns owner Art Modell moved the team to Baltimore in 1995. With no reason to renovate the structure, demolition began on December 17, 1995, as diehard fans ripped out seats to take home as souvenirs.

ABOVE LEFT *An elevated view of Municipal Stadium from 1935.*

TOP *Fans wait outside Municipal Stadium to get World Series tickets to see the Indians in 1948.*

ABOVE *The Cleveland Indians took on the Milwaukee Brewers in their final season in the stadium on September 25, 1993.*

RIGHT *Well-heeled fans head into a game at Municipal Stadium in 1946.*

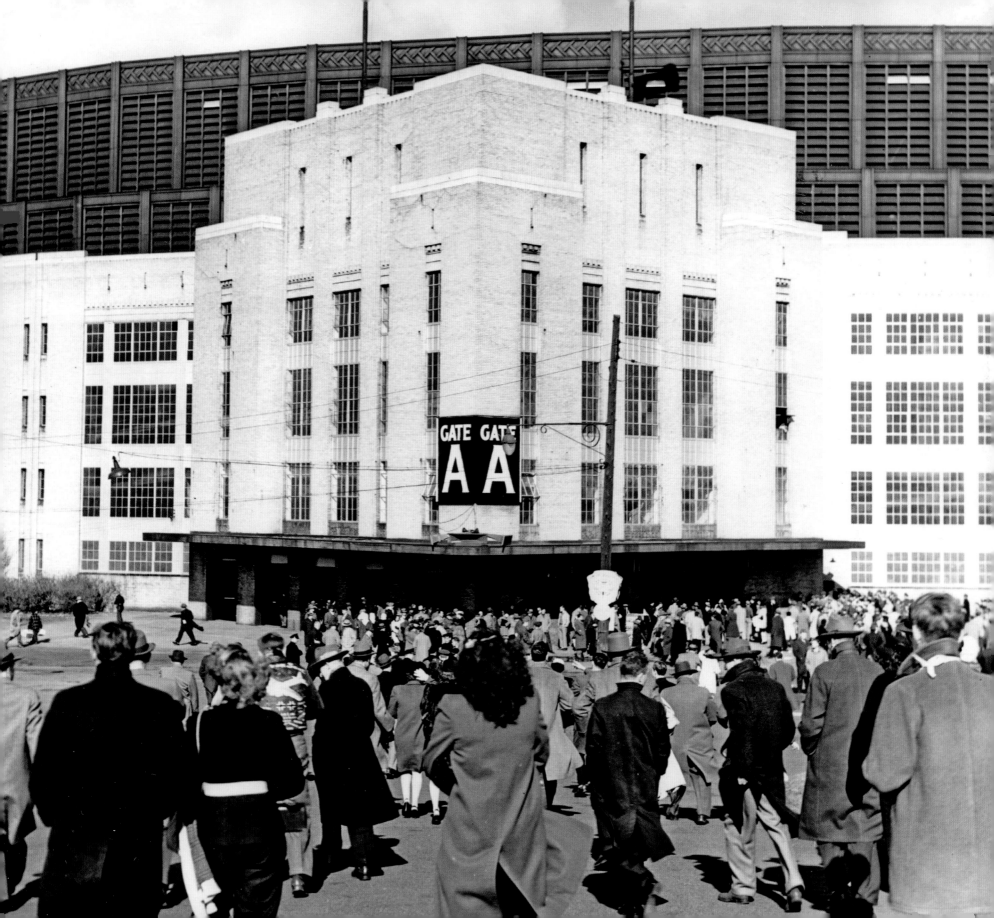

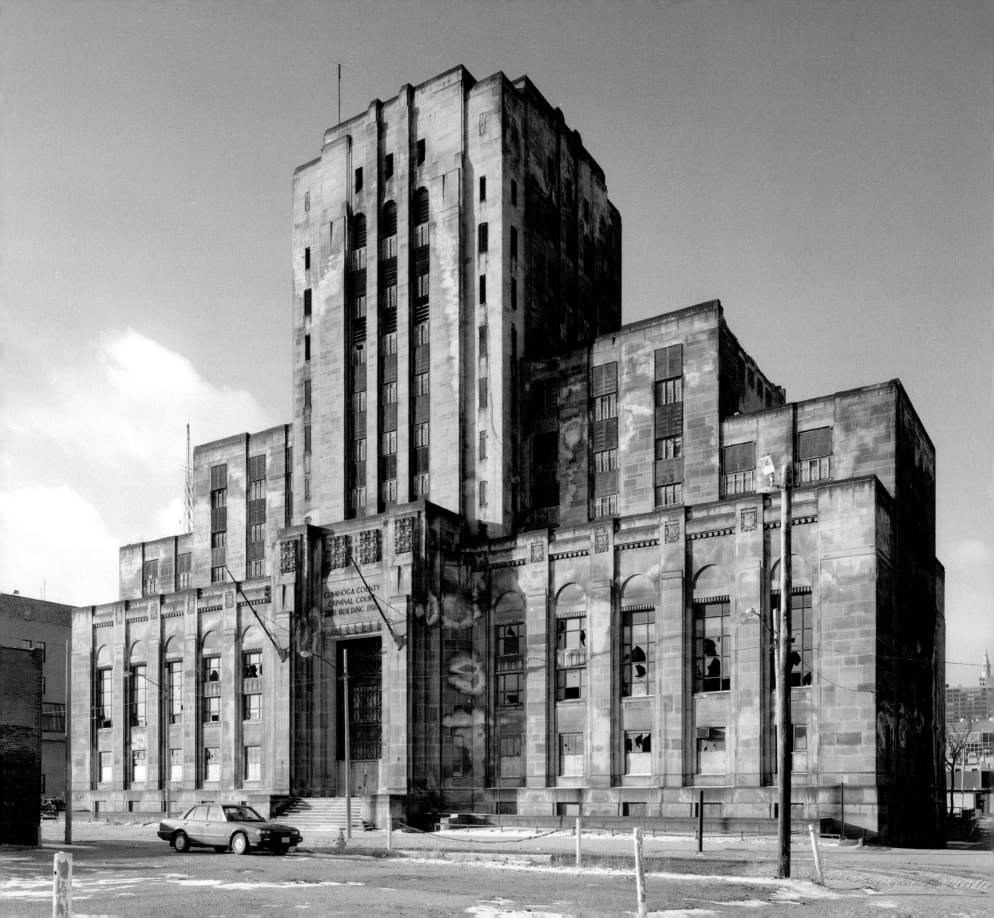

Cuyahoga Criminal Court Building

DEMOLISHED 1997

Cleveland has never had many Art Deco buildings, which makes it all the more of a shame that this 1931 masterpiece was so unceremoniously demolished in 1997.

Utility and safety, not design, were foremost in the minds of the government when it commissioned the Cuyahoga Criminal Court Building on East 21st Street, however. The main reason for the construction of the building that housed the county jail was the "dungeon-like" conditions of the existing jail at Public Square, where prisoners were forced to eat and sleep on the floors of overcrowded bullpens. This led to an uproar in the community. The need for a new jail and court facilities in the city that had grown to a population of more than 900,000 residents was acknowledged.

At the time of its opening, it was the 350-person jail, called one of the "most modern in the country" that was the subject of most of the media focus. It even included a hospital, a novelty at the time. The new jail was "1,000 times better than the old jail," one prisoner told the *Plain Dealer* newspaper. "The air here is good. You can eat like a horse. In the old jail the air was so rotten that you couldn't eat at all."

The 13-story building was also praised for its octagonal rotunda design that "maintained maximum security at the same time that it permitted efficient transfer from one to the other." It was an excellent example of form follows function designed by Cleveland architects Franz Childs Warner and George Evans Mitchell.

In addition to the jail, the building housed the Prosecuting Attorney-Criminal Division, Sheriff's Office and Cuyahoga County Criminal Courts. It was at these courts that the most famous trial in Cleveland history took place: the 1954 trial of Dr. Sam Sheppard for the murder of his wife Marilyn.

The building itself, with its signature Art Deco style was constructed of steel and concrete with a cut-back tower with a sandstone facade. The rest of the building was covered in light brick. Though the tower appeared four-sided outside, inside it was an octagon. The rotunda was topped with a light that could be raised and lowered; railings of wrought iron with sleek modern patterns bordered

each floor. The light fixtures were classic Art Deco, and elevator doors were two-tone cast bronze with streamlined style. The imposing yet elegant entrance was a triumph of Deco design, reaching toward the heavens in clean but bold lines with simple ornamentation.

None of this mattered by the late 1970s when the overcrowded jails and courts in this building had fallen into disrepair, just like the building they had replaced. The Cuyahoga County Criminal Court Building had a serious function after all; it wasn't a museum piece. So with the completion of the utilitarian Cuyahoga County and City of Cleveland Justice Center in 1977, the East 21st Street Cuyahoga Criminal Court Building was decommissioned. Attempts to preserve the spectacular structure failed. It was demolished for a parking lot in 1997.

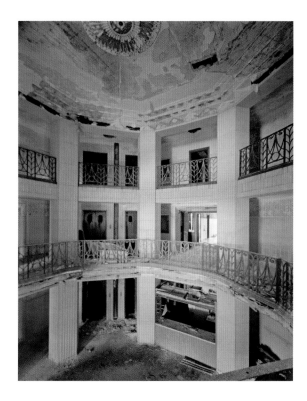

ABOVE *The halls and courtrooms of the Cuyahoga Criminal Court Building on East 21st Street were home to Cleveland's most famous criminal case, the 1954 trial of Dr. Sam Sheppard for murdering his wife.*

LEFT *The octagonal rotunda in the courthouse and jail building was said to maintain "maximum security at the same time that it permitted efficient transfer from one to the other."*

OPPOSITE *Designed by Franz Childs Warner and George Evans Mitchell, the Cuyahoga Criminal Court Building was one of Cleveland's few prominent Art Deco buildings.*

Mt. Sinai Medical Center CLOSED 2000

Mt. Sinai Medical Center was founded with the most altruistic of reasons: to "care for the needy and sick." It was this mission that would eventually be its downfall. But for more than 100 years, the Jewish hospital served the poorest and neediest Clevelanders with open arms, and beds.

The teaching hospital launched by the Young Ladies' Hebrew Association had more goals than just taking care of patients, however. It was also founded with the purpose of providing Jewish physicians with a place to practice. In an era of anti-Semitism, they didn't always find it easy to get a position at area hospitals. Mt. Sinai Medical Center welcomed them. The hospital welcomed any patient, too. Though founded with the goal of catering to the underserved east side Jewish population, Mt. Sinai's doors were open to patients of any creed.

The roots of Mt. Sinai go back to 1892, when the Young Ladies' Hebrew Association began its charitable work among the poor on the east side. By 1902, the group decided it needed a hospital building to expand its mission, and became the Jewish Women's Hospital Association. The association purchased a house on East 37th Street, and in 1903 a 29-bed hospital was opened.

A decade later, a larger hospital was needed. The Jewish Hospital Association of Cleveland was formed, and in 1913 the East Side Free Dispensary on East 55th Street was opened. Soon, an even bigger building was needed for the hospital that was becoming a destination for many impoverished inner city residents. In 1916, the hospital moved eastward, along with the city's Jewish population. A 160-bed facility opened near Wade Park on East 105th Street.

At its opening, this building was considered the city's "most modern hospital." The children's ward, with glass partitions to prevent the spread of infection was especially praised. The *Plain Dealer* newspaper called it "a hospital arranged upon the pavilion plan, yet so well connected that administration will be most efficient, a group of buildings that may be added to indefinitely without disturbing the harmony of the parts."

Grow it did.

Supported by philanthropists in the Jewish community, Mt. Sinai took another big step forward in 1927 with a $1.35 million expansion that included a research laboratory and school of nursing.

Another expansion increased the bed capacity to 390 patients in 1951. The 1950s were an important

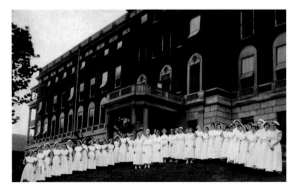

decade for Mt. Sinai. Just a few years later, in 1955, the board of trustees made a fateful decision that would have serious consequences more than 40 years later. It refused a move to the suburbs, where much of the Jewish community had moved, saying it would be abandoning the poor residents of the area. Instead, the medical center continued to invest heavily in its urban home. In 1960, another 12-story building was added, taking bed capacity to 524, along with an outpatient center.

This was also a big decade for the hospital medically. Dr. Jac S. Geller performed the world's first successful separation of conjoined twins on December 14, 1952.

By the late 1960s, Mt. Sinai had become the main facility serving uninsured and poor Clevelanders, a mission it supported through the United Appeal and the Jewish Welfare Fund. At the same time, the research branch of the hospital was making breakthroughs in assisted fertility treatments.

But research proved expensive, especially for a hospital with an impoverished patient base. By the 1970s, Mt. Sinai was having financial problems, and closed its nursing school. In the late '70s, the board began to think about finally moving to the suburbs, but an outcry from city leaders saying that would be abandoning the African-American community caused them to rethink this move.

By 1995, Mt. Sinai was in serious financial straits and the board was forced to sell to the for-profit Pennsylvania Primary Health Systems. Despite the new ownership, the hospital system continued to lose money and closed its doors in 2000, more than a century after it opened. Four years later, the hospital buildings were demolished by nearby Case Western Reserve University.

FAR LEFT *At the time of its opening near Wade Park and East 105th Street in 1916, Mt. Sinai was considered the city's "most modern hospital."*

LEFT *Nurses line up outside the Mt. Sinai school of nursing in the 1920s. The last class graduated in 1970.*

RIGHT *The Mt. Sinai nursing school building was a part of the hospital's $1.35 million expansion in 1927.*

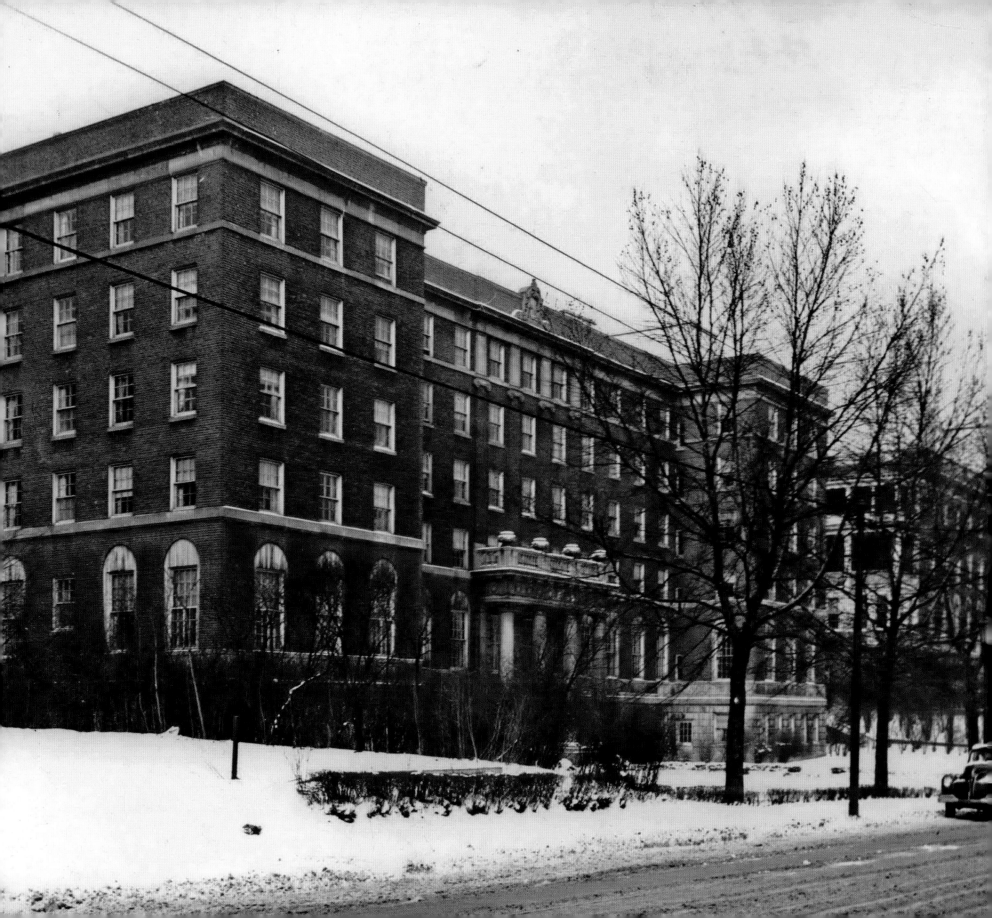

House of Wills CLOSED 2005

Today the monumental House of Wills on Cleveland's East 55th Street is known as the supposedly haunted, crumbling funeral home with the mysterious name. It's a trite reputation for one of the most notable names in Cleveland's African-American community—and a building with a rich and fascinating history.

The House of Wills, named for founder John Walter Wills, was one of Cleveland's longest running African-American businesses when it closed in 2005 (a satellite home closed in 2014). It was much more than just a place for families to bury their loved ones—it was a welcoming community center in a time of segregation.

Opened in 1904 as Gee & Wills, the home was first located on Central Avenue. In 1907, the name changed to J. Walter Wills & Sons. In its first decades, Wills' funeral home moved around quite a bit in Cleveland's predominantly black Central neighborhood. It wasn't until 1941 that he settled at what would become his permanent address at 2491 East 55th Street.

Built in 1900, around the same time Wills first opened his business, the Gothic brick house was designed by Cleveland architect Frederick William Striebinger as the Cleveland Gesangverein Hall. The social hall was in what was then a German and Jewish area around East 55th Street. The building later housed the Cleveland Hebrew Institute, and was even said to have been a speakeasy during Prohibition.

The building's function as a social hall continued when the House of Wills moved in. Wills, founder of the Cleveland NAACP and Negro Welfare Association chapters, opened his building to civil rights meetings and other community gatherings during a time of segregation. At one time, it was the largest African-American-owned funeral parlor in the state.

The House of Wills was no ordinary funeral home, however. It was known for its elaborately decorated, themed viewing areas and chapels. The most famous were the ornate Egyptian Slumber Rooms. The yellow and blue spaces had sphinx sculptures, engraved columns and decorative molding with Egyptian motifs.

There was also a Grecian chapel with classical columns and décor. The brightly lit casket showroom was called the Cloud Room. A mod-1960s area—complete with shag rugs, a kidney-shaped table and half-moon couch—was called "Dreamwald." The space was dedicated to "free cultural use" and hosted many of the House of Wills civil rights meetings.

The building itself, now grey and vine-covered, was once painted bright pink. The House of Wills hearses weren't run-of-the-mill either; they were snazzy Cadillacs.

Wills, who lived above his funeral home, passed away in 1971. The home in his name continued on for several more decades, run by family members.

The House of Wills eventually closed in 2005. It has been abandoned for more than a decade, though a new owner began trying to rent the "haunted" building out to ghost hunters in 2016.

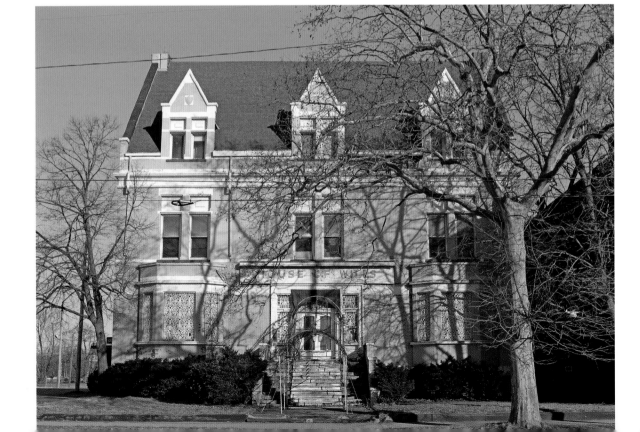

RIGHT *The House of Wills on East 55th Street in Cleveland's Central Neighborhood was more than a funeral home, it was also a community center and meeting place for civil rights activists.*

LEFT *Today, the House of Wills sits empty and neglected.*

BELOW *The House of Wills was known for its elaborate, themed areas, such as the Egyptian Slumber Rooms, the Grecian Chapel and the casket "Cloud Room," pictured.*

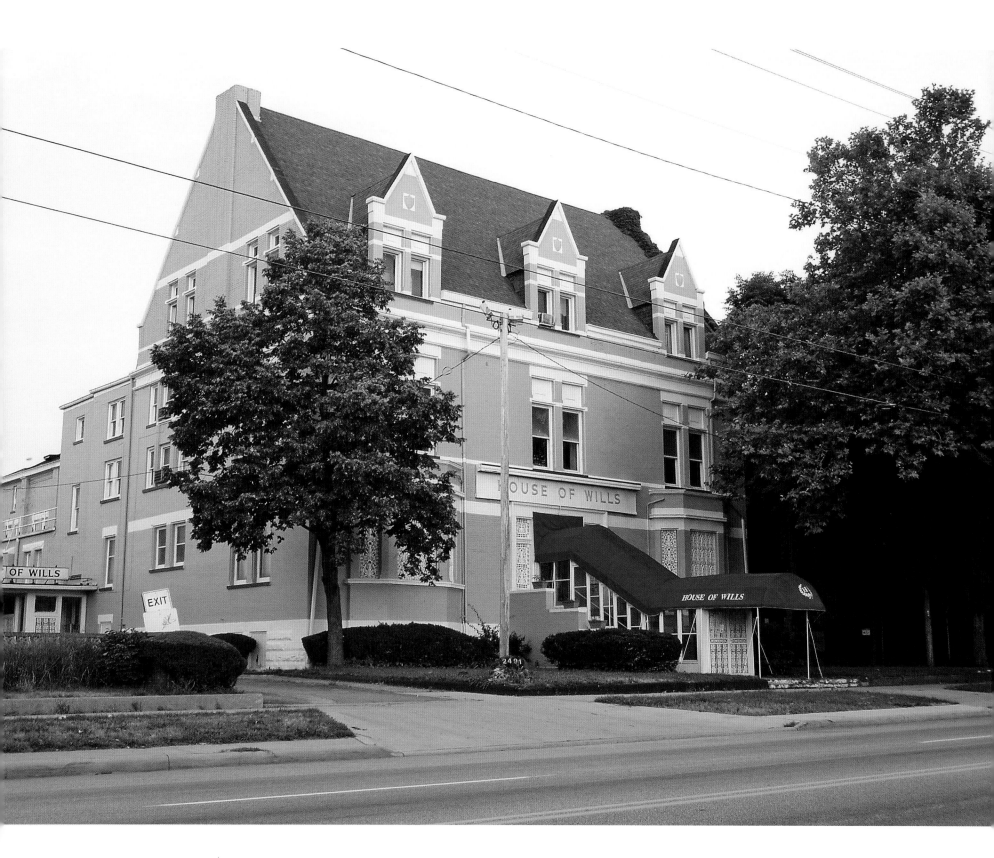

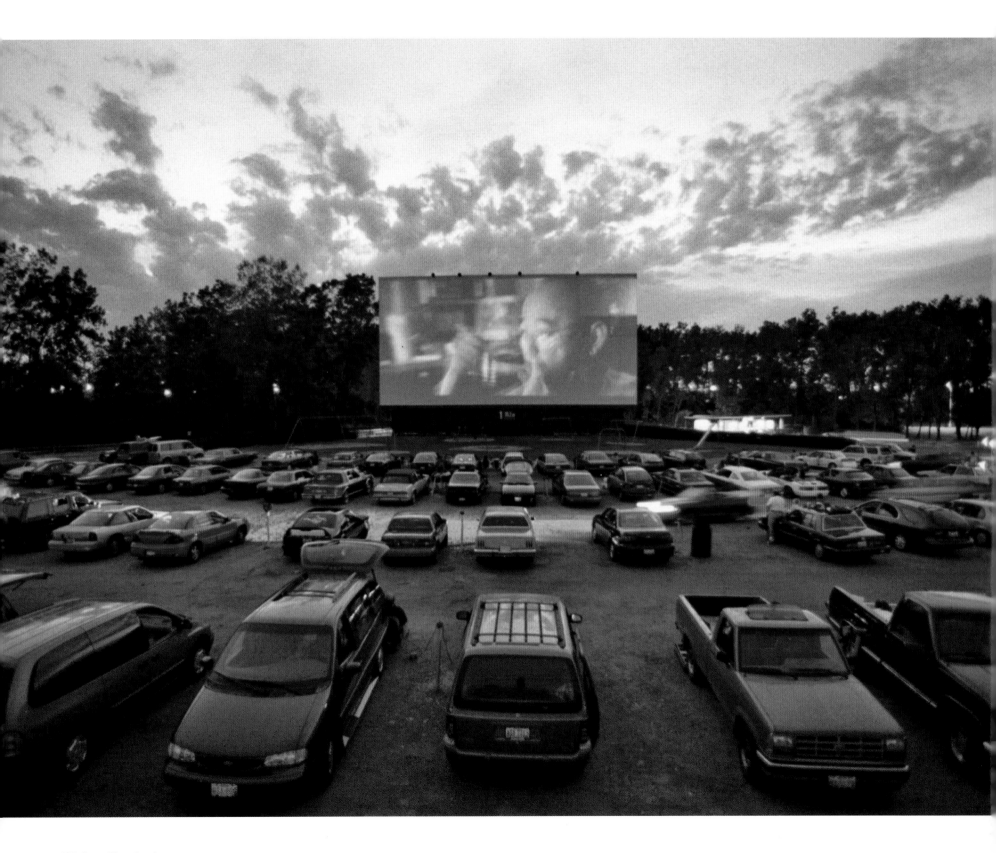

Memphis Drive-In DEMOLISHED 2006

The Eddie Cantor *Story* was the opening night attraction and kids got in free when the Memphis Drive-In opened in the suburb of Brooklyn on April 16, 1954. With three screens and space for 1,000 cars, it was billed as "Cleveland's newest, largest and most modern drive-in theater" in advertisements. They played double features every night.

Opened in the heyday of the American car craze, the Memphis had a lot of competition in the Cleveland area. It was one of 10 drive-ins opened after World War II in the city. By the mid-70s there were 16 drive-ins in town, also including the North Ridgeville Aut-O-Rama and the Miles Drive-In, which was already showing adult entertainment by the 1960s. Ohio had 189 outdoor theaters at one point—a lot for a region where it's only warm enough to sit outside four or five months a year.

With its enormous asphalt and gravel lot, and carnivalesque Googie-style sign, the Memphis had more than movies going for it. There was a playground on site for restless youngsters, and three days a week it hosted day-time flea markets. In 1952, the Wintner family, who owned the drive-in, had also opened the Memphis Kiddie Park across the street. The amusement park for pint-sized guests included the Little Dipper Roller Coaster, a carousel and mini-Ferris Wheel for toddlers. Many families would make a day of it, going to the park for rides or mini-golf in the afternoon, and topping their day off with a double feature across the street.

With three screens, the Memphis showed a wide variety of features. Early ads mentioned such retro classics as Steve Reeves' *Giant of Marathon*, *Days of Wine and Roses*, *What Ever Happened to Baby Jane?*, Dennis Hopper's *Glory Stompers*, and *Pillow Talk*. The latter was the type of film that earned drive-ins reputations as "passion pits."

The theater would typically open in April and close in October. The concession stand sold everything from hot dogs to popcorn, cotton candy and ice cream.

Despite the rise of DVDs and the suburban multiplex, the Memphis held its own for more than five decades. It never resorted to adding X-rated fare, unlike some of their competitors, and remained a first-run theater until the end.

The Memphis Drive-In was still going strong in the early 2000s, the last drive-in left in Cuyahoga County and the only three-screen theater left in the state. Unlike many theaters, it kept the detachable metal window speakers till the end, and the 1950s and '60s dancing hot dog concession stand ads, too. Admission was $7 for two first-run flicks, and just $2 for kids. The retro "hamburgers are delicious" and "popcorn, serve yourself" signs still hung in the concession area.

But the neighboring American Greetings Corporation made the Wintner family an offer it couldn't refuse for the 20 acres of land in 2006, and the owners decided to sell. The Memphis projector went dark after 52 years of summer fun. The last picture show screened October 1, 2006—a double feature of *Beer League* and *Jackass 2*.

A few years later, the greeting card company decided it didn't want to develop the site after all, and it sits empty and weed-strewn to this day.

OPPOSITE *The 1998 remake of* Godzilla *was a perfect fit for the vintage Memphis Drive-In, opened in 1954 in the suburb of Brooklyn.*

BELOW LEFT *Adult admission was just $7 for a double-feature, and kids got in for $2 in 2006.*

BELOW MIDDLE *The last movies to screen at the Memphis hardly recalled its glory days:* Jackass 2 *and* Beer League.

BELOW *The Memphis Drive-In kept its vintage car window speakers until its last days.*

Steve's Lunch **DESTROYED BY FIRE 2015**

Think Edward Hopper meets John Waters and Charles Bukowski for a cup of coffee and a chili dog, and you've almost got the vibe of this famed all-night diner on Cleveland's near west side that was destroyed by a fire in 2015. Steve's was a late-night, or early morning, stop for night owls, early birds, cabbies, punks, assorted party animals, cops and graveyard-shift workers for more than six decades. It stayed open all day and did a steady lunch and dinner business, but it was after hours when Steve's was most popular. In a town like Cleveland that shuts down early, it was a late-night oasis.

Steve's doors first opened at 5004 Lorain Avenue, on April 16, 1953—and only closed twice in 62 years before the fire. The 24/7 hot dog diner went dark for a day out of respect following President John F. Kennedy's assassination in 1963, and for a few days following a small fire in 1972.

Nothing much changed in all those decades at Steve's Lunch, including the vintage counter-top jukeboxes. No one ever messed with the beloved chili sauce recipe created by original owner Steve Spanakis, a Greek immigrant to Cleveland. It was partly that spicy sauce, heaped on top of the dogs and fries, that had Clevelanders of all stripes coming in for so many years. Not to mention the hash browns and eggs and hot and fresh coffee. Daily specials were written in neon marker only slightly brighter than Steve's yellow walls, to which the specials were randomly taped.

But Steve's lure was about far more than the food. It was a time capsule come to life, from the retro lunch counter to the 1950s Seeburg Consolettes on the counters. These tabletop gems were hooked-up to record players in the basement that spun vinyl 45s, with the sound running back through a wire into the machine. Popular tracks until the day Steve's closed included "Heartbreak Hotel," Merle Haggard's "Okie From Muskogee" and—what else—Buck Owens' "Hot Dog."

Spanakis sold the diner to longtime patron Ed Salzgerber in 2002. He didn't change a thing.

Steve's fans extended beyond Cleveland nighthawks. Drew Carey and George Clooney stopped by for a look and a dog, while Cleveland Indians superstar Grady Sizemore even did a glam photo shoot at the diner for *GQ* magazine in 2008.

Unlike so much of vintage Cleveland, Steve's never went out of style. It was hopping day and night until St. Patrick's Day 2015, when a fryer on the stove caught on fire. The 1860 building had walls with glue framing and flames quickly consumed the whole structure. It wasn't insured due to the age and condition of the building. Fortunately, all of the patrons and staff made it out, but a big piece of Cleveland flavor died that day.

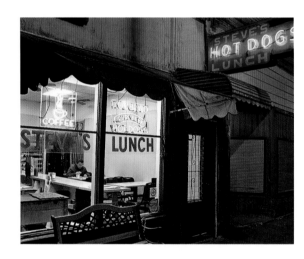

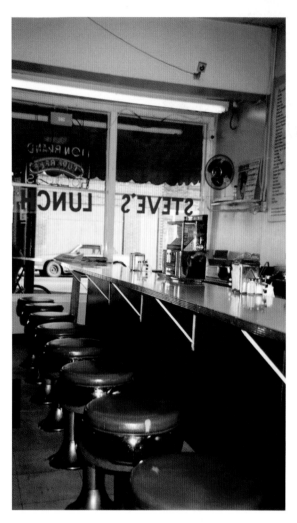

ABOVE LEFT *Any night was an adventure at Steve's Lunch, where punks and cops and third-shift workers and priests and party animals easily mingled.*

ABOVE *Steve's Lunch kept its vintage bottle-cap stools till its last day.*

LEFT *Vintage 1950s Seeburg Consolettes on the counters spun vinyl 45s in the basement of Steve's Lunch.*

RIGHT *Opened on Lorain Avenue on Cleveland's near west side in 1953, the 24/7 Steve's Lunch only closed twice before its final day: after President Kennedy's assassination and following a small fire in 1972.*

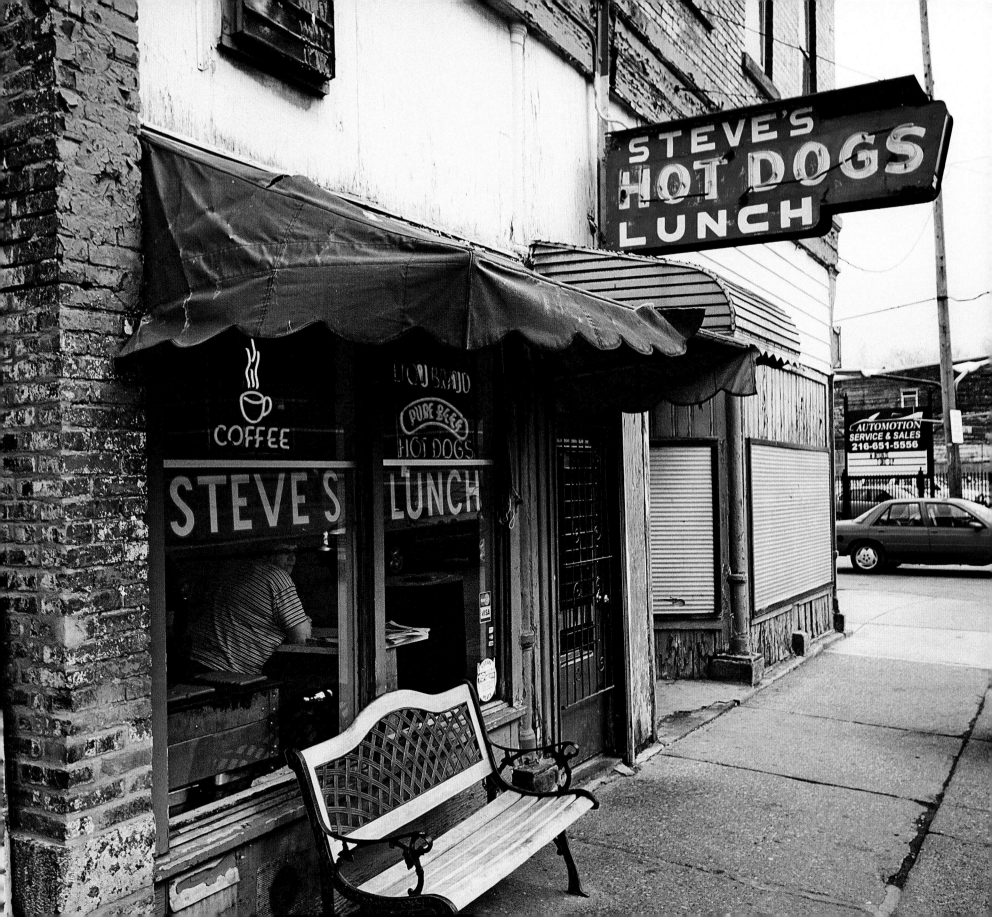

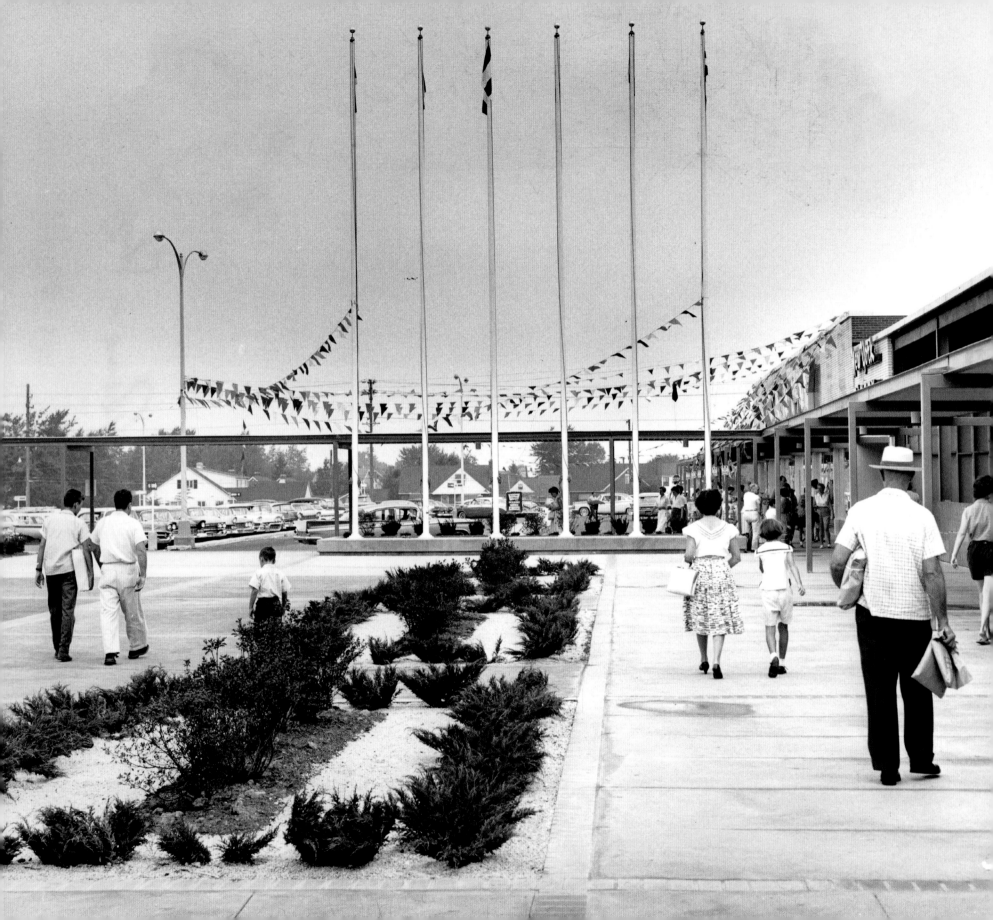

Parmatown Mall DEMOLISHED 2016

It was hard to tell by the time of its inglorious end, but Parmatown Mall was once the epitome of swanky on the south side of Cleveland. Opened in 1956 in the booming suburb of Parma—where the population grew from less than 20,000 to more than 110,000 between 1950 and 1980—Parmatown was a sprawling temple of commerce that embodied the late 20th-century suburban dream. There were department stores, and dress stores, and men's stores, and shoe stores, and a movie theater, and an arcade, and restaurants and even a cocktail bar. And, oh, yes, there was a porpoise. And, even a monkey.

Parmatown Shopping Center first opened as an open-air strip-mall to serve the thriving community. The 33 original shops included Richman Brothers, Marshall's Drugs and the S.S. Kresge Co., where a whimsical Santa Claus castle had children lined up at Christmas time. The May Company department store opened in 1960. Higbee's

opened its 185,000-square-foot store in 1967. "We are extremely pleased to begin this venture which will climax in the Fall of 1967 with the opening of another beautiful, full-line Higbee department store with which we can serve another of Cleveland's prosperous and populous sections," said chairman John P. Murphy when the store was announced in 1965.

This was also the era of Konhee Joe—the Parmatown porpoise. Kept in a tank across from May Company, he provided hours of entertainment for area kids, though probably not as much for himself.

By 1965, the growing mall was enclosed, as was the trend. With two anchoring department stores, it drew Clevelanders from across town. They came for lunch at Higbee's, where the fancy Zodiac Room overlooking the mall was a dress-up lunch destination for young children, who were served chicken pot pies in tiny cardboard

stoves. They came to browse the elegant dresses at Winkleman's, or maybe catch a fashion show between the fountains in the center of the mall. Or shop the trendy racks of Miles shoes and Calvin's.

Teddi's chic restaurant and cocktail lounge became a popular suburban hotspot in the 1960s, too—day and night. "Teddi's is decorated in a most imaginative fashion. It has already become an oasis for hundreds upon hundreds of Parmatown Mall shoppers who enjoy stopping by for a luncheon or midafternoon cocktails," said a *Cleveland Press* article in 1968.

By the 1970s and '80s, Parmatown attracted more and more teenagers as mall culture took over America. They came to spend their coins at Aladdin's Arcade, or catch a late-night screening of *Pink Floyd – The Wall* at the movie theater. Others went to ogle the opposite sex with an Orange Julius or slice of Antonio's Pizza in hand in the food court, or check out the latest releases at Record Land.

Shoppers of all ages would stop by to say hello to Ringo the monkey at Faflik's (later Mr. Ed's) shoe store. They were warned not to stick their fingers in the cage of the understandably cranky simian.

By the mid-1990s, Parmatown had begun its slow decline, a victim of changing shopping trends and a location far from highways that didn't fit well with modern shoppers. The former belle of the south side had become a clearing house for cut-rate dress shops, cheap nail salons and airbrush joints. Dillard's, which had replaced Higbee's, closed in 2000. The site is now a Wal-Mart. The movie theater that opened in 1967 closed in 2004. Macy's, which had been the May Company, hung on until 2012.

The rest of the mall was demolished after a lingering death in 2015 and 2016 to make room for the Shoppes of Parma lifestyle center.

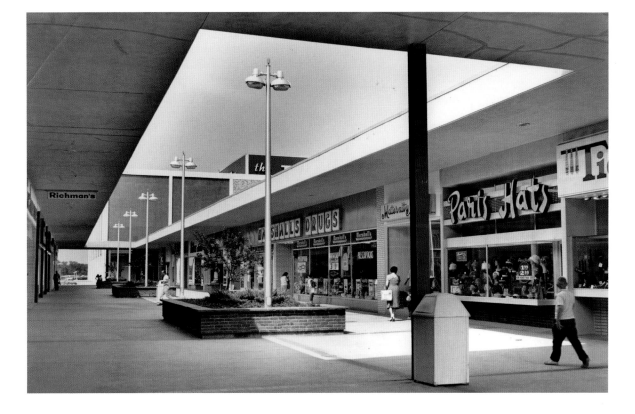

LEFT *In 1961, Parmatown was still an open-air shopping center, anchored by the May Company department store. It was enclosed in 1965.*

OPPOSITE *Shoppers in 1960 head to their cars after making their purchases at Parmatown. The mall was built to cater to the rapidly growing suburb of Parma. It was surrounded by enormous parking lots on all sides.*

Fifth Church of Christ Scientist DEMOLISHED 2016

The exterior of the church was made of Birmingham buff sandstone covered in Nebo marble. The roof was made of red clay tiles in a fishtail pattern and featured a central dome topped with a cupola, also covered in tiles. Three arched windows lined all eight sides. A short railing supported by balustrades edged the roof. Bail's goal was to create a visually pleasing church that reflected the rational beliefs of classicism, and he succeeded. "He discovered the church members liked the classical style. They believed it had a certain scientific order to it, which appealed to their principles," his son told the *Plain Dealer* newspaper in 2002.

By the 1980s, much of the congregation had either died or moved west and wanted their church to move as well. The Fifth Church was sold in 1989. Early plans that called for turning the building into a performing arts theater fell through, and plans to make it a grocery store raised an uproar. Bail's temple sat empty, slowly falling into disrepair as rain and wind and snow and vandals damaged it irreparably. Numerous activist groups argued that the church should be deemed a historic landmark and preserved, but sufficient funds were never raised. Though it had several reprieves of execution, in the end Bail's magnificent Fifth Church was doomed by more than two decades of neglect.

In 2014, the city of Cleveland ordered it demolished. It was razed by the end of 2016, with only the cornerstone and cupola lantern saved for posterity. Developers intend to incorporate the lantern into the outdoor public areas of the luxury townhouse complex planned for the site.

No Cleveland building was the subject of more failed preservation attempts than the Fifth Church of Christ Scientist on the Lakewood-Cleveland border.

In the end, it was Mother Nature who made the decision to demolish the landmark 1926 church. The building had fallen into such disrepair caused by exposure to the elements and vandals that it was deemed unsavable by 2014. The octagonal-shaped church had been vacant since 1990, when the congregation moved further west to the suburbs.

It was a tragic end for one of the most architecturally interesting buildings in the city. The church was one of the last buildings standing by famed local architect Frank W. Bail, who also designed the Gothic Lake Shore Hotel on Edgewater Drive.

The Fifth Church was the first west side Cleveland congregation for the young religion that arrived in the city in 1877 and constructed five churches in the area from 1891 to 1926. It cost $400,000 and took two years to build.

Bail, already a prominent name in Cleveland at the time of his hiring, came up with an unusual concept for the church. He modified the usual Christian Science round Neoclassical style into an octagon. It was designed to seat 900 congregants, with the octagonal shape providing the best sight lines of readers in the center for as many people as possible. Behind the reader's desk sat a pipe organ. The interior was marble and walnut.

ABOVE LEFT *In 1976, the octagonal Fifth Church of Christ Scientist was still an active church, located on the Cleveland-Lakewood border.*

RIGHT *Architect Frank W. Bail modified the usual Christian Science round Neoclassical style into an octagon in his striking design. The church completed in 1926 could seat 900 congregants.*

INDEX

Alhambra theater 107
Allerton Hotel 72–73
Alpine Shore Club 63
Alpine Village 62–63
Andrews, Samuel 33
"Andrew's Folly" 33
Anthony J. Celebreeze Federal Office Building 67
Archie's Lake Shore Bakery 115
Ark clubhouse 11
Bail, Frank W. 142
Bank Street 59, 95
Beidler, Herbert B. 83
Belden Street 15
Berea Road 15
Berger, Jules 75
Big Creek Valley 123
Billingsley, Peter 112
Birns, Alex "Shondor" 84, 111
Black, Robert 88
Bohannon, Jason A. 25
Boiardi, Hector 26
Bolivar Road 22
Bond Store 82–83
Bond Street 96
Boyce, Edward C. 8
Bramley, Michael 20
Bridge Avenue 53
Broadway Avenue 16, 22
Brookside Park 122–123
Brookside Reservation 123
Brookside Stadium 123
Brotherhood of Locomotive Engineers Cooperative National Bank Building 107
Bruell, Zack 95
Burke Lakefront Airport 124
Burnham, Daniel 11
Burnham & Root skyscraper 54
Calvary Presbyterian Church 79
Canal Street 88
Captain Frank's Seafood House 124–125
Carter Hotel 26
Carter Manor 26
Carter-Pick Hotel 26
Carter Road 103
Case, Leonard 11
Case Block 10–11
Case Hall 11
Case Institute 49
Case School of Applied Science 49, 92
Case Western Reserve University 11, 92, 132
Cedar Lee Theatre 100
Celebrezze, Anthony J. 124
Central Armory 66–67
Central Avenue 134
Central High School 11, 50–51
Central Market 19, 22
Chadwick, Cassie 33
Chamber of Commerce Building 54–55
Chester Avenue 49, 72
City of Cleveland steamship 42–5
Clark, Bob 112
Clark Avenue 91

Clark Avenue Bridge 90–91
Cleveland, Grover 67
Cleveland Aquarium 37
Cleveland Arcade 41
Cleveland Arena 49, 76–77
Cleveland Barons 49, 76
Cleveland Browns 46, 111, 127, 128
Cleveland Buckeyes 46
Cleveland Cavaliers 22
Cleveland Children's Museum 33
Cleveland Clinic 87
Cleveland Gesangverein Hall 134
Cleveland Heights 100, 115
Cleveland Indians 46, 127, 128
Cleveland Municipal Stadium 30, 126–9
Cleveland Museum of Art 49, 91
Cleveland Museum of Natural History 37
Cleveland Rams 46
Cleveland Spiders 46
Cleveland State University 33
Cleveland Street 25
Cleveland Zoo 123
Comès, John T. 79
Corrigan-McKinney strip mill 103
Cowell, George 95
Cowell, Herbert 95
Cowell and Hubbard Company 94–95
Creadon, Stephen S. 60
Crocetti, Dino 64
Cudell, Frank 120
Cuyahoga Building 98–99
Cuyahoga County and City of Cleveland Justice Center 131
Cuyahoga Criminal Court Building 130–131
Cuyahoga River 12, 19, 57, 80, 91
Dalitz, Moe 64
Detroit Avenue 12, 57
Detroit-Superior Bridge 12, 57
Detroit-Superior Bridge Subway 56–57
Dickey, Lincoln G. 30
Diebolt Brewing Company 16–17
Diebolt brothers 16
Dillard Department Store 112
Doan, Nathaniel 87
Doan Brook 37
Doan's Corners 49, 76, 86–87
Dunn, "Sunny Jim" 46
Dunn Field 46
Dunning, Nelson Max 26
Dyer, J. Milton 11, 25, 80
Eagle Avenue 19
East Ohio gas explosion 38–39
East Technical High School 50
Eaton, Cyrus 103
Edgewater 123
Edgewater Drive 142
81st Street 79
East Technical High School 50
Elliot, John 96, 107
Elysium Arena 48–49, 76, 87
Engineers Building 96, 106–107
Euclid Arcade 33
Euclid Avenue 32–33, 34, 41, 49, 50, 63, 68, 75, 76, 79, 83, 87, 95, 96, 99, 108, 111, 112
Euclid Avenue Opera House 11

Euclid Beach Park 8, 20, 49, 53, 70–71
Everett, Sylvester T. 33
Federal Reserve Bank 127
Feighan, Edward 60
Feighan, John T. 60
Feller, Bob 46
Fifth Church of Christ Scientist 142–143
55th Street 33, 50, 119, 134
First Baptist Church 41
FirstEnergy Stadium 30
Forest Hill Estate 34–35
40th Street 50
45th Street 103
Fourth Street 11, 22
Frank, Leo 75
Freed, Alan 76, 104
Frolics Bar 84
Fulton Fish Market 124
Garfield Building 96
Gaslight Inn 72
Geller, Jac S. 132
Gordon, William 37
Gordon Park 37, 53, 123
Gordon Park Bathhouse 36–37
Great Lakes Exposition 28–31
Grdina Park 38
Greene, Danny 111
Hammond, George F. 64
Hanna, Leonard 33
Heard, Charles W. 11
Heights Rockefeller building 34
Hickox, Charles G. 41
Hickox Building 33, 40–41, 83
Higbee, Edwin Converse 112
Higbee's Department Store 68, 112–113
Hippodrome Theater 96–97, 107, 108
Holden, Liberty E. 64
Hollenden Hotel 64–65
Hollenden House 64
Homestead, The 34
Hope, Bob 20, 87, 128
Hotel Euclid 108
Hotel Winton 26–27
Hough Avenue 115
Hough Bakeries 114–115
House of Wills 134–135
Hower, John G. 112
Hubbard, Addison T. 95
Hughes, Langston 50
Hulett, George 116
Huletts 116–117
Humphrey, Dudley 49
Huntington Bank Building 99
Huron Road 22
Industrial Flats 19, 91, 111
Ingersoll, Frederick 20
Innerbelt Freeway 57
Interstate 71 123
Interstate 77 120
J.M. Pearce Co. Wall Paper building 57
JACK Casino 112
Jennings, Gilbert P. 79
Jewish Orphan Asylum 120
Johnson, Tom L. 11, 15, 42, 53, 99
Jones Block 11
Keith's 105th Street Theatre 87

Key Tower 54
Knox, Wilm 107
Koz, Russell 100
Krenzler, Alvin I. 96, 108
Lake Erie 8, 34, 37, 45, 59, 71, 80, 92, 116, 124
Lake Shore Hotel 142
Lakeside Avenue 11, 67
Lakeshore Boulevard 63
Lakeshore Road 115
League Park 46–47, 53, 127
Lehman, Israel 22
Lehman, Joseph 119
Leo's Casino 74–75
Lexington Avenue 46
Lincoln, Abraham 59
Lorain Avenue 100, 138
Luna Park 20–21, 53
Madison Avenue 15
Mall, The 11, 54
Marriott Society Center Hotel 107
Mason Street 15
Massimo da Milano Italian restaurant 57
Mather, Samuel 33
McCormick, Anne O'Hare 79
McKinley, William 67
Memorial Shoreway 37
Memphis Drive-In 136–137
Mickey's Show Bar 84
Mileti, Nick 76, 111
Millionaires' Row 32–33, 34, 68, 79, 108
Mintz, Leo 104
Mitchell, George Evans 131
Modell, Art 111, 128
Mooers, Louis P. 25
Mt. Sinai Medical Center 132–133
Muni Stadium 30, 126–9
Murphy, John P. 141
National City Bank building 41, 84
National City Center 83
Ninth Street 33, 41, 50, 59, 80, 84
Ninth Street Pier 124
O'Donnell, Martin 103
Old City Hall 10–11, 25
Old Stone Church 11, 33
Oldfield, Barney 25
118th Street 100
105th Street 87, 132
156th Street 71
140th Street 8
107th Street 49, 87
110th Street 20
131st Street 103
Ontario Avenue 22
Ontario Street 19, 107
P.C. O'Brien Building 108
Packard, James 15
Parmatown Mall 140–141
Payne, William 33
Peerless Motor Car Company 24–25
Perry-Payne Building 120
Pershing Avenue 91
Petti, Nicola 100
Pile, Leonard A. 115
Pirchner, Herman 30, 63
Pittsburgh Avenue 16, 25
Playhouse Square 63, 95, 112

Plymouth Congregational Church 41
PNC Center 83
Prospect Avenue 26, 41, 50, 104, 108
Public Hall 127
Public Square 11, 53, 54, 71, 96, 112, 131
Q Arena 22
Quad Hall Hotel 75
Quigley Avenue 46, 91
Quincy Avenue 25
Record Rendezvous 104–105
Redding, Otis 75
Republic Steel 102–103
Richardson, John 120
Richfield Coliseum 76
Richman, Henry 119
Richman Brothers Company 118–119
Richmond Mall 104
Robison, Frank De Haas 46
Rockefeller, John D. 34, 50, 67
Rockefeller Building 107
Rolling Road 18–19
Roosevelt, Theodore 88
Roxy Theater 84
Ruble, Edward A. 16
Ruth, Babe 46
Ryan, William 8
St. Agnes Roman Catholic Church 78–79
St. Clair Avenue 38, 88, 107
St. Joseph Roman Catholic Church 120–121
St. Stephen Catholic Church 120
Schmitt, Theodore 22
Schweinfurth, Charles Frederick 33
Scofield, Levi T. 11, 50
Schroeder's Bookstore 99
Schutz, Anton 91
Schwarzenberg, Christian 119
79th Street 88
72nd Street 37
Sheriff Street 22
Sheriff Street Market 22–23
Shoppes of Parma 141
Short Vincent 84–85, 111
Sixth Street 57, 59, 64, 67, 84, 95
65th Street 53
61st Street 38
62nd Street 38
66th Street 46
Smead, Isaac D. 19
Smead Rolling Road 18–19
Smith, George H. 33, 41
Society for Savings Building 54, 99
Sohio skyscraper 99
Sprackling, Adolphus E. 108
Spanakis, Steve 138
Standard Brewing Company 60–61
Standard Building 107
Standard Theatre 108–109
Sterling Lindner Davis Company 68–69
Steve's Lunch 138–139
streetcars 52–53
Striebinger, Frederick William 134

Superior Avenue 11, 53, 57, 64, 95, 99
Superior Viaduct 12–13
Sutphin, Albert C. 49, 76
Swasey, Ambrose 92
Swingos, Jim 111
Swingos Hotel 111
Taft, William Henry 88
Tayler, Robert Walker 53
Taylor Road 92
10th Street 26
Terminal Tower 16, 19, 59, 104
Theatrical Grill 84, 110–111
Third Street 11, 91
13th Street 72
30th Street 33
Trailside Museum 37
Train Avenue 60
Trinity Cathedral 33
25th Street 12, 57
21st Street 131
27th Street 16
23rd Street 120
U.S. Coast Guard Station 80–81
Uehlin, August 16
Union Depot 58–59
Union Terminal 16, 19
University Circle 49, 71
Van Sweringen brothers 16, 53, 59, 112
Variety Theatre 100–101
Veeck, Bill 111
Veterans Memorial Bridge 12, 57
Vincent Avenue 84
Visconti, Frank 124
Vorce, Myron Bond 108
W.O. Walker Industrial Rehabilitation Center 87
Wade Park 132
Ware, William R. 54
Warner, Franz Childs 131
Warner, Worcester 92
Warner and Swasey Observatory 92–93
Water Street 59
Weber, Nathan 71
Western Reserve Building 99
Wexler, Morris "Mushy" 84, 111
Whiskey Island 80
White, Rollin 88
White, Thomas 88
White, Walter 88
White City Amusement Park 8–9
White Motor Company 88–89
Whitla, Willie 64
Williamson, Samuel 99
Williamson Building 98–99
Wills, John Walter 134
Willis, Winston E. 87
Winton, Alexander 15
Winton Motor Carriage Company 14–15
Woodhill Road 20
Woodland Avenue 20, 22, 120
Woodland Hills 20
Young, Cy 46

OTHER TITLES IN THE SERIES

ISBN 9781862059344

ISBN 9781862059924

ISBN 9781862059931

ISBN 9781909108714

ISBN 9781909815032

ISBN 9781909108448

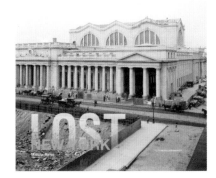

ISBN 9781909108431

ISBN 9781909108639

ISBN 9781862059351

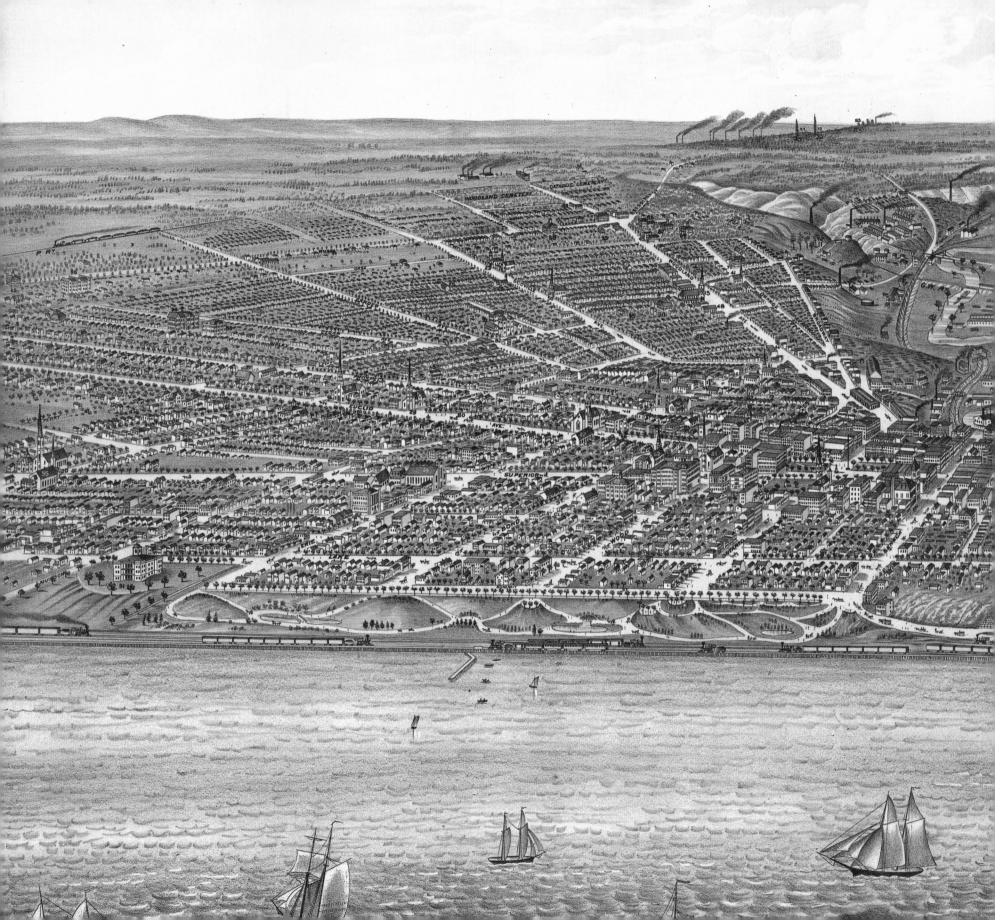